ROMAN
GARDENS

ROMAN GARDENS

Villas of the Countryside

PHOTOGRAPHS BY ROBERTO SCHEZEN

•

TEXT BY MARCELLO FAGIOLO

THE MONACELLI PRESS

First published in the United States of America in 1997 by
The Monacelli Press, Inc.
10 East 92nd Street, New York, New York 10128.

Copyright © 1997 The Monacelli Press, Inc.

Library of Congress Cataloging-in-Publication Data
Fagiolo, Marcello, 1941–
Roman gardens / photographs by Roberto Schezen ; text by Marcello
Fagiolo.
p. cm.
Contents: [1] Villas of the countryside.
Includes bibliographical references.
ISBN 1-885254-57-1 (v. 1)
1. Palaces—Italy—Lazio. 2. Architecture, Renaissance—Italy—Lazio. 3.
Architecture, Baroque—Italy—Lazio. 4. Gardens, Renaissance—Italy—
Lazio. 5. Gardens, Baroque—Italy—Lazio. 6. Sculpture gardens—Italy—
Lazio. 7. Gardens, Italian—Italy—Lazio. 8. Garden ornaments and
furniture—Italy—Lazio. I. Schezen, Roberto. II. Title.
NA7755.F27 1997
728.8'2'094562—dc21 97-18503

Printed and bound in Italy

Typography by Paul Montie/Fahrenheit
Translated from the Italian by Alessio Assonitis

CONTENTS

ROMAN
GARDENS

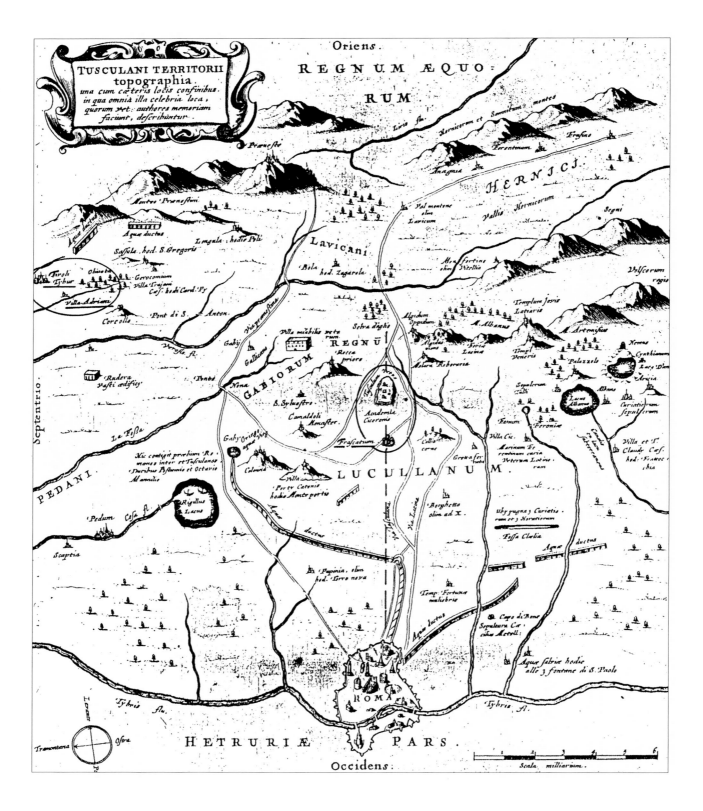

1. Map of ancient Lazio (by A. Kircher, 1671). In it are shown the relationship between Tivoli and Hadrian's Villa (upper left) and the axis that joins ancient Tusculum, Frascati and its villas, and Rome (center).

In Lazio—the region of Italy with Rome at its center—Renaissance and baroque villas and gardens have histories that are intimately fused with those of ancient times. If Rome is the garden of the emperors and the popes, the traditional site of classical gardens, then Lazio is, and has been since antiquity, a manifestation of the mysterious *genius loci*—partly dominated by Etruscan culture and partly by Latin and Italic culture—and a reference point for the myth of the garden that, through the example of Rome, was spread throughout the world.[1]

In ancient times, outside of Rome, the *horti romani*—that is, the gardens of patricians, aristocrats, and intellectuals—were scattered throughout the territory of Lazio (then known as Latium), clustered especially around the Albani Hills beneath Mount Cavo, site of Lazio's most important sanctuary, which was dedicated to Jupiter (figs. 1, 2). Of great renown, particularly through the writings of Cicero, was the organization of the *villae tusculanae* around Tusculum (today Tuscolo), near Frascati. Beginning in the late sixteenth century, the custom of the *villeggiatura*, or holiday excursion, gave rise to a new system of villas built by nobles and cardinals, in some cases directly upon ruins of ancient villas.[2] The new *teatri delle acque*, or water theaters, such as the one at Villa Aldobrandini, looked back at history by emulating ancient nymphaeums and at the same time paved the way for the future, setting the stage for the evolution of the French garden.

On the slopes of the Tiburtini Mountains just beneath Tivoli, Hadrian's spectacular villa, designed by the emperor himself in the second century A.D., came to serve as the archetype of a universal vision of art and history, which aimed at re-creating various wonders of the Mediterranean world in a striking collage, the appeal of which seems to be not only a consequence of its decay but of the dialogue it created between water and nature. At Villa d'Este in Tivoli, planned by the great architect-archaeologist Pirro Ligorio many centuries later, this dialogue, with memories of Hadrian as well as with ancient sanctuaries and Tivoli's acropolis, including the Temple of Vesta, was restored.

Just as Villa d'Este pays homage to ancient local cults, like those of Hercules and the Tiburtine Sibyl, the villas around Viterbo in Lazio honor mysterious Italic, Etruscan, and sometimes Egyptian divinities, as well as sacred mountains and lakes. In this area, a circle of aristocrats and cardinals—the Farnese, Orsini, Gambara, and Madruzzo families, to name a few—built extraordinary villas. Villa Farnese at Caprarola, both royal palace and acropolis of a rural hamlet, had both hanging gardens accessible from the main apartments and upper-level gardens dedicated to the local guardian divinities. Villa Lante at Bagnaia produced the first *via d'acqua*, or waterway, which was to have innumerable imitators in both nineteenth-century America and modern Europe. Vicino Orsini's Villa of the Monsters at Bomarzo represents the underworld of pagan mysteries with its praise of folly, the monstrous, and the irrational. Similar evocations emanate from the mysterious Fonte Papacqua (i.e., Acqua di Papa) of Soriano nel Cimino.

2. Schematic map showing the relationships among villas, mountains, lakes, and ancient sites around Rome (based on a plan by Christian Norberg-Schulz). In it are shown the historic/ mythic roots (the various *genius loci* are underlined) of the three principal groups of villas clustered around the *urbis romae* axis heading toward the Albani Hills and the sanctuary of Jupiter in Lazio.

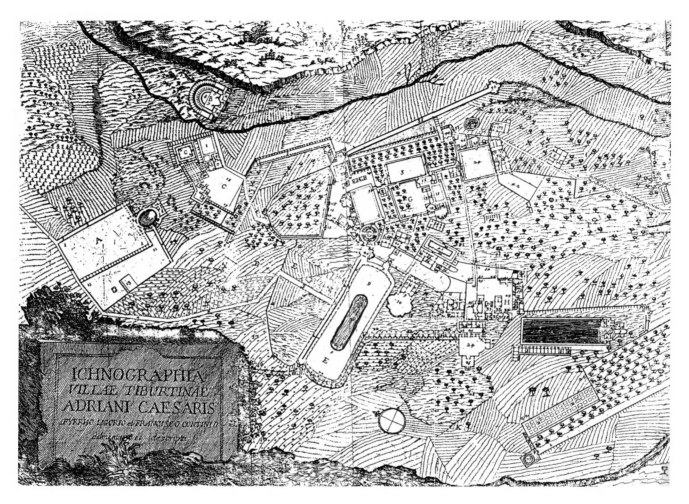

ICHNOGRAPHIA
VILLAE TIBURTINAE
ADRIANI CAESARIS

3. Hadrian's Villa, Tivoli: Site plan (by Pirro Ligorio and Francesco Contini).

Two themes resonate throughout the thousand-year history of the villa in Lazio: on the one hand, the villa as image of absolute power and quintessence of the world (which was set in an artificial nature, modeled on examples derived from both near and distant lands, and guided by the omnipotence of the sovereign) and, on the other hand, the villa as seclusion from the world and refuge in myth. Personifying these themes are the historic figure of the emperor Hadrian and the divine figure of Saturn, who according to mythology, took refuge in Lazio.[3]

Hadrian's Villa

In antiquity, the terms *villa* and *horti* designated the rural estates immediately outside the urban center. The term *villa* referred strictly to the lord's headquarters and not to the larger farm complex it controlled. According to aristocratic tenets, the villa was not "a place of country pleasures, such as hunting, but rather a center of intense cultural activity, of artistic and literary *otia*, which are more easily cultivated when not in Rome. It can truly be considered a *theater of art and culture*."[4] In opposition to *negotia*, or political affairs, *otia* (leisure activities) were refined cultural models of Greek or Hellenistic origin, which were disapproved of in Rome but were nourished far from the capital by aristocrats. The culture of *otia* seems to have prevailed in the imperial villas of Lazio as well: the Villa of Tiberius at Sperlonga, the Villa of Nero at Anzio, the Villa of Domitian at Castel Gandolfo. According to the majority of scholars, even the most outstanding villa complex of Lazio, Hadrian's Villa, must have been dedicated to the nourishing of *otia* and to the literary meditations of the emperor (fig. 3).[5] (So that these pursuits would not be interrupted, especially by the traffic of laborers and construction materials, an ingenious system of underground tunnels was constructed, most of them carved out of rock.)[6]

Hadrian's Villa should, according to H. Stierlin's recent interpretation, be conceived as not only a place of leisure and repose but also as a *palatium*, with all the imperial functions and rituals of the Roman and Byzantine *palatia*. Considered from this perspective,

the so-called Pecile functions as a hippodrome or, better yet, as a circus—a feature often present in imperial villas, in some cases accompanied or substituted by a sort of stadium. (In the quintessential *palatium*, the one flanking the imperial residence on the Palatine—the original source of the word—there is the Circus Maximus, the largest construction ever designed for spectacles.) This colossal 110-by-235-meter *pecile* is positioned on an east-west axis aligned with the trajectory of the sun, symbol of the circus games.[7] At the center of the southern side is an exedra that probably served as the imperial loggia; the large central water basin—a motif found in various areas of Hadrian's Villa that will recur frequently in the history of gardens—would seem to emphasize the *euripus*, the small canal that runs parallel to the tracks of ancient circuses.

The enigmatic *teatro marittimo*, or maritime theater—one of the archetypes for the theme of the island within the garden—has been interpreted as a private study, even a minimal residence for the emperor's complete isolation. Within a windowless cylindrical enclosure is a *circumambulatio* (circular walkway), then a circular moat that originally had two drawbridges, and finally a central island modeled after the famous *ornithon* (aviary) built by Varro and described in his *De re rustica*. At the center of the *ornithon* was a wooden pavilion, within which was a *coenatio* (dining room) with a *triclinium* (three lounges for recumbent dining) and a central rotating table. This pavilion was covered by a small dome that functioned as a clock that indicated both daytime and nighttime hours and also as a wind rose. On the basis of this analogy, Stierlin constructed the hypothesis that the central area of the maritime theater was itself covered by a small wooden cupola that functioned both as a *torre dei venti*, or weather tower, modeled on the Athenian prototype, and as a planetarium that corresponded to the plan of the island's convexities and concavities somewhat like the mechanism of a watch. The site, which surely must be connected with the *coenatio* of the Domus Aurea—the dining room with rotating planetary vault designated for the ritual banquets of Nero-Jupiter—would have been crowned with a baldachin-like pavilion

structure. It served as an image of the skies that ordained the emperor-*cosmocrator* sovereign of the heavens, at the center of the orbits of the planets and stars, and surrounded by the pool, similar to the ancient Ocean that surrounds Earth: "The *coenatio* is actually an 'aula regia,' a baldachin-throne, a cosmic place in which the emperor-god consecrated some kind of sacred rite, similar to the Chrysotriclinium in the Palace of Constantinople. In this 'aula regia,' or private audience chamber, only the initiated were allowed to participate in the imperial rite."[8] Here Hadrian could tabulate important horoscopes with the help of the positions of the stars and the wind rose, like a clairvoyant lord of the universe, and controlling jets of water, was able to arrange a kind of *hierogamia*, the cosmic marriage of sky and earth: "This *theater of the universe* thus became the supreme site of imperial adoration as well as laboratory of prophetic knowledge. Here, the almost homophonic terms *divinazione* [divination] and *divinizzazione* [deification] are conflated."[9]

The quasi-autobiographical history of the construction of the Canopus, rebuilt during this century with its colonnade and pool, illustrates this issue. The Canopus is the only positively recognizable feature of Hadrian's Villa related to the artificial canal of Alexandria, which gave access to the Serapeion, the temple of Serapis, here rebuilt in the form of a monumental nymphaeum, which probably also functioned as a *coenatio*. It was Hadrian himself who built the temple of Alexandria; here he identified himself with Serapis, an Egyptian god who had ties to Zeus, Hades, and Dionysus. Also relevant is the mysterious suicide of Hadrian's lover, Antinous, who drowned in the pool of the Canopus; this incident led to Hadrian's founding of the city of Antinoupolis. In other areas of the villa, Hadrian could identify himself as a young Jupiter or Apollo-Helios or Dionysus and even evoke—in the round temple of Venus—the mythical descent of Rome from the goddess of love, a symbiosis between goddess and city that the emperor had already consecrated when he planned and erected the Temple of Venus and Rome. The "pantheon" of Hadrian's

Villa should be understood, as least in part, as the adoration of the sovereign in various aspects of divinities and therefore as a sanctuary of imperial religion. This varied gallery of theophanic cults is intertwined with the traditional image of the emperor's villa, passed down through historiography as an eclectic consummation of the wonders of the world. Not merely a compendium of elements, it is instead a global and cosmopolitical vision of the world influenced by Stoic thought:

> *Hadrian's universalism tends to identify the empire with the totality of the Roman and Hellenistic world: in the temple of the Divine Hadrian in Rome, the images of the provinces support this imperial edifice; in Athens, a great sacred temple dedicated to the Panhellenic Zeus expands the ties between the Greek* poleis *to all the State. Hadrian, ironically considered as* graeculus, *sought to centralize the diverse cultural tendencies manifested in every region of the empire. The itinerant court of the emperor-architect settled even in the most remote territories, where the* Hadrianopolis *and cities with temples dedicated to the emperor abound. . . . The imperial residence at Tivoli represents the universal dimension of Hadrian's cultural politics; it is the virtual image of a* Eucosmia, *a perfectly ordered world that is capable of achieving an equilibrium between opposing forces.*[10]

This is not at all a ritual appropriation of the wonders of the world, which Hadrian visited, as was the parading of models of conquered cities in Roman triumphs, or the replication, by some Chinese emperors, of the palaces of conquered towns in their capital cities.[11] Rather, it is a sort of theater of memory or an intellectual reconfiguration of sites of memory that evokes and suggests different episodes, and that is reenacted on the stage of the mind as opposed to being literally reproduced in a kind of Disneyland.

Many of these sites bear witness to the identification of the sovereign with the conquered regions and, above all, with the appropriation of each *genius loci* by means of Hadrian's identification with various divinities. Two other architectural masterpieces attrib-

uted to Hadrian, the Pantheon and his mausoleum, reflect a similar imperial deification. The ray of light that penetrates the oculus of the planetary dome of the Pantheon[12] transforms it into a kind of solar sanctuary: "The dome evokes a celestial vault, the oculus is the luminous disk of the sun. . . . The sphere refers to the mechanism of the universe in accordance with the *harmony of the spheres*. By means of Pythagorean and Platonic principles, Hadrian sought to represent the cosmic order over which he presided as *cosmocrator*, Sun of the Empire."[13] Even the mausoleum—crowned with the chariot driven by the Sun, i.e., Hadrian-Helios—was conceived as a sort of solar apotheosis of the emperor. It should be mentioned here that the symbolism of Hadrian's Villa as an image of absolute power and as Regia Solis, the Palace of the Sun of the Hundred Columns (borrowing a famous Ovidian image), was to be used again at Versailles, *reggia* of the Sun King.

Saturn and the Diaspora of the Olympian Gods

Cradle of Italian civilization, according to the ancients, Lazio was considered the quintessence of Italy. The Virgilian term *Saturnia Tellus* (the land of Saturn) could have been extended to refer to the entire peninsula rather than just to the region that had been the refuge of the god. Saturn, the great old man of Lazio, and the first and most arcane *genius loci*, personified the memory and the survival of the golden age during the silver age, in turn presaging the harsh bronze age. Virgil wrote:

> In that first time, out of Olympian heaven,
> Saturn came here in flight from Jupiter in arms,
> An exile from a kingdom lost; he brought
> These unschooled men together from the hills
> Where they were scattered, gave them laws, and chose
> The name of Latium, from his latency
> Or safe concealment in this countryside.[14]

The myth of the *Saturnus pater* (Saturn as the founder of this region) was still popular during the Renaissance and the baroque, appearing in Leandro Alberti's *Descrittione di tutta Italia* (1551) and Athanasius Kircher's *Latium* (1671). In this last account, the old lord of Crete was substituted by the legendary figure of Saturn-Sabazius, rather than by the Saturn-Janus-Noah who was supposed to have taken refuge in Lazio in order to avoid the conspiracy of his son Jupiter-Berosus, king of Babylonia. In both versions of the myth, Saturn is said to have founded a city at the foot of the Capitoline as well as to have introduced laws and tools for the cultivation of the fields and to have taught techniques for harvesting and planting grapevines. (The Varronian term *Saturnus a satu* is derived from the word for sowing, *satus*.) Discounting the role of the indigenous inhabitants from pastoral prehistory, the eponymous hero of Lazio would have been the inventor of both the culture of the city and the cultivation of the fields.

Apart from the numerous literary citations, the artistic representations of Saturn are very limited. An exception is the Saturn-Janus-Noah present in the Villa Turini-Lante on the Janiculum, and thus in the mythical *arx ianiculensis*, the citadel on the Roman hill consecrated by that very god (Janiculum derives from Janus). Curiously, the image of Saturn is almost entirely absent from the historic villas of Lazio and thus in the sites where culture (*cultura*) married cultivation (*coltura*). Why is the figure of the *genius loci* of Lazio paradoxically missing, or *latente*, as if it were taboo? Perhaps the god was too marred by the scourge of retribution that condemned him to the persecutions of his own son after the castration of his father, Uranus-Heaven. Or perhaps, more simply, it was necessary to exorcise the figure of the god that would have been assimilated to the Greek Kronos, or Time, who devoured his own offspring, destroying the works and days of humanity.[15]

It may be possible to retrace the vestiges of Saturn in the more hermetic components of gardens. In the depiction of Lazio illustrated at the beginning of the seventeenth century in Cesare Ripa's *Iconologia*

(fig. 4), a warriorlike Roma is portrayed sitting on Saturn's cave, symbol both of initiatory-esoteric concealment and of the passing of time (through the reference to the "cavern of eternity").

The taboo against Saturn might have been evoked in grottoes of sixteenth-century gardens, such as the one at Villa d'Este at Tivoli, or in certain enigmatic representations, like the Fonte Papacqua, where the old bearded man carved into the rock strongly resembles the drawing by Ripa. But more frequent and closely affiliated with the concept of the garden itself is the myth of the golden age of Saturn, alluded to by the acorns emerging from the center of the fountain at Villa Lante at Bagnaia, or the acorns lined up like giant trophies next to the pine nut in the hippodrome of Bomarzo. These recall Dante's verses from *Purgatory*:

> *The first age was as fair as gold; when hungry,*
> *men found the paste of acorns good; when thirsty,*
> *they found that every little stream was nectar.*[16]

In general, it can be said that the villas of Lazio are the metaphorical refuge of the Olympian gods. Just as many Italian cities from the Veneto to Puglia were founded as a result of the Trojan exodus, it seems as if a sort of Olympian diaspora led to the formation of numerous villas in the semblance of colonies or of Olympic *castra* (encampments). The adventures of heroes like Odysseus are relived in imperial villas between Lazio and Campania, almost as if to fix in solid rock the legends that had touched those places. The most important example is the spectacular grotto at the Villa of Tiberius at Sperlonga, where various colossal sculptures represent the dramatic events of Odysseus's voyage, from the blinding of Polyphemus to the fight against Scylla.[17]

Recent research has established an association between the grotto of the Villa of Tiberius and other grottoes, both natural and artificial, each of which functioned as an imperial *coenatio* and resembled Cyclops' cave.[18] The prototype was the cavern of Sperlonga, which perhaps served as a backdrop for the garden of the villa. Originally covered with sand, it was later reconfigured with artificial rocks and the addition of an imitation sea (a pond stocked with sea fish), so that it vividly simulated the tormented travels of Odysseus.[19]

Another replica of the cavern of Sperlonga—aside from the nymphaeum of Claudius at Baia— was built in the nymphaeum of the "Bergantino" in Domitian's Villa at Castel Gandolfo, which included sculptural groups of Scylla and Polyphemus. It has been suggested that there was some sort of variation of this in the nymphaeum[20] at Hadrian's Villa, thought to have included a Polyphemus group (heads of several companions of Odysseus have been discovered). Meanwhile, in the waters of the Canopus are thought to have been two paired Scylla groups, alluding to the deadly perils of Scylla and Charybdis. Generally speaking, the artificial landscape of Hadrian's Villa appears to be dominated by a mystical pantheism, where Olympian deities cohabitate with Egyptian gods, where the woods of Pan are found alongside the Vale of Tempe, and where the enchantment of the Elysian fields counterbalances the fear of hell.

Beginning in the sixteenth century, the gods of classical mythology were represented more frequently and diffusely in the villas of Lazio, far from the conscientious censorship of the papal court and the Counter-Reformational climate, than in the Roman ones. Above all, the figure of Hercules appears to be the guardian deity of gardens, including those of Caprarola, Villa d'Este, and Villa Aldobrandini, where the mythical adventures of the hero are evoked. In the Palazzo Farnese at Caprarola, the frescoes of the Loggia of Hercules recount the myth of the creation of

4. Allegory of ancient Lazio (from C. Ripa, *Iconologia*, 1616).

14

Lake Vico. Here Hercules is said to have planted his club in the soil; none of the local peasants could unearth it, and when Hercules himself did, he released the gush of waters that created the lake. At this site, a temple was supposed to have been dedicated to the memory of Hercules's labor. However, the Palazzo Farnese was itself built as a monument to Hercules: the circular courtyard, which collects rainwater and funnels it into an underwater reservoir, evokes Lake Vico in both shape and function. (The faunlike *mascherone*, or mask, at the center of the courtyard confirms the theme of the *axis mundi*, which ideally connects the superior aerial world of the noble inhabitants of the palazzo with the underworld where earth, water, and fire dwell.) The club of Hercules becomes associated with the scepter of the Farnese dominion, surmounted by the family's heraldic lily. At either end of the *via d'acqua* of the palazzo's upper garden (fig. 5), water once gushed out from heraldic lilies, synthetically re-creating the legendary Herculean labor.[21]

At Tivoli, however, the myth of Hercules Saxanus flourished.[22] The hero—both defender of the ancient town of Tybur and mythical founder of the Este family—is said to have defeated the armies of Albio and Bergio in battle with the aid of Jupiter, who hurled stones from Olympus.[23] The Este garden is associated with the Garden of the Hesperides, where Hercules had once plucked the golden apples (later incorporated into the Este coat of arms). Along the central axis, starting from the Fountain of the Dragons, custodians of the mythical gardens, Hercules was supposed to have been represented three times: first as an old man in repose, then with a child in his arms, and finally as the custodian of the palazzo. This axis of the villa

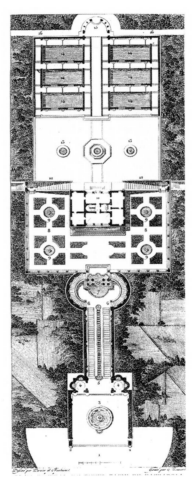

5. Palazzo Farnese, Caprarola: Plan of the upper garden, with Pleasure Casino in the center (by Percier-Fontaine, 1824).

alludes to the famous episode of Hercules at the crossroads, and from here, the choice is between the Grotto of Venus,[24] or "of voluptuous pleasure," and the Grotto of Diana, "dedicated to honest pleasure and chastity."[25] In the Villa Aldobrandini, Hercules (associated with Cardinal Pietro Aldobrandini) is depicted in the act of supporting the celestial globe of Atlas, a direct metaphor for Pope Clement VIII, uncle of the cardinal. Furthermore, the two spiral columns that demarcate the vanishing point of the perspective of the water theater allude, on the one hand, to the monumental columns of Trajan and Marcus Aurelius and, on the other, to the Columns of Hercules.

Another important issue is the dichotomy between the complementary Apollonian and Dionysian poles. At the threshold of the age of humanism, the relation between these two deities was captured by Petrarch, who dedicated to Apollo and Bacchus two of his gardens at Vaucluse. If the *Apollo* of Villa Aldobrandini was meant to inspire, as G. B. Agucchi suggested, "virtuous things and liberal arts," then the *Bacchus* at Villa d'Este alludes not only to the vice of drink but also to the themes of death and regeneration celebrated in Dionysian mysteries. Meanwhile, the *Triumph of Bacchus* in the Villa Carolina at Castel Gandolfo religiously exalts the "culture" of the vine of the Castelli Romani area.[26] Similarly, even the *Venus* of Villa d'Este does not allude so much to amorous pleasures but rather, as Pirro Ligorio pointed out, "to a terrestrial Venus, mother of all loves and of all intellects, of all things unified with the beautiful and celestial Venus."[27]

In sum, a great number of gods succeed one another on the grounds of the villa, some of which are represented with heraldic animals (the dragon of the

Boncompagni family, the eagle of the Este and of the Borghese families, the crayfish of the Gambara family). Another mythical animal, Pegasus, is represented at Tivoli, Bomarzo, and Bagnaia in the act of opening the spring of Mount Parnassus. By means of this conceit, the water of the gardens is metaphorically associated with the spring of Poetry, while the villa is compared to the dwelling of the Muses and the Arts. If the nymphaeum was intended as Sanctuary of the Muses and as *sacellum* of mysterious waters, the villa could have been conceived as *Museum*, or Temple of the Muses and Parnassus restored.

The Shelter of the Powerful

The metaphor of the refuge of the gods appears to suit the programs of the villas and castles of Lazio built for the retreat of nobles and cardinals. These *reggie dell'esilio*, or residences of exile, were sites where ambitions, frustrated by history, could be carried out in the kingdom of nature. This phenomenon is parallel to the more general tendency to convert a constellation of medieval castles into a chain of pleasure palaces or to sublimate the local countryside and the vineyards to the artificial landscape of the garden. Apart from certain areas around Rome and Viterbo, late medieval Lazio still partly conformed to the description given by Gregorovius in 1859:

> All those country towns that can be seen in the outskirts— and that are older than Rome itself, dating back to the age of Saturn—sit dark and sinister on rocky hills, unchanged by time. The medieval feudal lords have built their castles in these towns, while the peasant, today as always, farms with the sweat of his brow the vineyards, the olive tree, and the cornfields. . . . It is striking to go through a town that from far away appears to be a paradise and it is really only a deserted and picturesque land with a few miserable fields and a thick growth of broom trees and asphodels, which falcons fly over.[28]

The organization of villas and noble residences echoes the strategy of distribution of towers and fortresses according to radial axes that originate in Rome. During the Middle Ages each noble family with a fortress within the Roman city walls also had a corresponding fortified bastion, which controlled access to Rome, outside the walls. Similarly, the villas and country estates were often an integration of the city palaces and suburban villas. This is exemplified by the relations among the different residences of the Farnese family: the palazzo in the city, the *vigna* on Via della Lungara, the *barco* and the palazzo at Caprarola, the castle at Capodimonte with the Isola Bisentina in Lake Bolsena, and so on. The bastioned or turreted fortress survives in the palazzo at Caprarola, and in the first plan for the palazzo of Villa d'Este, as well as in the Palazzo Chigi at Ariccia, the Casino Sacchetti at Castelfusano, and the Villa Catena at Poli.

Raphael's prototype, the Villa Madama in Rome, offers a fortresslike typology, with cylindrical towers and walls that might have been battlemented. The drawbridge of Palazzo Farnese at Caprarola corresponds to the bridges that connect the main floor with the fenced-in gardens in the back. Analogous is the connection between the palazzo and park in the Marescotti-Ruspoli Castle at Vignanello and the Palazzo Giustiniani-Odescalchi at Bassano di Sutri.[29] Furthermore, it should be noted that the modern villa-fortress evolved from the ancient *villa rustica*, with its wall-enclosures dominated by angular projections, and from the *domusculta*, which in turn was the prototype of rustic fortified *casali* that were transformed into leisure residences after the Middle Ages.

The idea of a country residence for cardinals almost became institutionalized when, in a late-fifteenth-century conclave, it was proposed to allot to each cardinal the income and production of a castle or rural estate outside of Rome. The biography of Cardinal Alessandro Farnese, grandson and influential secretary of Paul III, is pertinent to this discussion.[30] An important figure in European politics until Paul III's death in 1549, Alessandro, with the advent of Julius III, took refuge in his castles at Gradoli and Capodimonte before he was obliged to go into exile. Restored to power in 1555 and aspiring to the papal throne, he asked his sister-in-law Margaret of Austria

to lend him the Villa Madama in Rome "in order to rest from business so that I can take pleasure in its restoration and tending." Denied his request, he asked Monsignor Archinto to rent to him for a short while "that place of Your Lordship at Tivoli, which has been described to me as such, which would suit me well as a retreat from Rome both for the air and for its proximity and for other needs." The first projects for the transformation of the pentagonal fortress of Caprarola into a palazzo-villa, which was begun several decades before by Sangallo the Younger and interrupted with the election of his patron as Pope Paul III in 1534, date to the following year. The intention was to create a new Farnese *reggia* in order to oversee the feudal lands of the Tuscia area near Viterbo. Conceived at the same time as the Escorial, the palazzo at Caprarola delineates the themes of the modern *reggia*, which were to pave the way for the Louvre, Versailles, and Caserta.[31]

The works at Caprarola, including the restructuring of the medieval village and the rural area surrounding it, intensified in the following decades, coinciding with the more frequent sojourns of the cardinal, whose power increased as his chances of being pope decreased, since powerful cardinals were thought to threaten the delicate equilibrium of European politics. Protagonist of seven conclaves, he was able to pressure the election of three of his favorite cardinals, gaining the title "creator of popes." Nevertheless, the disappointment resulting from so many missed elections was tempered with the development of the *reggia* at Caprarola and, in the last years of his life, with the building of the Gesù, the church in which the cardinal wanted to be buried.

Among other residences of exile were the Villa d'Este at Tivoli of Cardinal Ippolito, another aspirant to the papal throne, and the villas of Cardinal Madruzzo at Soriano and Cardinal Gambara at Bagnaia, both in the area of Viterbo. In the same category are two "inventions" of noble patrons, Vicino Orsini's Bomarzo, with its famous monsters, and Giacomo Boncompagni's castle on the waterfall at Isola del Liri. Several years ago, Eugenio Battisti wondered how it was possible that a group of intellectuals

and churchmen of such high political rank could have squandered such great sums on the building of villas. The result of his query was both cruel and, in part, paradoxical:

> *My interpretation of their letters and journals leads me to conclude that what had occurred was a kind of escape, a willed suicide, a desperate reaction against Counter-Reformational censorship, a dramatic awareness of the collapse of humanist ideals; in other words, a kind of testament that forces us to confront the meaning of the latent values in these famous gardens. These men preoccupied themselves with setting their gardens in adjacent areas, using the same architects and fountain designers, and exchanging correspondence. Each one imitated the world of the other with a kind of espionage, but none of them was able to escape a hermitlike existence. Thus, the residence outside of the city was no longer a place merely for temporary sojourns, but a permanent residence, as with Bomarzo and Bagnaia.[32]*

Continuity and Renascence of the Antique, from Tybur to Tusculum

Having obtained the governorate of Tivoli as compensation for both his unsuccessful bid for the papal seat and the support given to Julius III, Cardinal Ippolito II d'Este, son of Alfonso I, duke of Ferrara, and Lucrezia

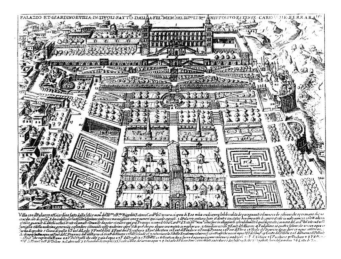

6. Villa d'Este, Tivoli: View of the garden looking toward the palazzo (etching by J. Lauro, 1625).

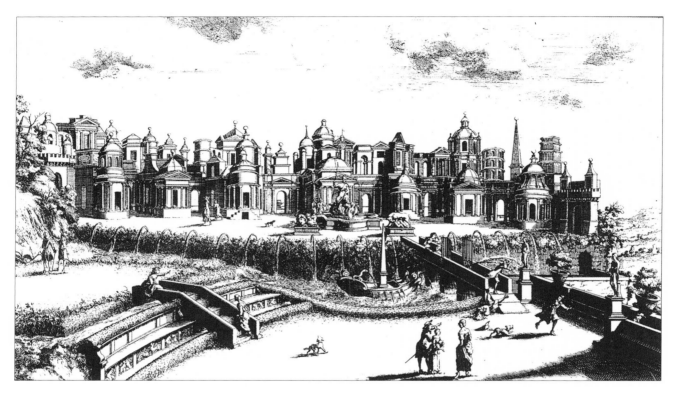

7. Villa d'Este, Tivoli: Fountain of Rome, or "Rometta" (etching by G. Venturini, 1691).

Borgia, arrived in the Tiburtine city on September 9, 1550, and was triumphantly received by the local population. Immediately, Cardinal Ippolito recruited Pirro Ligorio, appointing him as antiquarian advisor for the archaeological sites and the restorations of Hadrian's Villa and other Tiburtine antiquities. The creation of the garden at Villa d'Este (fig. 6), however, dates from after 1560, the time of the works to channel water and to remodel Villa Gaudente, where there used to be "a great empty place full of crags, rocks, and scrub."[33] The creation of impressive artificial terraced lands both connected Villa d'Este with the projects at Hadrian's Villa and also evoked the Hanging Gardens of Semiramis in Babylonia, a mythical wonder of the ancient world.

The *reductio ad culturam* of natural chaos had an imperialistic breadth so great that it compared with the Roman program that imposed Roman culture over acquired territories by means of the division of land into a geometric grid (*centuratio*) and the foundation of colonies and military encampments (*castrametatio*). Even in its plan, the villa seems to have parallels with the architecture of the Roman world. The villa can be read as a true *castrum* within a natural setting, with the palazzo being analogous in function to the ancient *praetorium*. It is, in fact, an appropriation that has its roots in the villas of imperial Rome, when the term *praetorium* often designated the residential buildings of aristocrats and emperors.[34] Even the orthogonal fabric of the roads of the villa recalls the plan of the *castrum*: remarkable are the five major *cardines* aligned on a north-south axis.[35] The recollection of the *castrametatio* technique is attributed both to Pirro Ligorio, who after having correctly identified the *castrum praetorium* in Rome often made use of castral typologies, and to Cardinal Ippolito, who with Pietro Strozzi, at the time of his French sojourn, had commissioned Serlio to draw the *castrum* described in a theoretical work of

Polybius. (This is a series of drawings and texts that made up the never-published eighth book of his architectural treatise.)[36] The reference to the ancient city was not merely meant to be theoretical, since the orientation of the villa-*castrum* appeared to have been influenced by the archaeological grid–like territory of Tivoli. This in turn characterized both the orientation of the Roman roads of Tybur and the extraurban buildings such as the ancient sanctuary of Hercules, which is not far from Villa d'Este and was identified by Ligorio as the Villa di Mecenate. Even certain ancient villas, which often have enclosures resembling urban walls,[37] are celebrated for their dominating fortresslike positions. Seneca himself wrote that the villas of Pompey and Caesar at Baia had a military character such that they could easily be called *castra* instead of *villae*.[38]

A second Roman model for the Villa d'Este can also be identified: the imperial baths. These were true citadels of leisure, almost a city within a city. The large square of the villa (about 200 by 250 meters with a longitudinal axis of more than 300 meters if the entranceway and the palace itself are included) has dimensions that compare to the Baths of Trajan (300 by 300 meters), Caracalla (350 by 400 meters), and Diocletian (180 by 215 meters). The enclosure, with two major exedras[39] that project laterally, makes up part of the structure, which is typically bathlike. Unquestionably the baths were selected as a model because they represented possibly the peak of Roman civilization, as did villas.[40] In this extraordinary space devoted to hygiene, sport, culture, and social activities, the Romans found not only a place for baths and cures but also gyms for gymnastics, terraces for heliotheraphy, gardens and porticos for walks, fountains and nymphaeums, indoor and outdoor sculpture collections, libraries, and conference rooms.

If the baths were both cathedrals of waters and museums or temples of culture, then the court of Ippolito d'Este was seen—according to the humanist

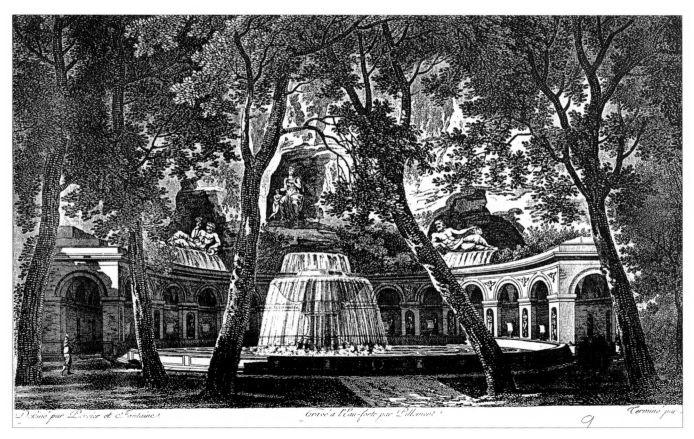

8. Villa d'Este, Tivoli: Fountain of Tivoli, or of the Tiburtine Sibyl (by Percier-Fontaine, 1824).

Ercole Cato, evoking the epoch of Hadrian's Villa—as "an academy, symposium, a theater of the world." All of Villa d'Este was conceived and experienced in both the spirit of ancient culture and the spirit of the theater. Visitors played the roles of both spectators and actors as they walked through avenues and fountains, immersed in a series of actions and reactions and continuous scenery changes, in an atmosphere of ever-changing sounds of water, or at the center of impro-vised water games. Sources of the time describe many areas of the villa as theaters. The Fountain of Rome, or "Rometta," is an architectural scene influenced both by the *scaenae frons* of ancient theater and by medieval and humanistic stage (fig. 7).[41] The proscenium of the fountain, which could have contained actors for academic plays, had a series of symbolic stone figures: *Rome, Tiber*, and *She-Wolf with Romulus and Remus.* Even though the Fountain of Tivoli, or of the Sibyls, is described as the "queen" of the fountains "in the shape of a theater" (fig. 8), other fountains can similarly be considered water theaters, including the *pulcherri-mum piscinae theatrum* of the Fountain of the Dragons at the center of the sacred Herculean representation and the *nobilissimum theatrum* of the Fountain of the Deluge. Prototype for the water spectacles of the late sixteenth and seventeenth centuries, this grandiose stage emulated the Trofei di Mario (or Nymphaeum of Alexander Severus); even its subsequent transforma-tion into the Fountain of the Organ fits into the wider context of musical water spectacles. While other scenographic nymphaeums, like the fountains of Venus, the Owl, and the Emperors, will not be discussed here, it is imperative at least to mention that the two fish-ponds with the never-executed Mete Sudanti allude to an ideal aquatic circus.

If at Tivoli Villa d'Este was the only complex that attempted to emulate the ancient Tiburtine villas, at Frascati, on the other hand, during the course of half a century—between the pontificates of Gregory XIII (1573–85) and Gregory XV (1621–23)—a resplendent constellation or zodiac of twelve villas[42] was built, which aimed at resurrecting the ancient city of Tusculum, to which the system of the *villae tusco-lanae* was attached (fig. 9). These villas belonged to

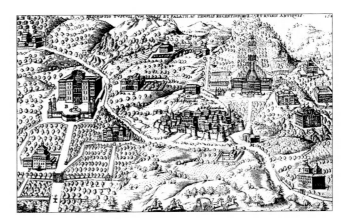

9. Scheme of *villae tuscolanae* in Frascati (etching by J. Lauro, 1625).

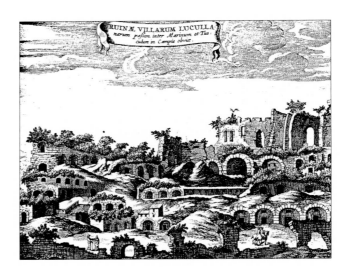

10. View of the ruins of Lucullus' *villa tuscolana*.

such famous figures as Cato, Lucullus (fig. 10), Sallust, Pompey, Cicero, and Tiberius. The phrase "Tuscolo Restituita" appears on a medal coined by Pope Paul III, who had in 1537 transformed the hamlet of Frascati into a city, thus establishing the custom of the holiday excursion for popes and cardinals to the new city of Tuscolo.[43]

The medieval town was enlarged, taking into account the plans for the cathedral and the Villa Rufina (later Falconieri). Villa Rufina was built in 1546 by Bishop Alessandro Rufini as his own summer residence and also as a place of "repose for the busy mind of the pope." This villa-fortress—along with the Caravilla, the small villa of Annibal Caro—is thought to have instigated the rebirth of the *otia tuscolana*,

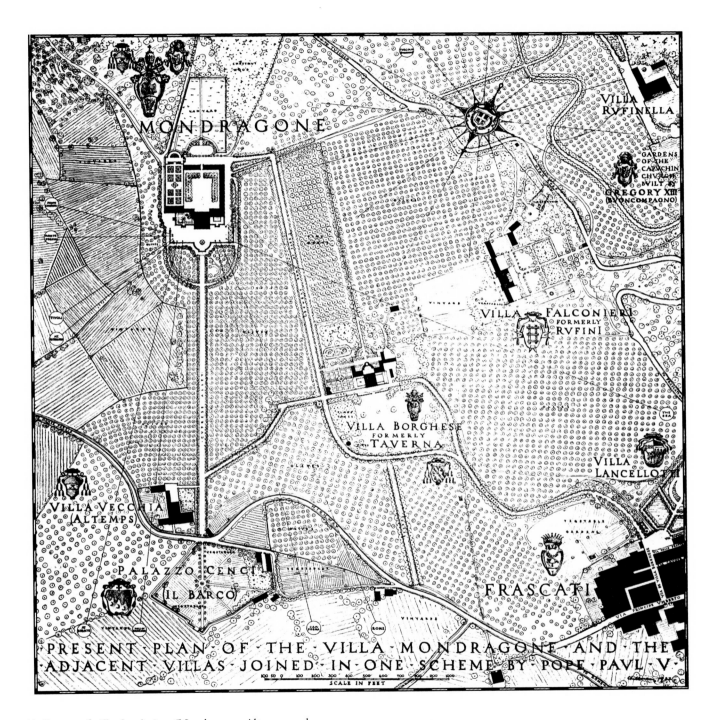

The labels visible within the map image include: MONDRAGONE, VILLA RVFINELLA, GARDENS OF THE CAPVCHIN CHVRCH BVILT BY GREGORY XIII (BVONCOMPAGNO), VILLA FALCONIERI FORMERLY RVFINI, VILLA BORGHESE FORMERLY TAVERNA, VILLA LANCELLO, VILLA VECCHIA (ALTEMPS), PALAZZO CENCI (IL BARCO), FRASCATI, PRESENT·PLAN·OF·THE·VILLA·MONDRAGONE·AND·THE·ADJACENT·VILLAS·JOINED·IN·ONE·SCHEME·BY·POPE·PAVL·V, SCALE IN FEET

11. System of *villae borghesiane* (Mondragone, Altemps, and
Borghese-Taverna) in the area between Frascati and ancient
Tusculum (drawing c. 1920, American Academy in Rome).

which took place especially during the pontificates of Pius IV and Gregory XIII.

Writing to his friend Torquato Conti in 1564, Caro expressed a desire to build "a town of villas from Poli to Rome." That dream of an association of *gentilhuomini politici* through a plan to create a chain of villas remained an intellectual metaphor. However, around Frascati a kind of *città di ville*, or city of villas, comparable in its breadth and quality to the ancient system of the *villae tuscolanae*, did in fact arise. Several of the new villas were built directly over remains of ancient edifices and foundations, positioned to enter into a dialogue with the two poles of the territory: ancient Tusculum, with its remains at the top of the mountain, and Rome, in the valley, about twelve miles away, toward which the facades of the surrounding villas, like sunflowers, were oriented.

The slope of the hills of Tuscolo is like a theater or amphitheater [44] made up of various individual villa-theaters, strategically placed in order to make optimal use of the irregular terrain, the infrastructures of pre-existing sites, and above all, the extraordinary views of Rome. It is interesting to note that the city of Frascati is placed exactly on the axis that connects ancient Tusculum with Rome. Furthermore, along a similar axis are placed the longitudinal structures of two of the most ancient villas—Villa Rufina and Villa Rufinella.

A different orientation, which seems to radiate from the ancient theater of Tusculum, is shared by Villa Mondragone, Villa Vecchia, and Villa Taverna,[45] which are slightly to the east of this axis and which constituted a kind of feudal territory of the Borghese family at the beginning of the seventeenth century (fig. 11). Four villas of the western area, the Aldobrandini, Borghese-Ludovisi, Belpoggio, and Montalto-Grazioli, have a similar orientation, considered to be ideal even from a solar perspective. In the final analysis, this constituted an intense and continuous dialogue between villas and cities, between artificial and natural landscapes.

The Triumph of Order over Chaos

The *ritirata*, or retreat, of the powerful often assumed sacred connotations, including the recollection of the primeval human setting: "God Most Powerful before everything else planted a garden," stated Sir Francis Bacon. The difficulties encountered by Ippolito d'Este in bridling the savage nature of the site recalls an almost demiurgic operation, one worthy of ancient emperors and emulating the creation of the cosmos from chaos by the hand of the Great Architect of the Universe. Daniele Barbaro, patriarch of Aquilea and translator of Vitruvius, stressed the almost supernatural and instantaneous character of the cardinal's Tiburtine creation:

> Nature must admit to having been overpowered by art and by the splendor of its soul; almost in an instant, gardens were born, and woods were created, and trees full of luscious fruit in a night were found, and valleys grew out of mountains, and in mountains of hard rock riverbeds were made, and rock was parted in order for water to spring, and the dry earth was flooded, and watered by springs, and by streams, and by rare fishponds.[46]

In another passage, he recalled: "The art of humankind and the power of the cardinal have forced and upset the nature of this garden, and the world gripped with fear when men were seen with metal clubs ripping out hard stones that were buried in it, in order to give shape to this garden planned by architects."

Ippolito and his architects imposed order not only on the nature of the place but also on history itself. He razed some areas of the medieval nucleus of Tivoli and built part of his villa in populated areas. The walls of his villa are partially used as a defensive system for the garden. (From the countryside, the works for leveling the terrain and structuring the terraces of the area are clearly visible, as is the transformation of several medieval towers in the area into a belvedere.)

Other grand-scale operations occurred on the hills of Frascati, where "crags were tamed by iron and fire," as an inscription in Villa Rufina attests. It is precisely in villas such as these that Michel de Montaigne discovered how "art was able to utilize correctly for its own ends such an uneven, mountainous, and lumpy land, since its inhabitants have managed to reap out of it such beauties that cannot be reproduced on our flat lands, and were able to make use with great art of this unevenness of terrain."[47]

The Axis of Dominion

In the labyrinths of Lazio's villas, Ariadne's string is laid out according to the axis of symmetry of the garden, which is both the privileged route and the optic ray of visual dominion over artificial nature. The axis of the garden may even transgress the boundaries of the villa and permeate the territories of nature and history.

As I have tried to demonstrate elsewhere, especially in regard to Villa Madama and other Roman villas,[48] the axis of the villa must be identified with the dominating line of vision. The axes can be traveled physically or, on the contrary, cannot; they can even be invisible (or at least visible only to the mind's eye). There are covered and uncovered axes, physical ways and waterways. Notable examples of aquatic axes are the Viale delle Cento Fontane (Path of the Hundred Fountains) at Villa d'Este at Tivoli (which extends from the Fountain of Tivoli and the Fountain of Rome along the axis between the opposing poles of the temple of the Tiburtine Sibyl and the city of Rome, far away on the horizon) or the waterways of Bagnaia, Caprarola, and Frascati. At Bagnaia, for example (figs. 12, 13), the waterway descends "down through a marble canal so long that when the water moves with great force over these obstacles, it breaks and jumps with much foam, which from far away seems like rings of a very large silver chain."[49] In the powerful structuring of biomorphic concatenated volutes, the *catena d'acqua* (water chain) can be read as a transfiguration of the *gambero*, or crayfish, the emblem of Cardinal Gambara. In a complex labyrinthine itinerary, one

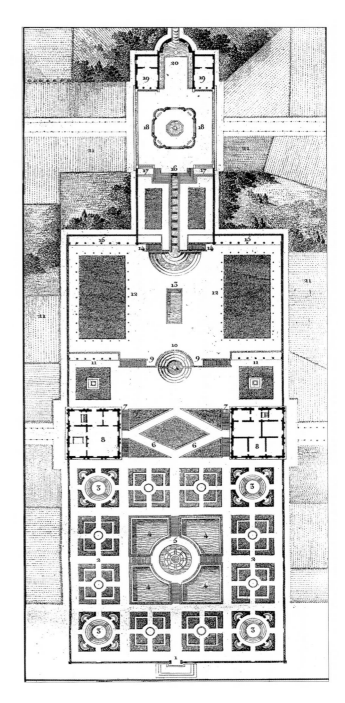

12. Villa Lante, Bagnaia: Plan (by Percier-Fontaine, 1924).

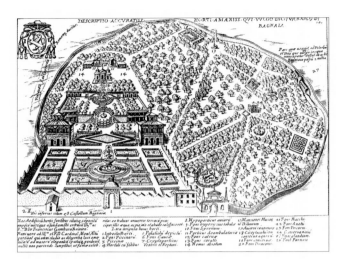

13. Villa Lante, Bagnaia: View of the geometric garden and the barque (etching by J. Lauro, 1625).

encounters first the park, then the upper fountains, and finally the lower gardens of Bagnaia; it is a progressive landscape that spans from the kingdom of primeval nature during the golden age to human civilization after the deluge. The rectilinear flow of water and then the order of the garden spring from the generative chaos. Humanity is reborn from raw matter by means of art, magic, and grace.

The gardens can be read as the encoded incarnation of the axis of human history with the discovery of irrigation, agriculture, hunting, and fishing. At first the flow of water is tempestuous, then it descends linearly but with jumps and rapids, as if it were a torrent, until it finally calms when it reaches its goal, the Fountain of the Fishponds or of the Moors, which resembles its origin. The fountain of the lower garden is a sort of terrestrial paradise that binds itself conceptually to the theme of the golden age expressed in the park. The perfect orientation of the garden to the four cardinal directions alludes to terrestrial paradise and its four mythical rivers.

Views and Visions

With villas such as the Aldobrandini, the role as belvedere is extremely significant. First of all, the villa is incorporated into the panorama (fig. 14). This panorama is an urban one, since the villa, according to

an account at the time, "ends with the city of Frascati, and it seems as if the valley were governed by it, and the villa ornaments the city and the city the villa."[50] It is also a "natural" panorama, in which the villa is like a gem or mirage visible from many miles away, almost as if it were engaged in a dialogue with the cupola of St. Peter's in Rome. Furthermore, the panorama is incorporated into the villa. The residence of Cardinal Pietro Aldobrandini is centered in the surrounding territory, as if nature were embracing it. The water theater (figs. 15–17), erected by human genius, echoes the "great theater" of Lazio's natural landscape devised by the creator. Goethe once stated: "Everyone debates over places of delight, but one need only gaze from a summit such as this in order to convince oneself that a villa placed in a more wonderful position is hard to find." It is known that the cardinal purchased Villa Rufinella, situated above Villa Aldobrandini, because "both in front of it and at its sides, there is nothing that can dominate it: rather, of all the sites, this is the superior one."[51]

Another outstanding panorama is the one savored by Goethe himself from a loggia of Villa d'Este:

> *Admire all the city with its garden, the olive woods, the mountains circling the city, the great plain, and the countryside of Rome, with a view to Ostia, thirty miles away; all the gardens along with the Aniene River are exposed, one can even see the villa of Quintilius Varo, the villa of Hadrian, and the villa of Augustus. I say that this is one of the most beautiful views in the world, and in the morning when the sky is limpid and clear, one can see Rome with St. Peter's.*

No less exciting is the panorama described in the novel *Villa Falconieri* by R. Voss in 1896: "Above me there was Frascati, nestled among its lush vines. I could see the Roman countryside covered with ruins up to the great Etruscan plains. I could see the clear shores of the Mediterranean with its dark and wild thickets, the mountainous territory of the Sabina, with its long, bare mountainous chains, with snow-covered summits and the stern cities sculpted in rock." In these villas,

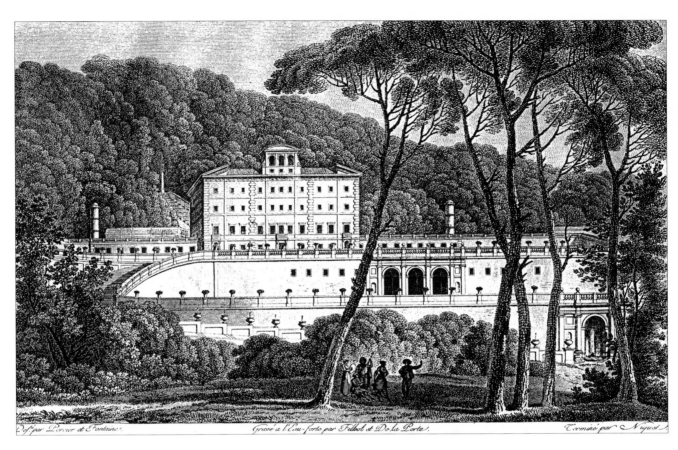

14. Villa Aldobrandini, Frascati: View of the palazzo (by Percier-Fontaine, 1824).

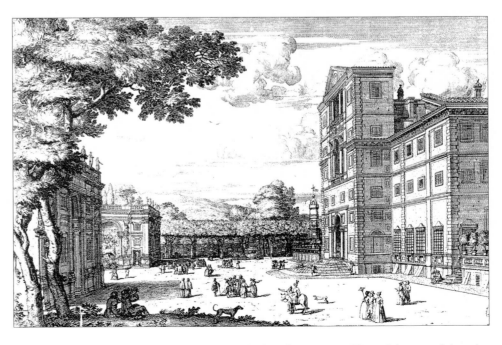

15. Villa Aldobrandini, Frascati: View of the rear of the palazzo
and the water theater (etching by D. Barrière, 1649).

16. Villa Aldobrandini, Frascati: Rustic fountain in the upper garden (etching by G. B. Falda, 1675).

"can be rediscovered the modernity of what Alberti had written, that a villa 'needs to be visible and must look out to a city, a castle, a sea, or vast plains.'"[52] Oftentimes, the panorama is tied to the antique: "From here you can see the ancient Tibur, the hills, and the countryside of Cato. What more beautiful view could you imagine below?" reads an inscription by Scipione Borghese at the Villa Mondragone at Frascati.[53] There is a symmetrical correspondence between the visual primacy of a villa conceived as a crown of the landscape or as a *Stadtkröne*, crown of the city (as in the case of Caprarola), and the decorative cycles that focus on painted landscapes. The villa thus becomes the center of a world fixed on the frescoed walls through a process of projection and appropriation.

Inspired by a yearning for knowledge without boundaries, Alessandro Farnese, emulating the Gallery of Maps at the Vatican, commissioned in one salon at Caprarola frescoes of maps of the world and the heavens, under the intense gaze of such great explorers as Columbus and Vespucci. In comparison, the exhibition of maps in other salons—like the destroyed Villa Cesi at Tivoli or Villa Sacchetti-Chigi at Castelfusano—are of more modest stature. The images of an ideal dominion over the world exist alongside images of the physical dominion of the Farnese, with representations of the villas and the feudal territories of the family. In the atrium of the palazzo, Parma and Piacenza, Castro and Ronciglione, and Caprarola itself are represented

as an overture of the feudal power that has its historical exaltation in the Sala dei Fasti Farnesiani (Room of the Farnese Rise). At Villa d'Este the frescoes create the illusion that the walls have been knocked down to reveal the Este villas on the Quirinale and at Tivoli. Even more interesting are the painted views in the Palazzina Gambara at Bagnaia, where the most important villas from Tivoli to Caprarola are compared to Villa Gambara itself. Also significant are the catalogs of the feudal territories of the Cesarini family (at their castle at the Sinibalda fortress) and the Lancellotti (at their villa at Frascati). Equally impressive are the extraordinary stucco landscapes, true three-dimensional models, of the feudal territories of the Boncompagni in their castle at Isola del Liri, the lands of the Gallio, and the ten towns of the Duchy of Alvito in the villa at Posta Fibreno.

Landscape paintings, often set in remote regions and epochs that witness the *vis imaginativa*, the power of fantasy, are inspired by the pure spirit of contemplation. Alberti stated that "our soul greatly rejoices at the sight of paintings depicting pleasant landscapes, harbors, gardens, hunting scenes, water and country games, and landscapes covered with vegetation and flowers." The eye and the mind can scan vast rural horizons like those painted by Pier Leone Ghezzi in the papal palace at Castel Gandolfo in 1743. Some depict marine or lake landscapes (Castelfusano, Villa Falconieri, and Villa del Palazzolo) or, more appropriately, garden scenes, which sometimes cover both the walls and the vault in a kind of illusionistic panorama, or *stanza paese* (country room), as in the Room of the Columned Casino at Marino or especially the Room of Spring in Villa Falconieri at Frascati, painted by the artist-architect-scenographer Giovan Francesco Grimaldi in 1672. Here, the walls simulate an illusionistic perforated wall that competes with the garden outside (a conception influenced by the arcadian classicism of Poussin and Claude), as the painted fountains engage in dialogue with the fountain at the center of the room and their music is intertwined with the music of birds and the flights of putti. Frescoed vaults with fake bowers interwoven with vegetation and populated

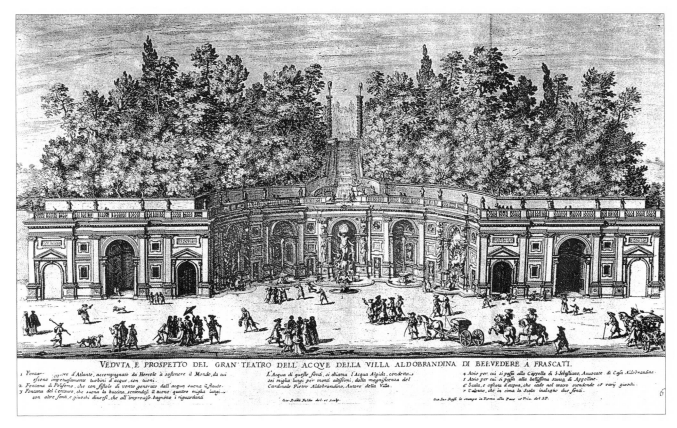

VEDVTA E PROSPETTO DEL GRAN TEATRO DELL' ACQVE DELLA VILLA ALDOBRANDINA DI BELVEDERE A FRASCATI.

17. Villa Aldobrandini, Frascati: The water theater (etching by G. B. Falda, 1675).

by birds and other animals are common; also important are the depictions of greenery in the Palazzina Gambara or the Room of Parnassus in Villa Aldobrandini at Frascati or the gallery in Villa Borghese Taverna at Frascati. There is no lack of arcadian or "antiquarian" landscapes, as in Villa Lancellotti at Frascati, or hunting scenes, as in Villa Rospigliosi at Maccarese. Often landscapes are elevated with mythological scenes (Villa Sora and Villa Aldobrandini) or biblical stories (like the important frescoes *Original Sin* and *Expulsion from Paradise* in Villa Aldobrandini). Even more interesting is the dynastic personalization of the landscape with figures of noble families included within (Villa Falconieri at Frascati, Villa Gabrielli at Marino). A document enumerating the types of landscapes found in villas was offered by Silvio Antoniano in a letter of 1601 to Cardinal Aldobrandini regarding the subjects to be painted at Frascati. Antoniano

preferred stories from the Old Testament that would "allow for the *vaghezza* [diversion] of towns and mountains"; he also proposed to represent "hunting, fishing, birding, agriculture, the cultivation of crops, vines, and olive trees, the pastoral art with flocks and herds, apiculture, horse breeding, and orchards. One might also include some other feature such as the verdant grass, the flowered meadow, the flowered shrubbery, the fruit trees, the green crops, and bundles of corn."[54]

Bomarzo: The Sleep of Reason

Product of the lucid delirium of its patron Vicino Orsini, the Sacro Bosco (Sacred Wood) of Bomarzo seems to represent the other side of the coin in respect to the geometric gardens in the majority in Lazio (figs. 18–20).[55] However, while the same architects or advisors employed for the construction of the "rational gardens" of the cardinals were commissioned, like Vignola and perhaps Pirro Ligorio, the pagan and fabulous mysteries have their apex at Bomarzo and contagiously permeate the rational gardens.

Already in 1564 Annibal Caro described the Bosco as a place of "marvel" as well as of "extravagant and supernatural things."[56] Thus commenced, in a context of mystery, the critical fortune of a site that for long periods of time remained in oblivion and was hidden by suffocating vegetation. Various readings and interpretations of the Sacro Bosco have been plausible and have enlightened diverse aspects of the personality of Vicino Orsini (1523–85), a contemporary of Alessandro Farnese but in many ways quite different from him. The struggle for autonomy and originality is a reflection of its creator: while it is true that the Sacro Bosco, as an epigraph proudly states, "resembles only itself and nothing else at all," it is also true that in order to identify the hidden unity of contradictions and to reconstruct them as they were, the psyche and imaginary universe of Orsini must be excavated. The evocative climate of birth and rebirth, as well as that of creation and re-creation, may be clarified through the use of metaphors.

Vicino Orsini was a magus-demiurge capable of capturing the form and life within the chaos of nature and molding the erratic masses and rock formations like an inspired artist (the poetics of the "non finito" of Michelangelo comes to mind) or like a god who gives life by blowing on mud. Somewhat less divinely, almost with a diabolical satisfaction, Orsini, drenched in mud like a Dantesque damned soul, could boast of the idea of reincarnating the myth of Deucalion and Pyrrha. When Zeus flooded the earth with the deluge and mud, these two heroes repopulated the world by tossing behind them the "bones of the ancient mother," i.e., stones that would be transformed into the men and women of the new age, "similar to sculpted marbles, which were roughly outlined but never finished."[57] In a frieze by Peruzzi in the Villa Chigi-Farnesina in Rome, the Deucalion-Pyrrha scene—with a topography resembling the Sacro Bosco—takes place beneath a classical temple that perhaps alludes to Mount Parnassus, the place of salvation. Similarly, a mausoleum-temple presides over the same scene in the *studiolo* of Francesco I in Florence.

Other creatures at Bomarzo function as metaphors for creation. The great dragon recalls the memory of the serpent of Mars, from whose teeth, planted by Cadmus, were born armed men. The giants reborn from the erratic rocks may represent the epilogue, palinode, and palingenesis of the Giants' assault on Mount Olympus. Hoping to emulate Giulio Romano's frescoes in the Palazzo del Te with *Favola dei Giganti* (Tale of the Giants), a fresco in the loggia of the castle at Bomarzo, Vicino Orsini in 1564 asked Annibal Caro for assistance. But despite the fact that Caro sent him a long description of the fall of the Titans and Giants, Orsini abandoned the project. Nevertheless, the figures of the gods and giants of myth seem to survive in the piles of rocks and shapeless limbs scattered around the Bosco. Perhaps the epicurean Orsini thought that he could spontaneously and continuously reproduce by means of his art the generation of humans and objects from

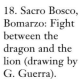

18. Sacro Bosco, Bomarzo: Fight between the dragon and the lion (drawing by G. Guerra).

19. Sacro Bosco, Bomarzo: Elephant (drawing by G. Guerra).

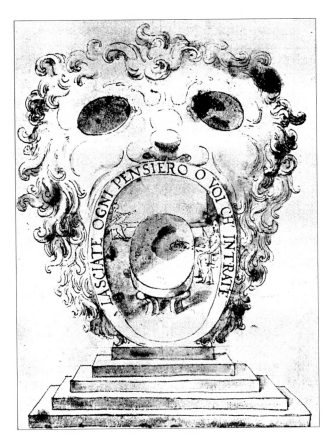

20. Sacro Bosco, Bomarzo: The Mouth of Hell with the inscription "Lasciate ogni pensiero o voi ch'intrate" ("Leave all hope, ye who enter here") (drawing by G. Guerra).

Among many counterinterpretations is one that designates the Sacro Bosco as a lighthearted parody of a sacred mountain, which conforms with the libertine and anticlerical spirit of Orsini. The pagan and diabolical sites of the Bosco function as counteraltars to, for example, the Sacro Monte of the Isola Bisentina at Bolsena, where seven chapels received from Leo X the same act of indulgence merited by a visit to the seven churches of Rome. It is not so puzzling, then, that the temple, the mystical apex of the Bosco, is analogous to the church in the Isola Bisentina, the mausoleum of the Farnese. In Vicino Orsini's mind, the praise of folly was united with a hymn to contradiction. There is no logical thread or single reading of the Sacro Bosco, because many artists with different ideas worked there under Orsini's guidance and because he changed his mind continuously and his creative exertions were multiple. In the last years of his life, Orsini filled his castle with contradictory mottoes in cartouches: to the thesis "Despise earthly matters: after death true pleasure lies"[58] is opposed the antithesis "Eat, drink, and enjoy yourself, after death there is no pleasure."[59] In a third motto, the inherent wisdom of moderation is advocated: "Holy men choose the just mean."[60] From this synthesis, one proceeds to the proud affirmation of self-consciousness as the principle of identity: "You can succeed only if you know yourself"[61] and "You must be yourself."[62] But more than a coincidence of opposites Orsini seems cynically to favor a perverse and continuous principle of contradiction as a factor of vital instability: precisely, the order of chaos.

In a letter of 1564, Caro wrote to Orsini defining the works of the Sacro Bosco as "theaters and mausoleums," centering them around architectural instances linked with Vignola, such as the Tempietto-Mausoleum and the Theater of Love, with its concave-convex steps inspired by the ones built by Bramante for the Belvedere. This area of the Bosco, which is regularly planned and apparently less consistent with Orsini's poetics, may reflect the inspiration or participation of his wife, Giulia Farnese, who was in charge of the construction in the absence of her husband. During this time she perhaps consulted with

earth—Mother Earth described by Lucretius or Cybele as Caro described her, that is, as mother of the Giants.

Bomarzo confronts traditional worlds and at the same time is itself an antiworld that has its roots in a world beyond: a world beyond classical tradition, significantly contaminated and imbued with the mysterious world of the Etruscans; a world beyond Western boundaries, with the desire to unite with exotic worlds; a world beyond perspectival space, with its constant search for sensational and astonishing spaces; a world beyond the human, with the exaltation of Roland's madness and the monstrous (in 1576 Orsini regretted not having "enjoyed the folly of the Boschetto"); a world beyond life, with a possible descent into Hades; and finally, a world beyond nature and matter, with the transfiguration of stone and rock.

Alessandro Farnese. In the following decades Vicino Orsini indefatigably carried out the project in the spirit of the future aphorism of Goya: "The sleep of reason produces monsters." But this is a kind of daydream under the vigilant and caustically ironic guard of the Lord of the Monsters. Often dreams manifest themselves in the eternal presence of the *genius loci*. The Etruscan atmosphere of the rustic sculptures materializes in a mimetic manner in at least one case: an architectural fragment of a fake Etruscan sepulchre that seems to have been knocked down by the fury of the giants or an earthquake.

The same magical and rustic atmosphere present at Bomarzo is characteristic of a kind of genetic patrimony of other sixteenth-century gardens of the Orsini family; exceptions are the famous Fonte Papacqua of Soriano nel Cimino, which balances the profane satirical scene with the sacred scene of Moses,[63] and other less important sites such as the Barco Colonna at Marino, whose remains are still visible in a *peperino* stone sculptural group.[64] The garden of Pitigliano, which needs to be excavated or extricated from thick overgrowth, was perhaps inspired by Vicino Orsini himself, companion at arms as well as relative of owner Nicolò Orsini. It is characterized by similar re-creations of the world of the Etruscans, with fake tombs and benches carved out of rock and positioned for meditation upon a landscape untouched for millennia.[65] Another member of the Orsini family, Paolo Giordano Orsini, in 1582 commissioned for the "secret garden" of the Fortress of Bracciano a hunting scene with a dog and a dying wild boar carved out of rock by the sculptor-architect Giacomo del Duca: "The group is in a forest, as indicated by a tree stump, and thus characterizes the western part of the garden as a predominately *mysterious* area. Cast in the shadow of the high walls of the castle, the mysterious appeal of the group is enhanced."[66]

The Triumph of Time

The golden age of the villas of Lazio lasted approximately three-quarters of a century, between 1550 and 1625. After this, very few important works were created. This time of the villas appears almost crystallized in Athanasius Kircher's *Latium* of 1671. In this work, Kircher privileges Tivoli, Palestrina, and the Castelli Romani as theaters for meetings and for the parallel dialogue between ancient and modern villas. From 1625 until the publication of *Latium*, various projects were undertaken by several protagonists of the Roman baroque. The first of these was Borromini's decoration of the facade of the Villa Falconieri at Frascati, which employed the same decorative symbolism that he used at the Palazzo Falconieri in Rome.[67] After introducing a neomannerist invention at Villa d'Este, the Fountain of the Glass, Bernini created the grandiose "natural" waterfall at the foot of the Fountain of the Organ—an allusion to the tumultuous waterfalls of the Aniene River—marking the arrival of a new fashion (fig. 21). Another project, the villa on the estate of the Chigi family at Formello, was built by Felice della Greca and Carlo Fontana.[68] Later known as Villa Versiglia, this was perhaps the first European homage to Louis XIV's Versailles and was undertaken while Le Nôtre's construction of the grand gardens was still in progress. This ideal copy of the prototype of the Sun King's palace did not enjoy great fortune. Abandoned after a short time, the villa is today but a few ruins covered with vegetation.

A similar destiny was suffered by other "modern Pompeiis" including the Renaissance ruins of Genazzano with its Nymphaeum of Bramante (a place for humanistic representations and naumachias),[69] the town of Castro (which was destroyed by Urban VIII), and the baroque ruins of Monterano (abandoned at the end of the eighteenth century due to malaria and the sack of the French troops). Among the ruins of Monterano were Bernini's works for the Paluzzi-Albertoni-Altieri family. Here, an extraordinary Berninian invention stands out: the front of the main palazzo, with its arcades imitating an ancient aqueduct, seems to emerge from the rocky foundation—a "reeflike

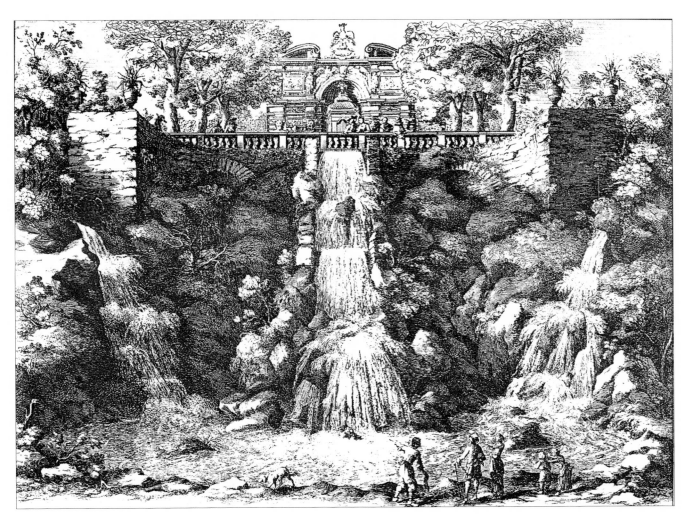

21. Villa d'Este, Tivoli: Fountain of the Organ with cascade proposed by Bernini (etching by G. Venturini, 1691).

formation" that Bernini proposed in vain in projects for the Louvre and only partially realized on a minor scale in the Fountain of the Four Rivers and the "naturalistic" Palazzo Montecitorio. This was yet another reincarnation of the mountain of Parnassus, with the heraldic lion of the Paluzzi-Albertoni, which like the mythical Pegasus, made water spring from rock.[70] The entire palace presented itself as a gigantic water spectacle, foreshadowing the Trevi Fountain in the context of Bernini's poetics of "ruinous" architecture (for instance, the fake ruined bridge at the side of Palazzo Barberini). Ironically, this simulated "ruin" incurred a tragic destiny of material ruin.

Also marked by vicissitudes of fortune is the garden at Ninfa, the medieval town in the Pontine marshes abandoned over the course of the sixteenth and seventeenth centuries due to malaria. At the foot of the Castello Caetani, the sixteenth-century Horti Nympharum was a garden of delight, a counterpoint to the desolation of the town's ruins. At the beginning of the seventeenth century, even this last oasis of artificial nature was buried by a veil of ivy and lush vegetation, marking the revenge of nature and the triumph of time over history. Between the eighteenth and nineteenth centuries, Ninfa became a place for meditation on *vanitas vanitatum* and human destiny. Some were enchanted by the fascination of these ruins, like Gregorovius: "The traveler who wanders here evokes the spirits and finds himself surrounded by nymphs and fairies. The enchanting Ninfa is the most seductive fable of history and nature that I have ever seen in the world."[71] Others have dreamed of the revenge of history over nature, like Goethe's Faust, who wished to stop time and drain the infernal marshes in order to create a new verdant paradise. In spring Ninfa must have appeared like a spontaneous garden, created by Flora and nature-architect. As Gregorovius wrote:

This ruinous city with walls, churches, towers, and convents drowned in the marshes and buried by thick vegetation is more attractive than Pompeii. Over Ninfa undulates a perfumed sea of flowers; every wall and every church is covered with ivy; over each ruin waves the purple flag of triumphant Spring. One meanders in this city of ivy, in its streets covered with grass and flowers between the walls where the wind plays with the leaves, where the silence is broken only by the shriek of a crow, by the gurgle of the Ninfeo stream, by the whistle of the wind in the canefields, by the melancholic murmur of grass. Everywhere there is an exaltation of flowers, which seem to grow in procession to the ruined church, to climb over the tower, to block every entrance. . . . One is immersed in this sea of flowers, one is inebriated by perfume. . . . The doors of the city are also blocked by vines, ivy, and brambles: it seems as if inside Ninfa the flowers fear the invasion of an enemy who comes from outside, like the Saracens or the militia of Barbarossa. These seem to entrench themselves behind bastions of ivy; perhaps at night they assault the enchanted city in order to abduct into their own marshes the spirit of the flowers.[72]

The garden of Flora, almost a metaphor of the Ovidian myths in the *Metamorphoses*, reckoned with human-gardener at the beginning of the nineteenth century when the Caetani family—first Onofrio and then his sons Gelasio and Roffredo—undertook the restoration of the ruins of Ninfa and the formation of a new English-style garden that made use of real ruins as opposed to fabricated ones. The art of gardens, in accordance with the rhythms of nature, gave life to the illusion of a triumph over time at the core of a renewed *Saturnia Tellus*—land of Saturn—where authentic ruins were incorporated as both trophies of time and monuments to memory.

1. An exhaustive study on the villas of Lazio has yet to be written. However, the following volumes should be consulted: I. Belli Barsali and M. G. Branchetti, *Ville della campagna romana* (Milan, 1975); D. Coffin, *The Villa in the Life of Renaissance Rome* (Princeton, 1979); and D. Coffin, *Gardens and Gardening in Papal Rome* (Princeton, 1991). For further reference see the following volumes in Franco Maria Ricco's series on Lazio: *Lazio delle delizie. Le dimore della nobiltà teatro del lusso e dell'illusione* (Milan, 1988); *Viterbo delle delizie. La Camera delle Belle castellane, cortigiane, dominatrici* (Milan, 1989); M. Fagiolo, *Roma delle delizie. I teatri d'acqua: grotte, ninfei, fontane* (Milan, 1990).

2. For example, the papal palace of Castel Gandolfo, built over Domitian's Villa.

3. A false etymology proposed that the word *Latium* derived from the fact that the god was *latente*—that is, in hiding in this very region. Ovid himself wrote in the *Fasti:* "Dicta quoque est *Latium* terra *latente* deo."

4. H. Mielsch, *La villa romana* (Florence, 1990), 6.

5. See H. Kähler, *Hadrian und seine Villa bei Tivoli* (Berlin, 1950); S. Aurigemma, *Villa Adriana* (Rome, 1961); B. dal Maso and R. Vighi, *Villa Adriana* (Florence, 1976); A. Giuliano, *Villa Adriana* (Rome, 1988); W. L. McDonald and J. A. Pinto, *Hadrian's Villa and Its Legacy* (New Haven: Yale University Press, 1995).

6. E. Salza Prina Ricotti, "Criptoportici e gallerie sotterranee di Villa Adriana," *Les Cryptoportiques* (1973): 219–59. This system recalls projects for multilevel circulation devised by Leonardo and others.

7. For the symbolism of the circus, see L. Hautecoeur, *Mystique et architecture* (Paris, 1954) and P. Wuilleumier, "Cirque et astrologie," in *Mélanges d'Archéologie et d'Histoire de l'Ecole Française de Rome* (1927). For the connection between the circus with a *palatium* and imperial ritual and for the significance of this theme, see the following studies: A. Bruschi, *Bramante architetto* (Rome-Bari, 1969); M. Fagiolo and M. L. Madonna, "La casina di Pio IV in Vaticano," *Storia dell'arte* (1972): 237–81; M. Fagiolo, *La città effimera e l'universo artificiale del giardino* (Rome, 1980); M. Fagiolo, "Arche-tipologia della piazza di S. Pietro," in *Immagini del Barocco. Bernini e la cultura del Seicento*, eds. M. Fagiolo and G. Spagnesi (Rome, 1982), 117–32; and A. Corboz, "Walks around the Horses," *Oppositions* 25 (1982).

8. H. Stierlin, *Hadrien et l'architecture romaine* (Freiburg, 1984), 149.

9. Stierlin, *Hadrien et l'architecture romaine*, 152.

10. A. Belluzzi, "*Omnium curiositatum explorator:* archeologismo e nuova spazialità nella architettura universale di Adriano," *Psicon* 4 (1975): 114.

11. It is known of the Chinese emperor Che-Huang-Ti that every time "he destroyed a kingdom, he took the plan of its building and rebuilt it in the capital in order to situate the women and booty stolen from the enemy. Therefore, the imperial city is, and not just in a mystical sense, the concentration of the empire." M. Granet, *La civiltà cinese antica* (Turin, 1954), 488.

12. Hadrian's Villa has similar domes.

13. Stierlin, *Hadrien et l'architecture romaine*, 107–8.

14. Virgil, *Aeneid* (trans. Robert Fitzgerald), 8.319–23.

15. On the other hand, it was precisely due to its exorcising function that a temple to Saturn was erected at Villa Torlonia in Rome around 1837. "The architect deemed it appropriate to erect a temple in honor of that destructive deity! Propitiated with this offering, let Saturn stave his severing sickle from this place forever!" G. Checchetelli, *Una giornata di osservazione nel palazzo e nella villa di Torlonia* (Rome, 1842), 71. See also M. Fagiolo, "Ideologie di Villa Torlonia," in *Giuseppe Jappelli e il suo tempo* (Padova, 1982), 549–86.

16. Dante Alighieri, *The Divine Comedy* (trans. A. Mendelbaum), 12.148–50.

17. See B. Andreae, *Odysseus: Archäologie des europäischen Menschenbildes* (1982); B. Andreae, *Praetorium Speluncae: Tiberius und Ovid in Sperlonga* (1994); and B. Andreae and C. Parisi, *Ulisse: il mito e la memoria* (Rome, 1996).

18. Polyphemus, both persecutor and victim of Odysseus, was believed to have been the progenitor of Tiberius and of the *gens Claudia*.

19. See A. Viscagliosi, "*Antra cyclopis:* osservazioni su una tipologia di *coenatio*," in Andreae and Parisi, *Ulisse*, 252–69. See also H. Lavagne, "*Operosa antra:* Recherches sur la grotte à Rome de Sylla à Hadrien," in *Bibliothèque des écoles françaises d'Athens et de Rome* (Rome, 1988).

20. This was later called the Serapaeum.

21. See M. Fagiolo, "Caprarola: la Rocca, il Palazzo, la Villa," *Palladio* 1 (1989): 45–66.

22. From the Latin term *saxa*, meaning rock or stone.

23. This episode is depicted in a fresco at Villa d'Este.

24. This was later dedicated to Bacchus.

25. For the interpretation of the villa at the crossroads of virtue and vice, see D. Coffin, *The Villa d'Este at Tivoli* (Princeton, 1960), 78–97.

26. See the Fountain of the Colonna of Genzano, emblem of the Colonna family and of the Dionysian vine.

27. For this interpretation regarding the hegemony of Venus over Hercules, see M. L. Madonna, "Il *Genius Loci* di Villa d'Este. Miti e misteri nel sistema di Pirro Ligorio," in *Natura e artificio. L'ordine rustico, le fontane e gli automi nella cultura del manierismo europeo*, ed. M. Fagiolo (Rome, 1981), 195–226.

28. F. Gregorovius, *Itinerari laziali* (Rome, 1980), 79.

29. See essays by P. Portoghesi, "Il palazzo, la villa e la chiesa di S. Vincenzo a Bassano," M. V. Brugnoli, "I primi affreschi nel palazzo di Bassano di Sutri," and I. Faldi, "Paolo Guidotti e gli affreschi della Sala del Cavaliere," in *Bollettino d'Arte* (1975): 222–95.

30. See M. Fagiolo, "Della Cancelleria a Caprarola: la committenza artistica del cardinale Alessandro Farnese (1520–89)," *Lecturas de Historia del Arte* (1989): 1–20; and C. Robertson, *'Il Gran Cardinale': Alessandro Farnese, Patron of the Arts* (New Haven: Yale University Press, 1992).

31. See G. Labrot, *Le Palais Farnèse de Caprarola* (Paris, 1970); I. Faldi, *Il Palazzo Farnese di Caprarola* (Turin, 1981); I. Guidoni and G. Petrucci, *Caprarola* (Rome, 1986); Fagiolo, "Caprarola: la rocca," 45–61; P. Portoghesi, ed., *Caprarola* (Rome, 1996).

32. E. Battisti, "Il ritiro nel giardino come suicidio politico e culturale. La tragedia dei grandi protagonisti del '500 romano," in *Protezione e restauro del giardino storico*, ed. P. F. Bagatti Valsecchi (Florence, 1987), 100–101.

33. *Descrittione di Tivoli, et del Giardino dell'Ill.mo Cardinal di Ferrara* (Paris, Bibl. Nat., cod. Ital. 1179). This work was attributed to Pirro Ligorio and published in Coffin, *Villa d'Este*, 141–50.

34. This very term was explicitly used in a plan of Villa Borghese in Rome in 1776. The plan was a late design for the seventeenth-century nucleus of the villa, accompanied with Latin notations, "Burghesiorum Villae Romanae iconographia," in an engraving of 1776. See B. di Gaddo, *Villa Borghese* (Rome, 1985), 112.

35. Again, a plan of Villa Borghese has similar traits.

36. The work has been identified and studied in P. Marconi, "L'VIII Libro di Sebastiano Serlio," *Controspazio* 1 (1969): 51–60.

37. See the turreted walls in the two villas in the Roman colony of Cosa (Villa Settefinestre and Villa delle Colonne) mentioned in A. Carandini, *Settefinestre. Una villa schiavistica nell'Etruria romana* (Modena, 1985) and Mielsch, *La villa romana*, 46–47.

38. In a letter to Lucilius, in *Epistulae*, 51, 11.

39. These have been identified as the Fountains of Tivoli and of Rome; a third exedra never built was supposed to have contained the Fountain of Neptune.

40. It is also important to note that the villa itself contained baths, as did Hadrian's Villa.

41. The fountain is described by Antonio Del Re "in the shape of a stage or semi-oval theater" in *Dell'antichità tiburtine* (1611), and Kircher affirms "alia scaena panditur" in *Latium* (1671). For an exhaustive analysis of the "Reembody" see M. L. Madonna, "La 'Rometta' di Pirro Ligorio in Villa d'Este a Tivoli," in *Roma antica*, ed. M. Fagiolo (Lecce, 1991).

42. The twelve villas at Capri, which belonged to Tiberius and were named after each of the twelve Olympian gods, should come to mind.

43. For the organization of the villas of Tuscolo, see C. Franck, *The Villas of Frascati 1550–1750* (London, 1966); Belli Barsali and Branchetti, *Ville della campagna romana*; and A. Mignosi Tantillo, ed., *Villa e paese. Dimore nobili del Tuscolo e di Marino* (Rome, 1980).

44. Using a topos of Pliny the Younger when he described the high Tiber Valley.

45. These villas were purchased by Scipione Borghese, who at that time sold the Caravilla, after restructuring it by building a spectacular waterfall.

46. From the dedication to Ippolito d'Este in the edition of Vitruvius's *Architettura* (Venice, 1567). See M. Fagiolo, "Il significato dell'acqua e la dialettica del giardino: Pirro Ligorio e la *filosofia* della villa cinquecentesca," in Fagiolo, *Natura e artificio* (Rome, 1981), 176–89.

47. M. de Montaigne, *Journal de voyage en Italie*, in *Oeuvres Complètes*, vol. 7–8 (Paris, 1928).

48. M. Fagiolo, "Gli assi segreti delle ville nel sistema sacrale del *Latium vetus*," *Il giardino storico del Lazio* (Rome, 1991), 16–26.

49. F. Ardito, "Descrizione del viaggio di Gregorio XIII (1578)," in *Documenti sul barocco in Roma*, ed. J. A. F. Orbaan (Rome, 1920). For an analysis of the villa, see M. Fagiolo, "Struttura e significato di Villa Lante a Bagnaia," in *Ville e parchi storici: storia, conservazione e tutela*, ed. A. Campitelli (conference proceedings, 1985; Rome, 1994), 219–30.

50. From the manuscript *Relatione di Villa Belvedere*, attributed to G. B. Agucchi by C. D'Onofrio, *La Villa Aldobrandini di Frascati* (Rome, 1963). See also K. Schwager, "Kardinal Pietro Aldobrandis Villa di Belvedere in Frascati," *Römisches Jahrbuch für Kunstgeschichte* (1963): 291–382; and M. Fagiolo, "Villa Aldobrandina Tuscolana: percorso, allegoria, capricci," *Quaderni dell'Istituto di Storia dell'Architettura* 62 (Rome, 1964): 61–90.

51. The testimony of Monsignor Agucchi is recorded in D'Onofrio, *La Villa Aldobrandini*, 113.

52. Belli Barsali and Branchetti, *Ville della campagna romana*, 60.

53. "Prospicis hinc Tibur, colles et rura Catonis. / Pulchrior aspectu quae tibi scaena subit?"

54. Letter of October 6, 1601 (Archivio Aldobrandini di Frascati) published in Mignosi Tantillo, *Villa e paese*, 175–76.

55. See M. J. Darnall and M. S. Weil, "Il Sacro Bosco di Bomarzo," *Journal of Garden History* 1 (1984): 1–94; H. Bredekamp, *Vicino Orsini e il Bosco Sacro di Bomarzo. Un principe artista ed anarchico* (Rome, 1989); and M. Fagiolo, "Le due anime nelle ville della Tuscia," in *Il giardino d'Europa*, ed. A. Vezzosi (Milan, 1986), 68–81.

56. In a letter to Orsini dated December 12, 1564.

57. These verses from Ovid's *Metamorphoses* (Book I, 368–410) were employed by Buontalenti to interpret in a context of primordial legend the *Prigioni* of Michelangelo, which he placed as supporting structure in the four corners of the Large Grotto of the Boboli Gardens.

58. "Sperne terrestria / post mortem vera voluptas."

59. "Ede bibe et lude / post mortem nulla voluptas."

60. "Medium tenuere beati."

61. "Nosce te ipsum sic vince."

62. "Te ispum eris."

63. See M. Festa Milone, "Il Casino del cardinal Madruzzo a Soriano nel Cimino," *Quaderni dell'Istituto di Storia dell'Architettura* 97–114 (Rome, 1970–72): 71–94; M. Festa Milone, "La triplice allegoria dell'Acqua di Papa. La fonte del cardinal Madruzzo a Soriano del Cimino," *Psicon* 8–9 (1976): 121–31; and J. Theurillat, *Les Mystères de Bomarzo et des jardins symboliques de la Renaissance* (Geneva, 1973), 143–54.

64. See F. Calabrese, in Mignosi Tantillo, *Villa e paese*, 288–91.

65. P. Portoghesi, "Nota sulla villa Orsini di Pitigliano," *Quaderni dell'Istituto di Storia dell'Architettura* 7–9 (Rome, 1955): 223–27; Bredekamp, *Vicino Orsini*, 137–38.

66. S. Benedetti, *Giacomo Del Duca* (Rome, 1974), 208.

67. See P. Portoghesi, *Borromini nella cultura europea* (Rome, 1964).

68. Fontana was the architect of another aquatic "rustic work," the Fountain of the Bluffs at Lanuvio.

69. See C. Frommel, "Bramante's *Ninfeo* in Genazzano," *Römisches Jahrbuch für Kunstgeschichte* (1969): 137–68; Bruschi, *Bramante architetto*; and C. Thoenes, "Note sul *Ninfeo* di Genazzano," in *Studi Bramanteschi* (Rome, 1974), 575–83.

70. See A. Pinelli, "Bernini a Monterano," *Ricerche di Storia dell'Arte* 1–2 (1976): 171–88.

71. Gregorovius, *Itinerari laziali*, 61. See also A. Forni, "Il mito di Ninfa nei viaggiatori stranieri dell'Ottocento e Novecento," in *Ninfa: una città, un giardino*, ed. L. Fiorani (conference proceedings Rome, 1990), 313–23, and G. Marchetti Longhi, "Ninfa nella regione pontina," *Palladio* (1964): 3–27.

72. Gregorovius, *Itinerari laziali*, 66–67.

Begun around the year A.D. 118, the villa was planned and built by Emperor Hadrian himself on a plateau with an abundant water supply just below the ancient town of Tivoli. This complex was built over the site of a more ancient villa near the therapeutic Acque Albule, which included baths as well as a temple dedicated to Hygeia, the goddess of health.

The colossal complex was erected in three separate stages, each demarcated by the emperor's travels (A.D. 118–21, 125–28, 134–38). It was a kind of villa-*palatium* that sought to emulate Nero's Domus Aurea, with its dozen or so separate quarters oriented in different directions; the *teatro marittimo*, or maritime theater (also known as "island villa"), served to bind the whole complex together. According to a tradition related by Spatianus in his *Vita Hadriani*, the emperor "built the Tiburtine villa in an extraordinary manner, re-creating in it the world's most famous sites and provinces that he had seen, such as the Lyceum, the Academy, the Prythaneium, the Canopus, the Pecile, the Vale of Tempe, and even Hell itself."

W. L. MacDonald and J. A. Pinto's recent study divides the complex into eight sections, the most interesting of which are the first, "the residential core"; the second, "beside the residential core," which includes the maritime theater, the baths (or the Heliocaminus), and the courtyard of the Fontana; the fourth, the "east-west group," including the Pecile, the stadium-garden, and the arcaded *triclinium*; and finally, the fifth, "the angled extension" along the axis between the *cento camerelle*, or hundred little rooms, and the Canopus, including the smaller baths, larger baths, and central vestibule.

HADRIAN'S VILLA

•

Tivoli

In the course of the past few decades, studies have focused on two of the most interesting structures of the villa (both restored during this century): the maritime theater and the Canopus-Serapaeum nexus, which was restructured after the death and deification of Antinous with many Egyptian overtones. MacDonald and Pinto defined this structure as a "scenic *triclinium*" with a "scenic canal": "In fact the Triclinium is a banquet hall composed of an elaborate two-part grotto, and the Canal is most likely the hall's ornamental water."

The situation at Hadrian's Villa is analogous to that at Versailles: "In both cases the monarch distances himself from the ancient capital and from the pressure of the urban masses. As opposed to Versailles, however, the buildings and spaces of Hadrian's Villa are not juxtaposed but penetrate each other. The villa does not consist of a single unified edifice with an adjacent garden, as at Villa d'Este at Tivoli, but rather of a series of pavilionlike structures dispersed in nature, whose axes adapt to the diverse terrain and perspectives" (F. Coarelli, 1982).

Rediscovered by artists and intellectuals as early as the sixteenth century (the first digs, restorations, and investigations were carried out beginning in 1550 by the future architect of Villa d'Este, Pirro Ligorio), the villa has become a model not only for similar structures but also for the architectural antiquarian culture at large, from Ligorio to Borromini to Piranesi, and up to Le Corbusier and postmodern architecture. The few works of art or copies that remain at the original site constitute only a very small part of the immense treasures of sculpture and mosaic that during the past centuries have enriched many museums and private collections.

Left: Plan of the Canopus-Serapaeum.

Right: Detail of the Tiber statue, next to the Nile statue in the Canopus.

Overleaf: Canopus.

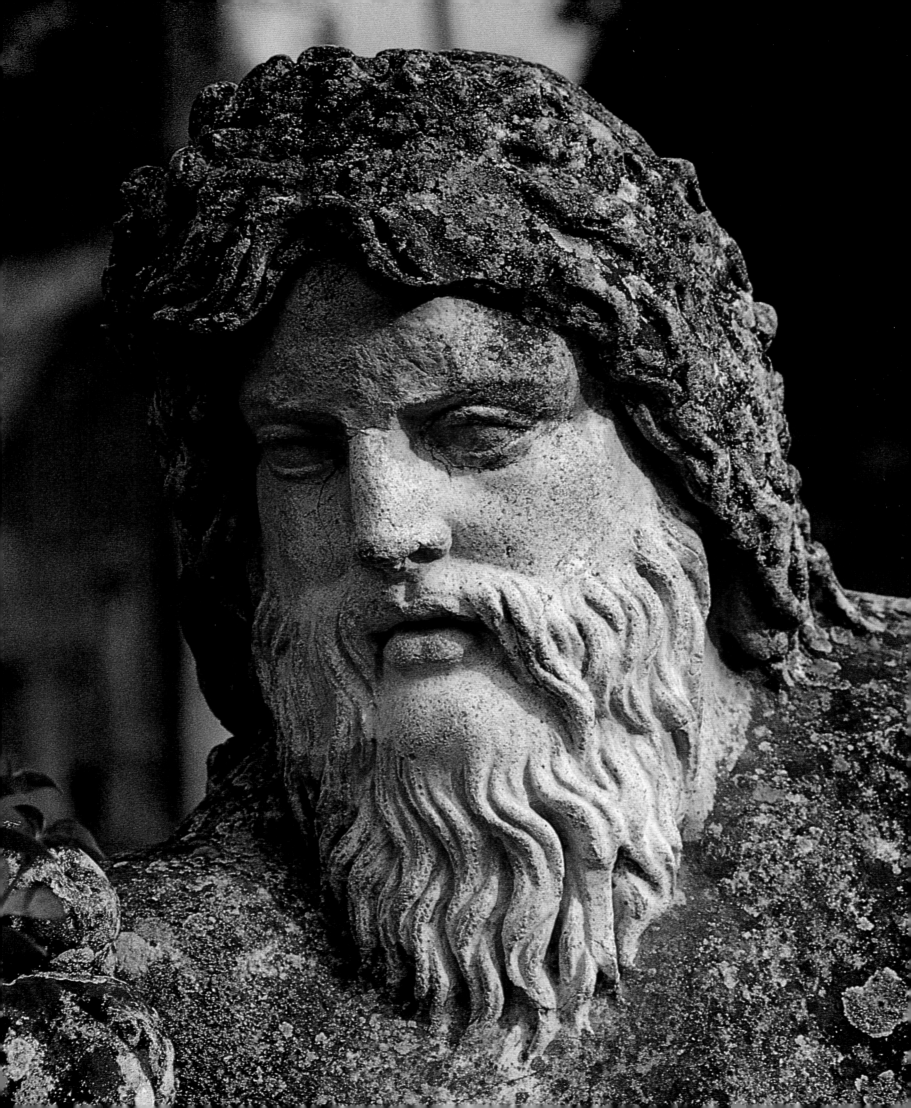

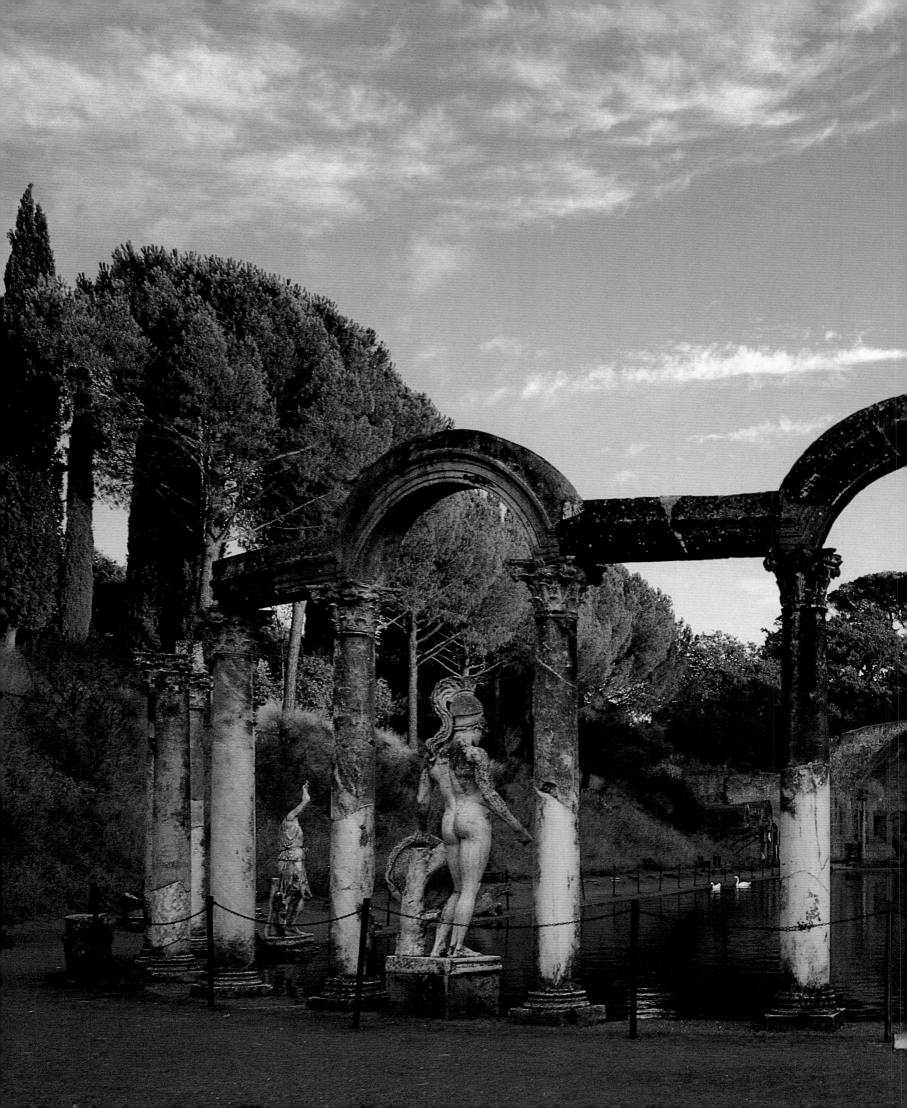

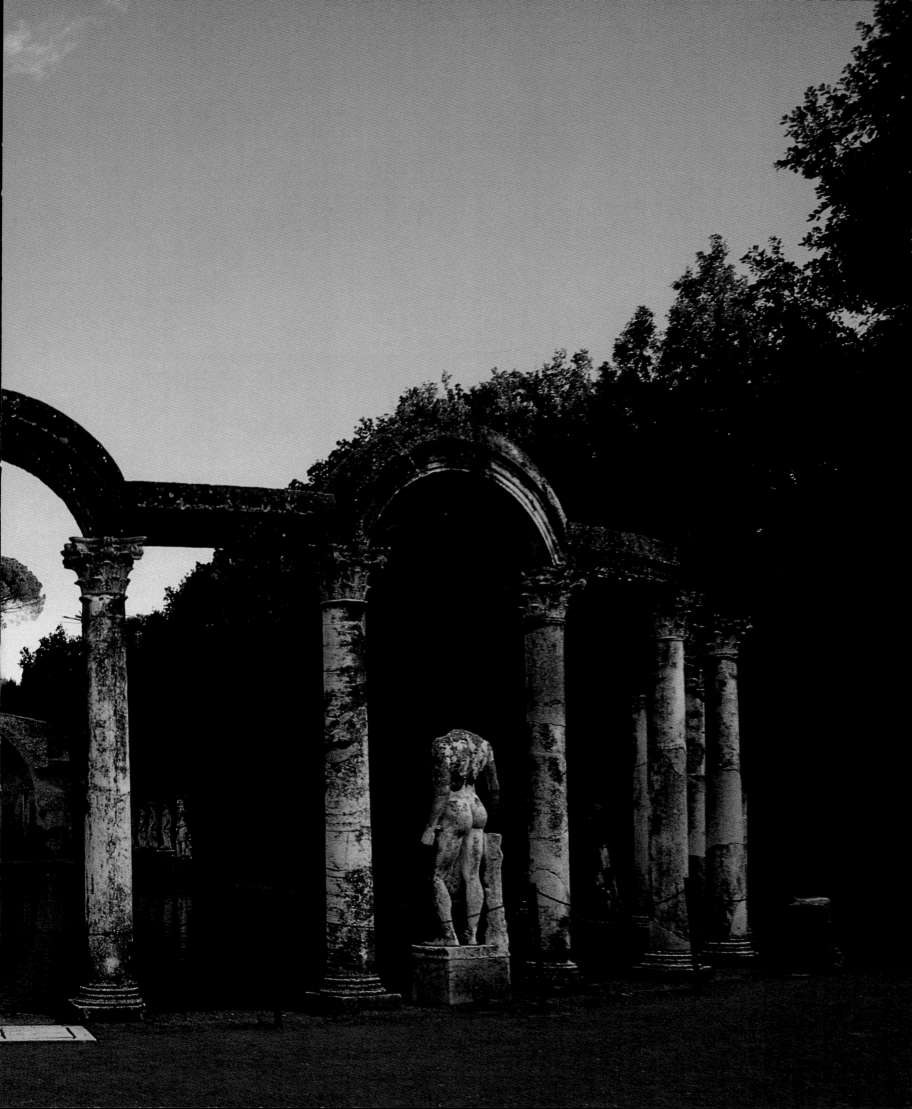

Statue of Mercury in the Canopus.

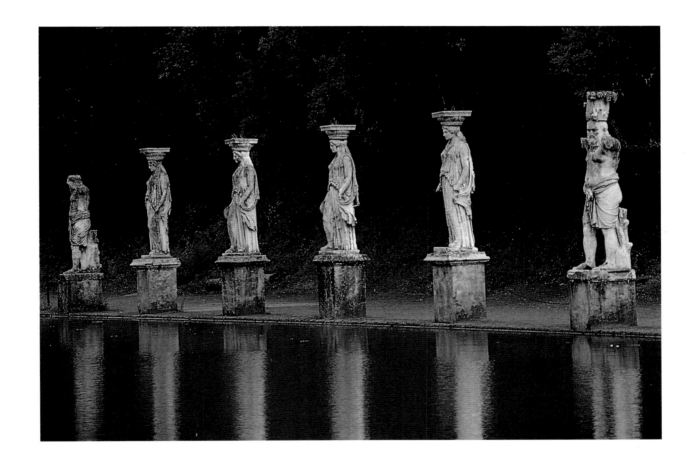

THE FOUR CARYATIDS IN THE CANOPUS, FLANKED BY TWO BASKET-CARRYING SILENI.

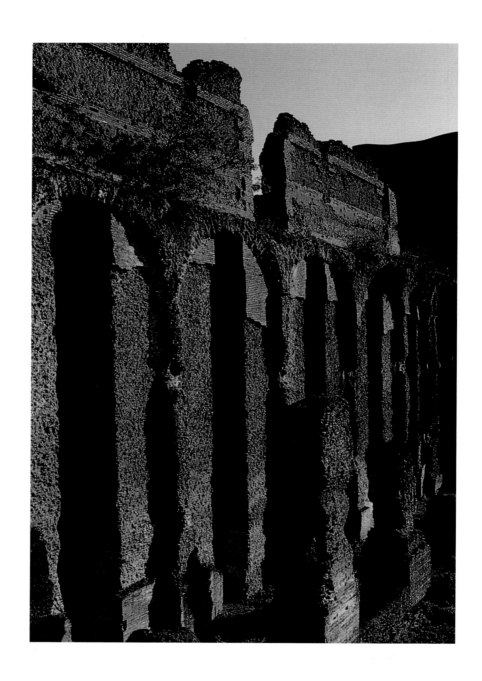

THE *CENTO CAMERELLE*, OR "HUNDRED LITTLE ROOMS,"
USED FOR THE SERVANTS' QUARTERS.

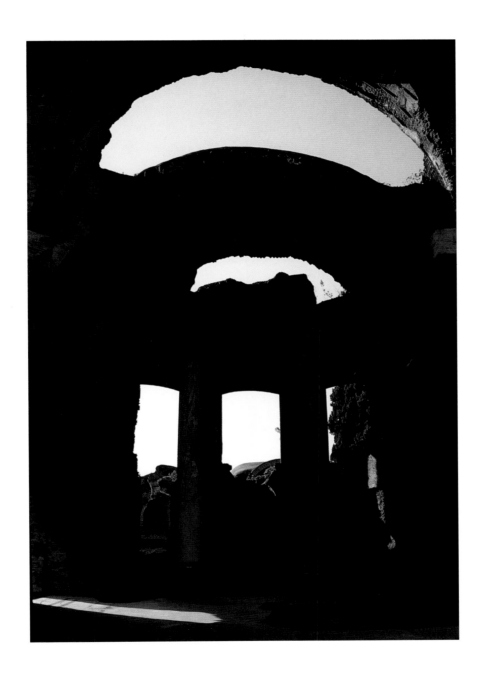

CENTRAL ROOM OF THE GRANDI TERME (LARGE BATHS).

Overleaf:
Grandi Terme.

Second overleaf:
Piccole Terme
(Small Baths).

Third overleaf:
Quadriportico with
pool in the stadium
complex.

Fourth overleaf:
Teatro marittimo, or
maritime theater.

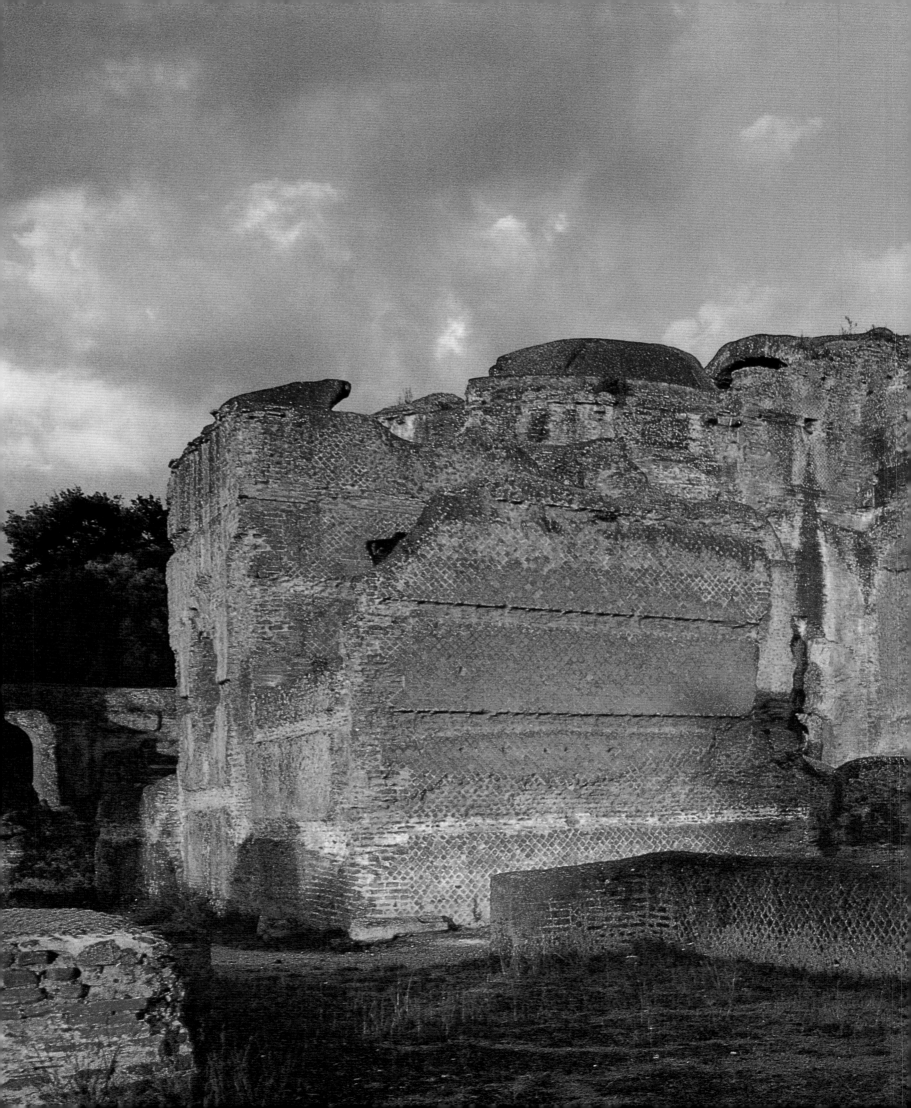

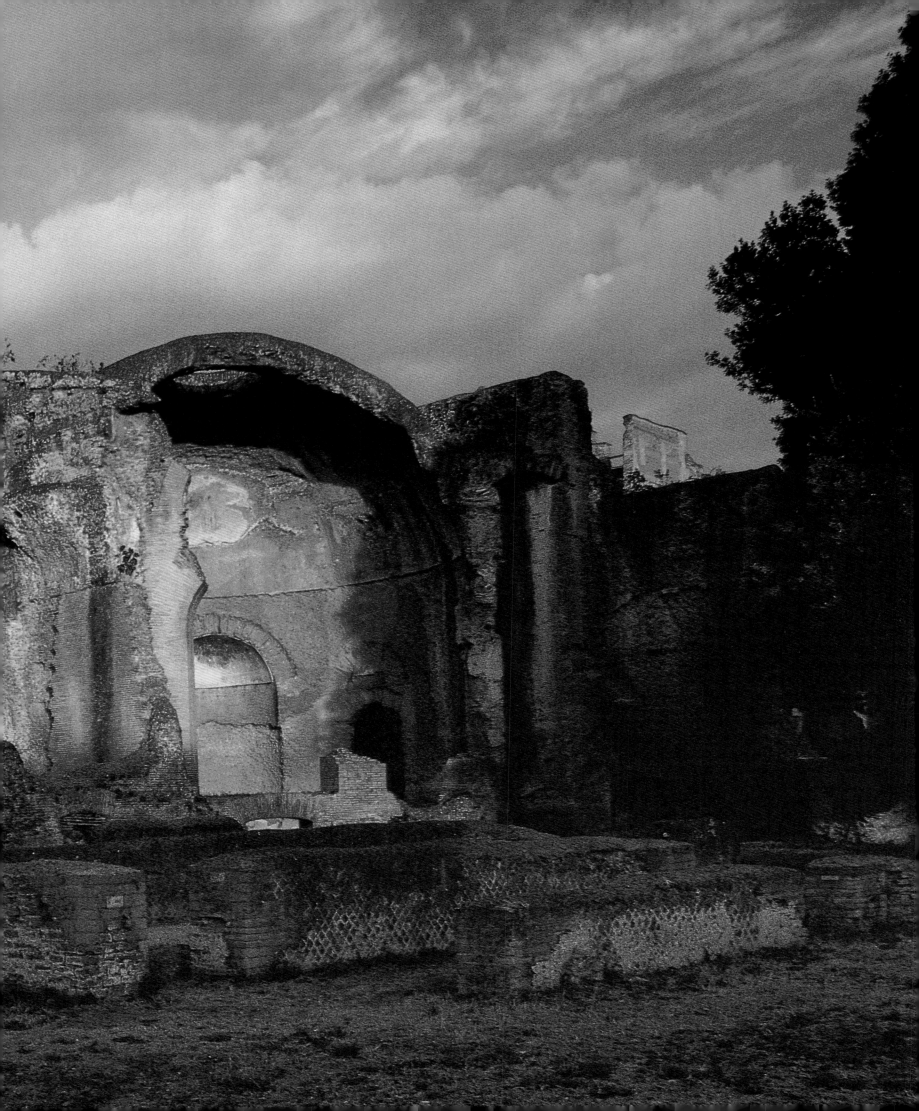

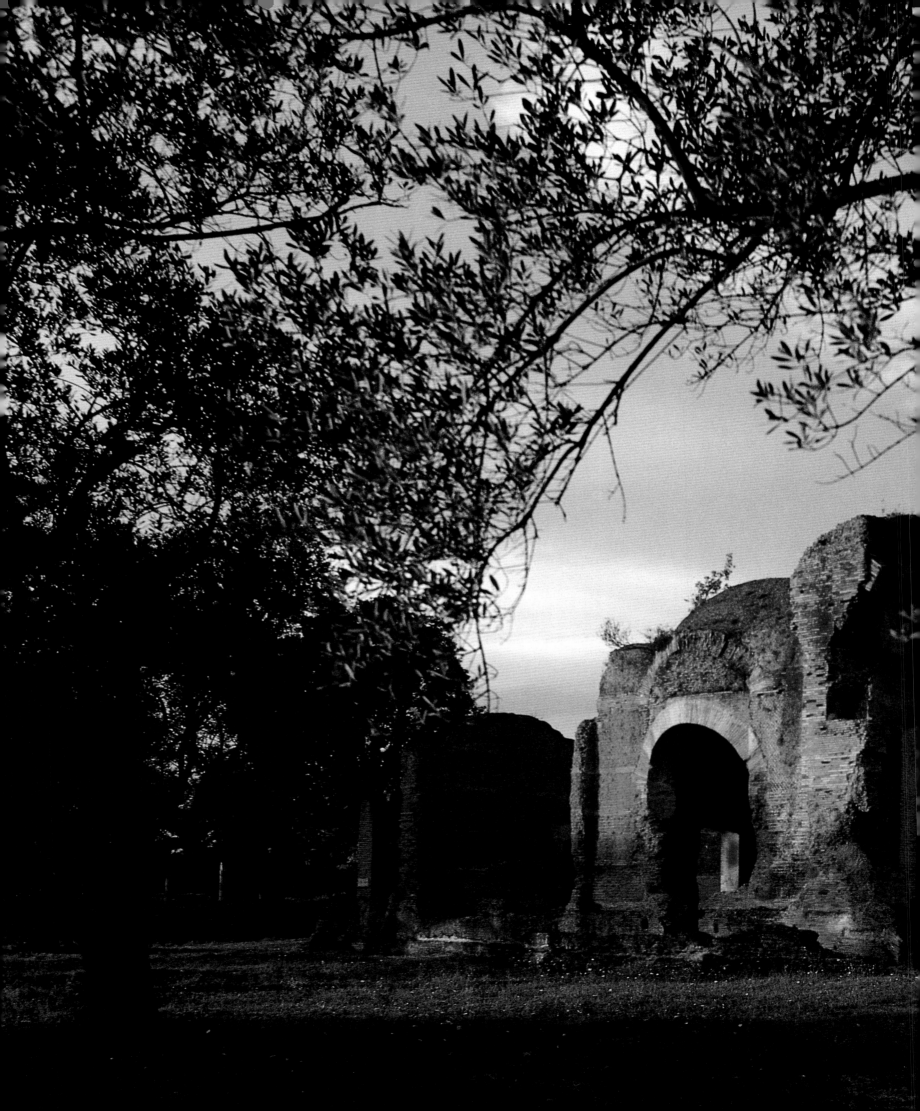

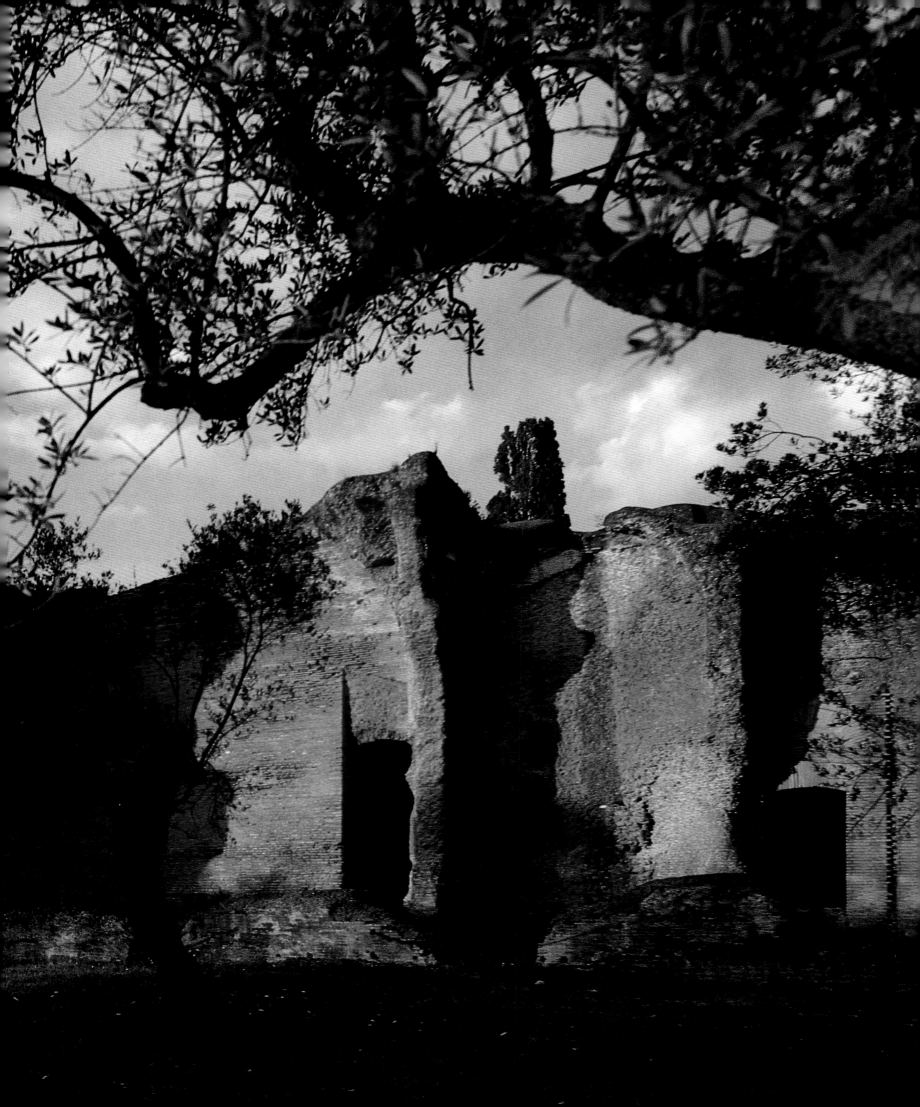

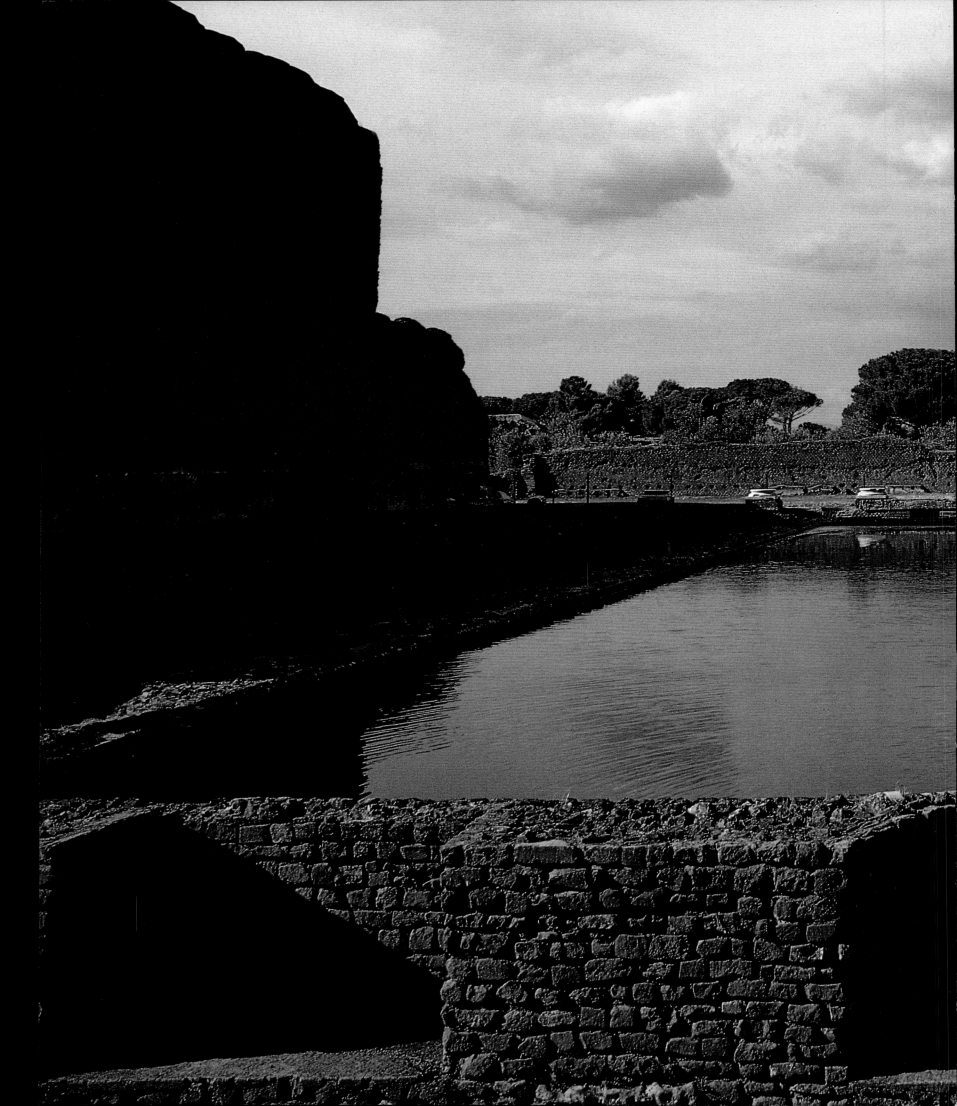

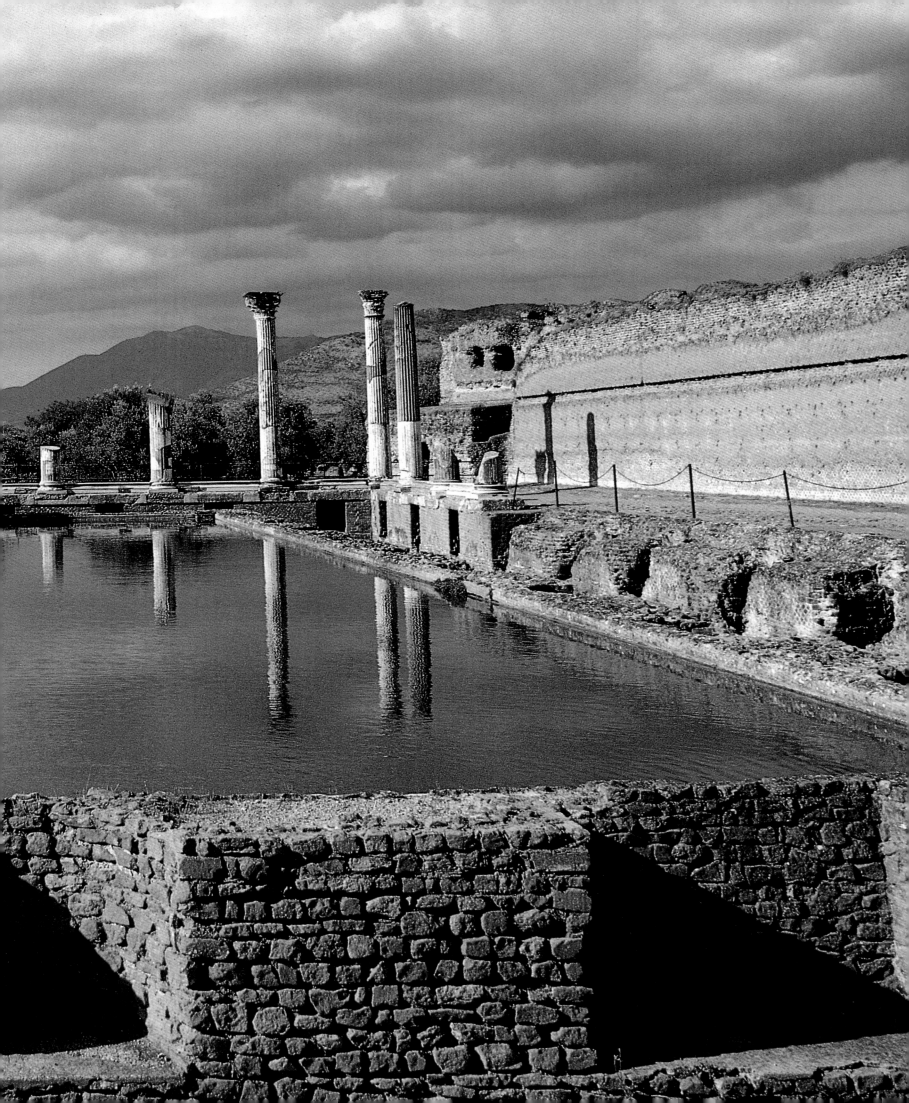

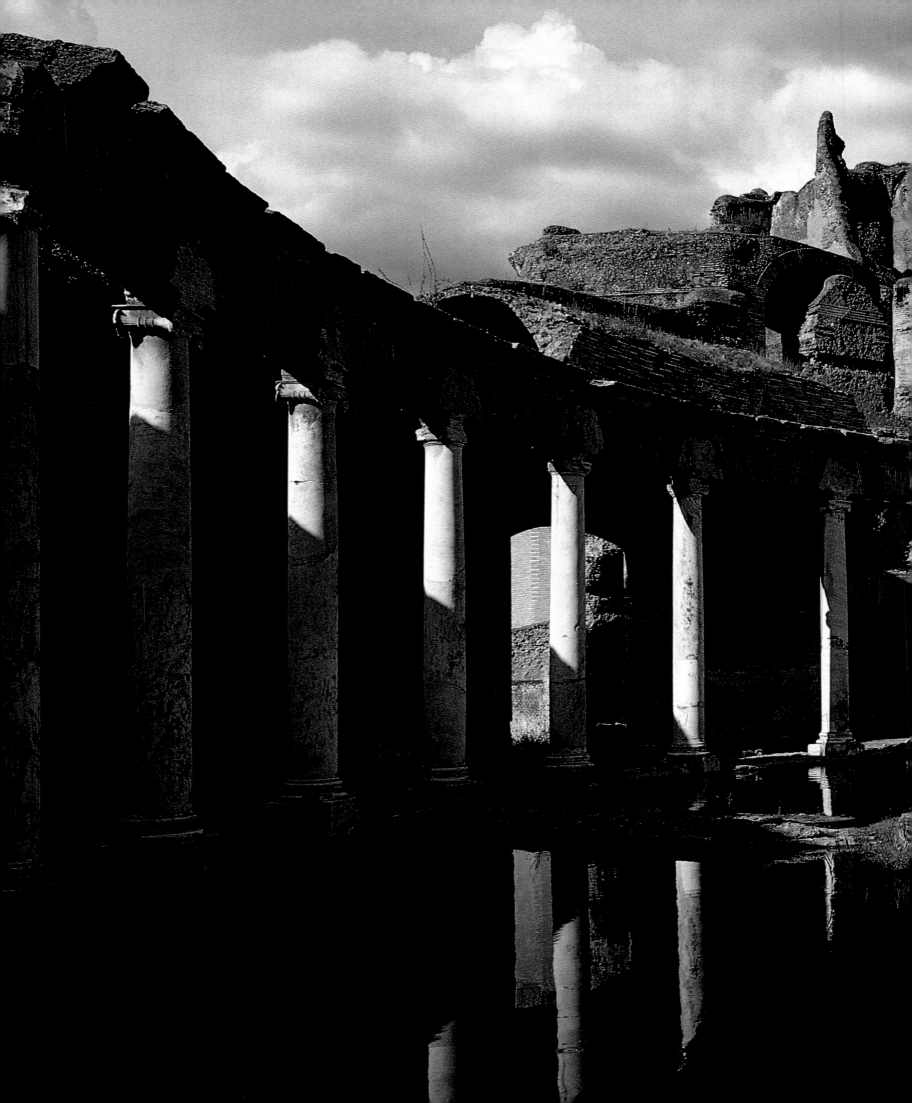

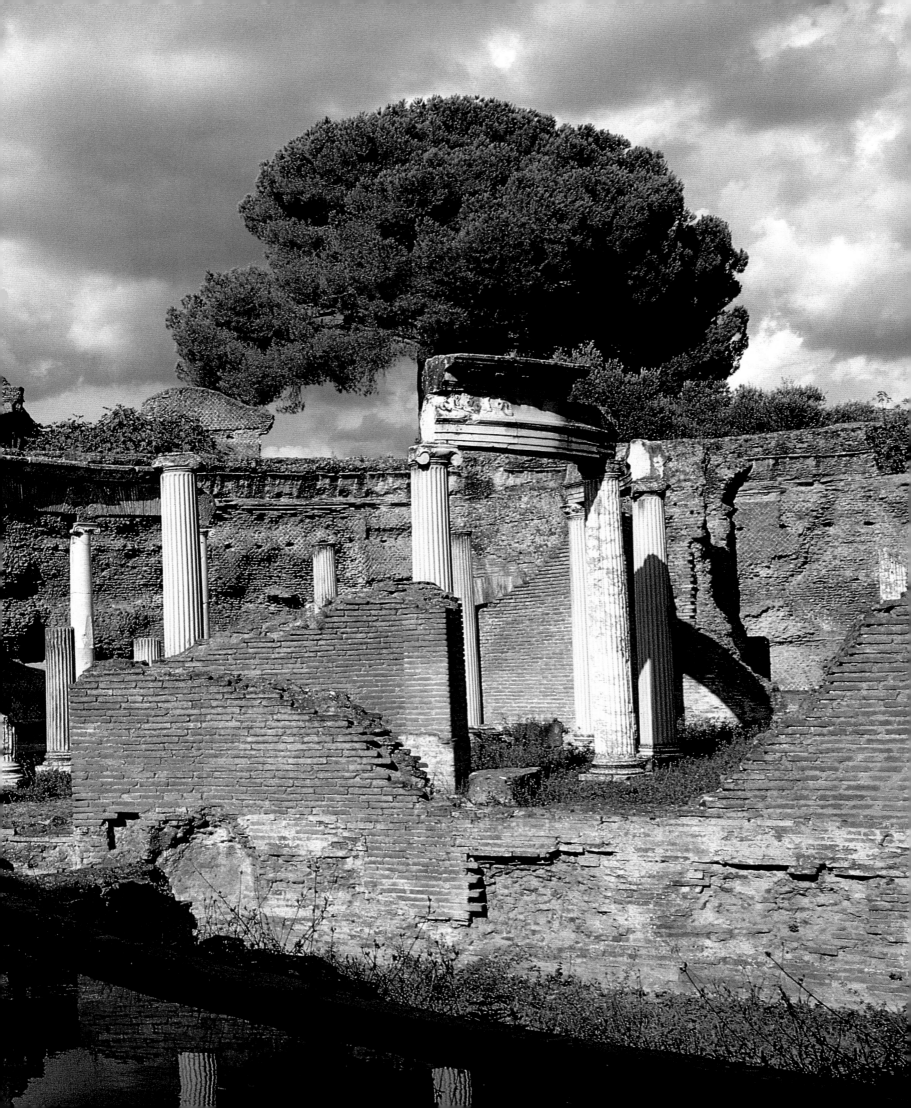

Cardinal Ippolito II d'Este took possession of Tivoli as governor of the city in 1550, installing himself in a Franciscan convent, within the walls of the city, that overlooked a valley covered with vines, houses, and churches. Already at this time the cardinal had begun to purchase the land in the area. However, it is only after 1560 that the construction of Villa d'Este was initiated, specifically, the restoration of the convent to a plan by Alberto Galvani, an architect from Ferrara, the incorporation of the newly acquired lands, and the provision of a plentiful water supply. Between 1563 and 1572, the palazzo was decorated by Girolamo Muziano, Cesare Nebbia, Federico Zuccari, and others with frescoes depicting both stories from the history of ancient Tivoli (inspired by Pirro Ligorio and M. A. Muret) and the gardens of the villa itself. The most important work on the gardens dates from about 1565 to 1572, when the architect-painter-archaeologist Pirro Ligorio was appointed as supervisor—although documents show he had been involved with the villa's construction since 1560.

VILLA D'ESTE

•

Tivoli

The terraced garden is set on a longitudinal axis (which starts at the palazzo and descends toward the lower entrance, passing through the Fountain of the Dragons and the Cypress Rotunda) and several cross-axes. The most important axis connects the two opposite poles of the Fountain of Tivoli and the Fountain of Rome, almost a microcosmic replica of the villa's actual location in Lazio. This is the Viale delle Cento Fontane (the Path of the Hundred Fountains), which represents the course of the Aniene River from Tivoli to Rome.

The Fountain of Tivoli, or the Sibyls, begun in 1565, consists of a large oval basin over which projects an artificial hill above a semicircular "theater" with ten nymphs. In front of the fountain, above a waterfall, is a colossal statue of the Albunea (or Tiburtine) Sibyl—or Mater Matuta—between two statues of the Erculaneo and Aniene Rivers, and beneath the Fountain of Pegasus, which alludes to Parnassus.

The Fountain of Rome, or "Rometta" (little Rome), begun in 1567, of which only a small part is standing, resembles a theatrical scene on a high podium. The Tiber is flowing at its feet, with the Tiber Island in the shape of a ship, along with the Bridge of the Quattro Capi (four heads). At the center is a statue of Rome. In its entirety, the scene consists of a synthetic representation of the seven hills of Rome, with the most important buildings abstractly replicated. These architectural representations are embedded in a concave surface whose outer rim alludes to the Roman walls, with portals at both ends.

The Fountain of the Deluge, or of the Ephesian Diana (later Fountain of the Organ), begun in 1568, is characterized by an emphatic mannerist style. Four telamons support the upper level of the facade, which is in turn divided by spiraling caryatids (added later) and surmounted by a large tympanum with the heraldic eagle of the Este family (also added later) in the center. In the central niche, behind the water organ, was originally a statue of the mother-goddess Ephesian Diana, which alluded to the general meaning of the villa: a hymn to fertile nature.

With the death of Cardinal Ippolito, construction on the villa was halted. Interventions following the cardinal's death include Bernini's Fountain of the Glass and his waterfall beneath the Fountain of the Organ (1660–61; the waterfall was significantly restored in the 1930s).

Left: Garden plan with the palazzo and the axis between the Fountain of Tivoli at left, the Fountain of the Dragons in the center, and the Fountain of Rome at right (by Percier-Fontaine, 1824).

Right: Mask at the entrance to the villa.

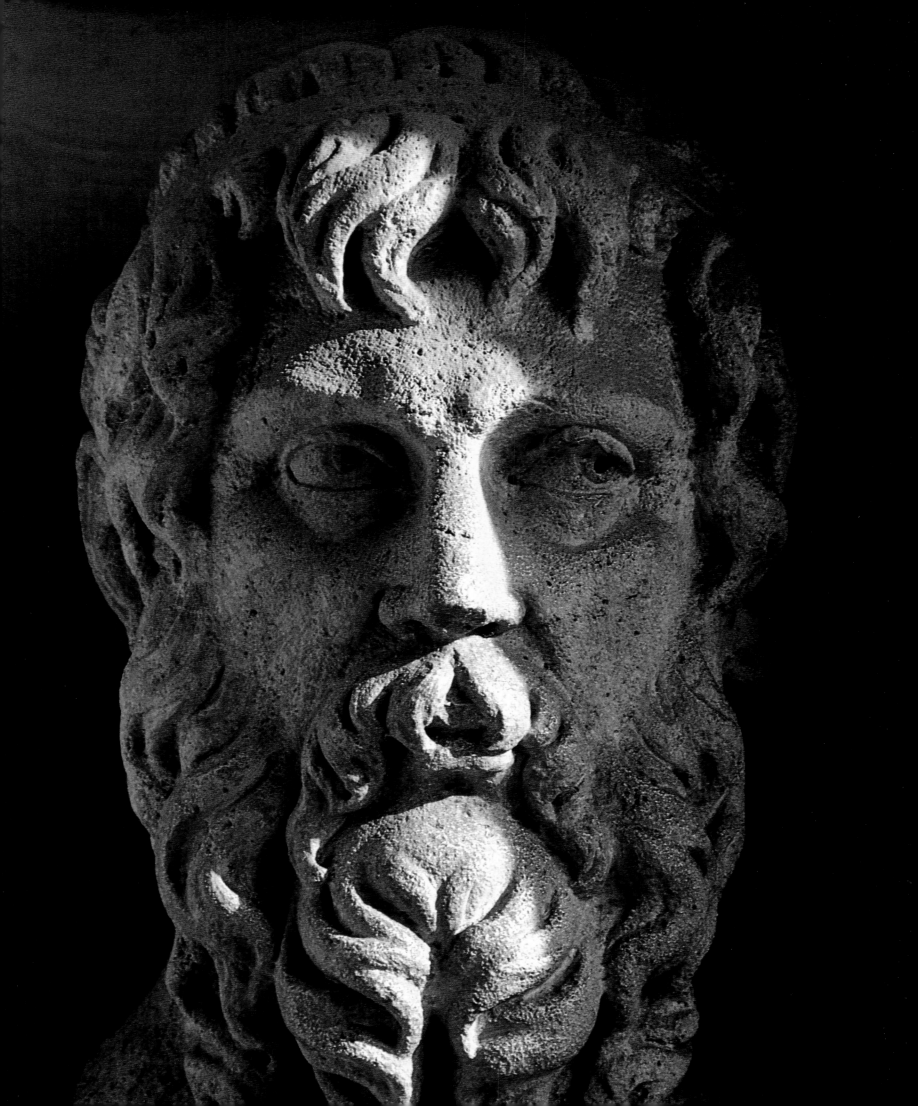

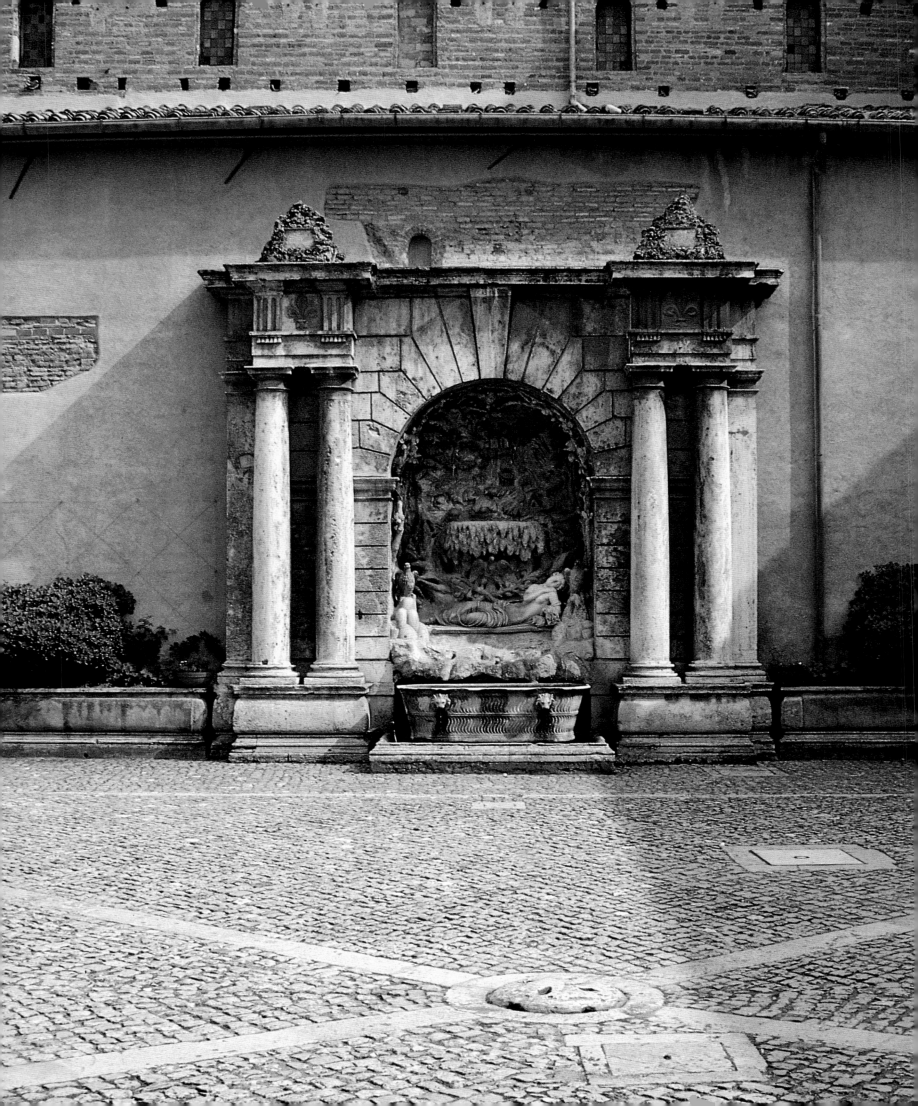

ABOVE: DETAILS OF THE FOUNTAIN OF VENUS, INCLUDING THE SLEEPING VENUS, THE COUNTRYSIDE WITH
WATERFALLS AND MILLS, AND THE HERALDIC EAGLE OF THE ESTE FAMILY.

LEFT: FOUNTAIN OF VENUS IN THE COURTYARD OF THE PALAZZO.

FRESCO IN THE ENTRANCE HALL SHOWING THE VILLA
(ATTRIBUTED TO G. MUZIANO, 1565–67).

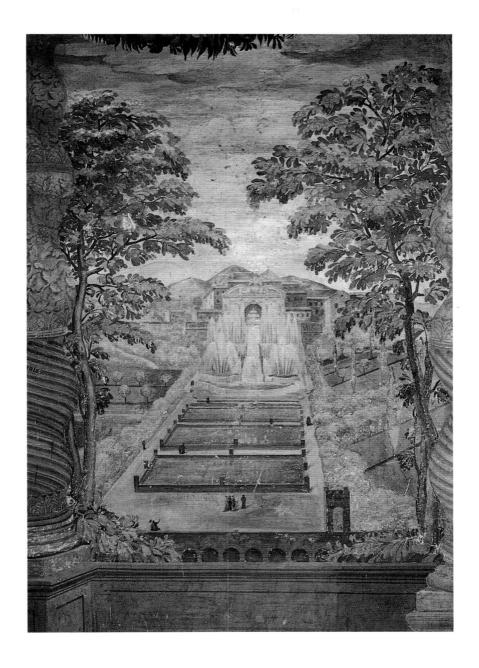

FRESCO SHOWING THE VILLA WITH THE FISHPONDS AND THE FOUNTAIN
OF THE ORGAN (ATTRIBUTED TO G. MUZIANO, WITH ADDITIONS MADE
AFTER BERNINI'S INTERVENTIONS OF 1660–61).

ABOVE: FRESCO SHOWING HERCULES AND ANTAEUS IN AN IDEAL LANDSCAPE.

RIGHT: FRESCO IN THE VAULT OF THE ROOM OF MOSES SHOWING A PUTTO HOLDING
A SHIELD OF HYDRA WITH ITS MANY HEADS.

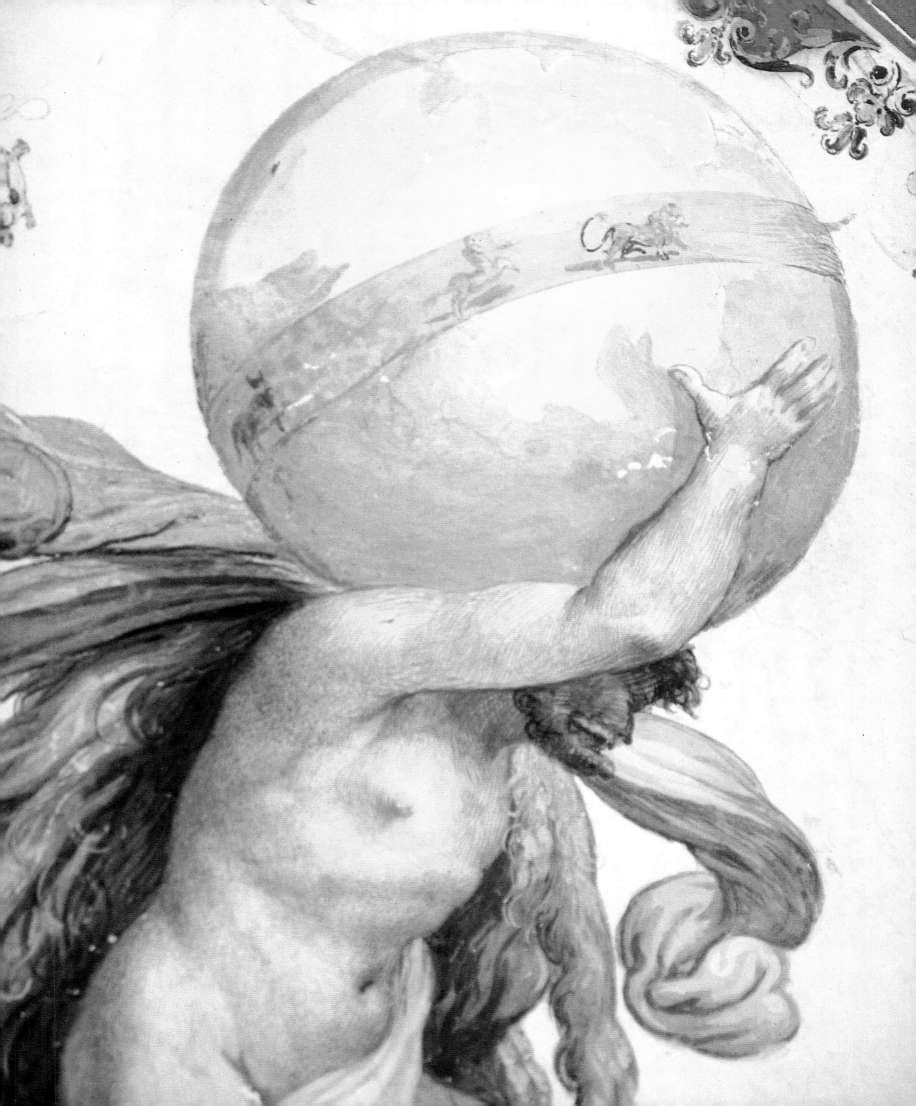

ABOVE: FRESCO IN A VAULT SHOWING A SPHINX AND TWO SATYRLIKE FIGURES.

LEFT: FRESCO IN A VAULT OF THE ROOM OF HERCULES SHOWING HERCULES
SUPPORTING THE CELESTIAL GLOBE OF ATLAS.

FRESCO IN THE ROOM OF THE HUNT SHOWING FRIEZE WITH A TROPHY OF GAME.

FRESCOES IN THE ROOM OF THE HUNT WITH MICHELANGELOESQUE DECORATIVE MASKS.

ABOVE: FRESCO IN THE ROOM OF THE HUNT SHOWING A HUNT IN AN IDEAL LANDSCAPE.

RIGHT: FRESCO IN THE ROOM OF THE HUNT SHOWING THE HERALDIC EAGLE OF THE ESTE FAMILY
ATOP A DOUBLE CORNUCOPIA WITH THE APPLES OF THE HESPERIDES.

ABOVE: BAS-RELIEF MOSAIC IN A VAULT OF THE GROTTO OF DIANA. FOUR MYTHOLOGICAL
MARINE SCENES ARE FRAMED BY BRANCHES HOLDING THE APPLES OF THE HESPERIDES; AT
THE CENTER IS THE HERALDIC EAGLE OF THE ESTE FAMILY.

LEFT: BAS-RELIEF MOSAIC IN THE GROTTO OF DIANA SHOWING PERSEUS FREEING
ANDROMEDES FROM THE DRAGON.

Overleaf:
Fountain of Tivoli,
or of the Sibyls.

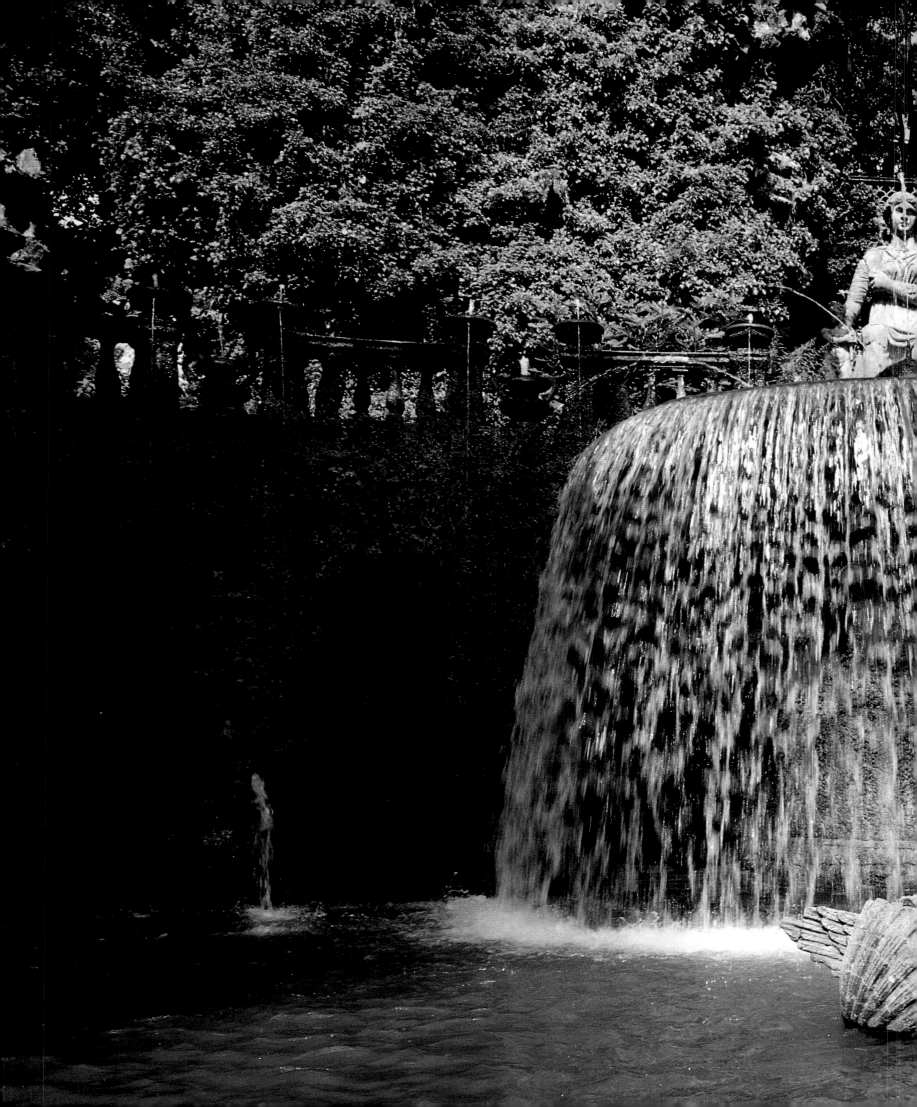

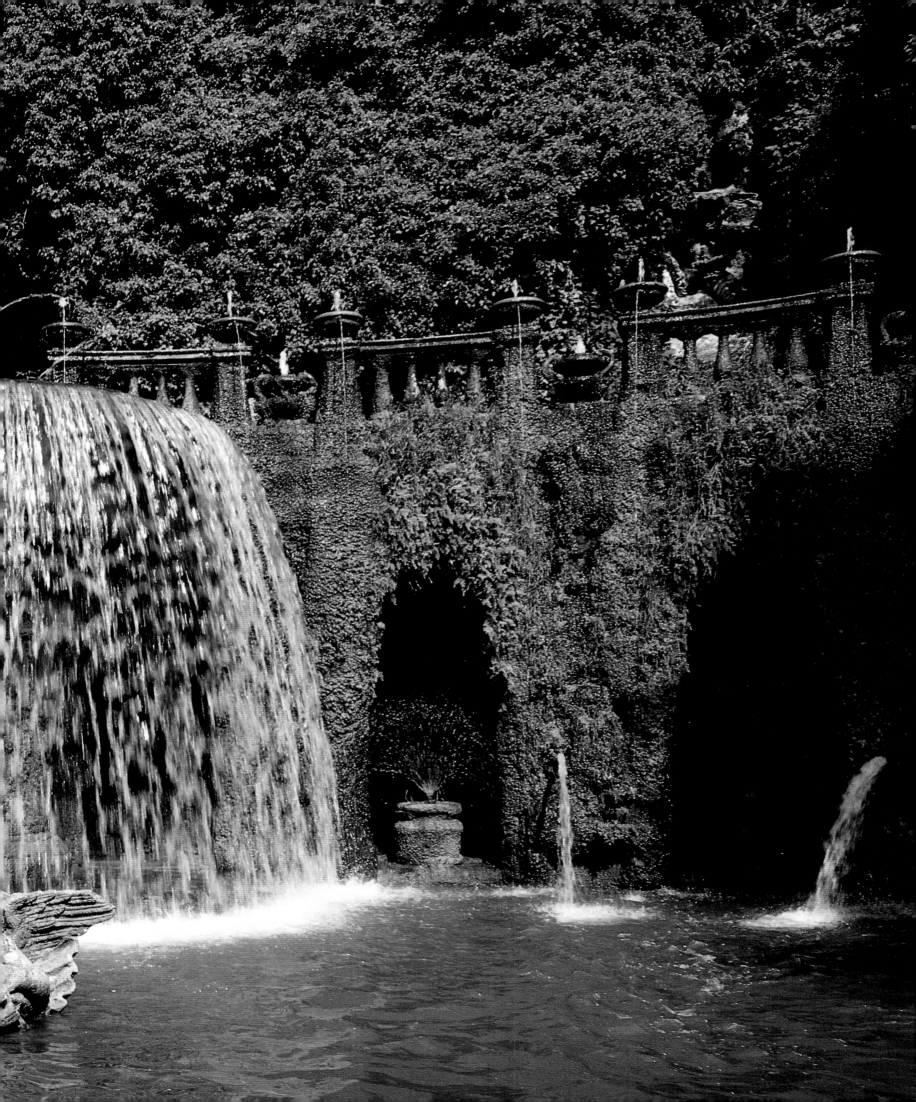

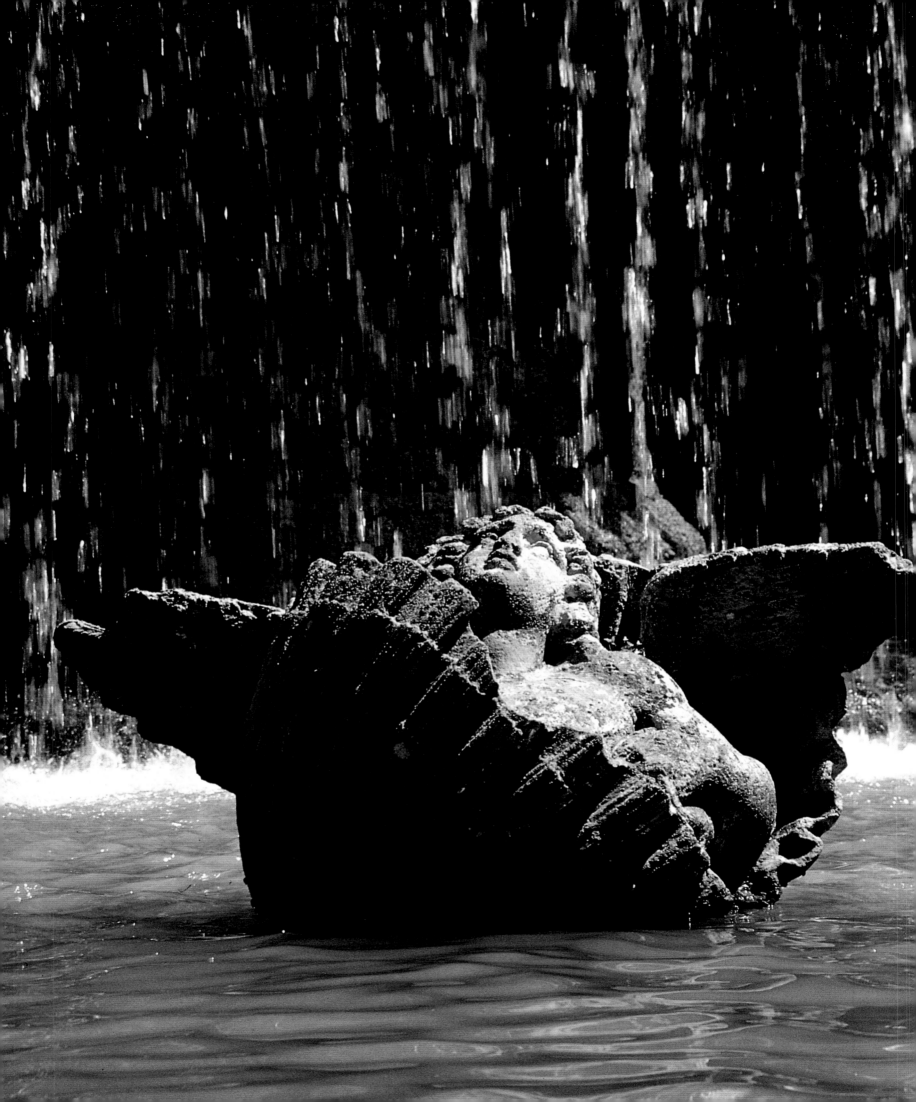

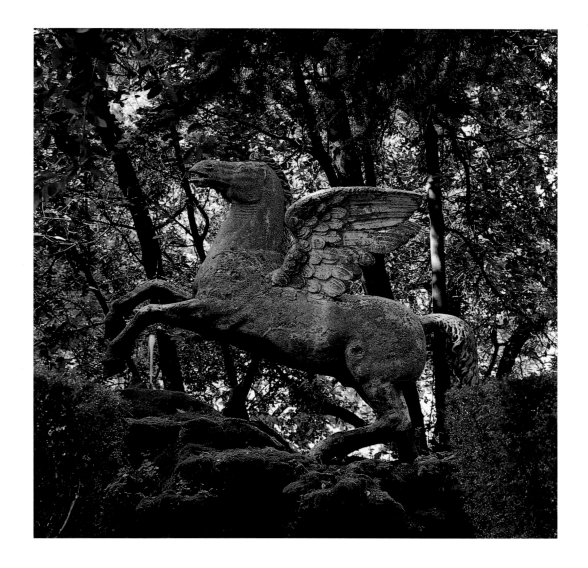

ABOVE: PEGASUS ON THE SUMMIT OF THE ARTIFICIAL MOUND OF PARNASSUS.

LEFT: FOUNTAIN OF TIVOLI, WITH THE SMALL "GENIUS" AT THE CENTER OF THE OVAL BASIN.

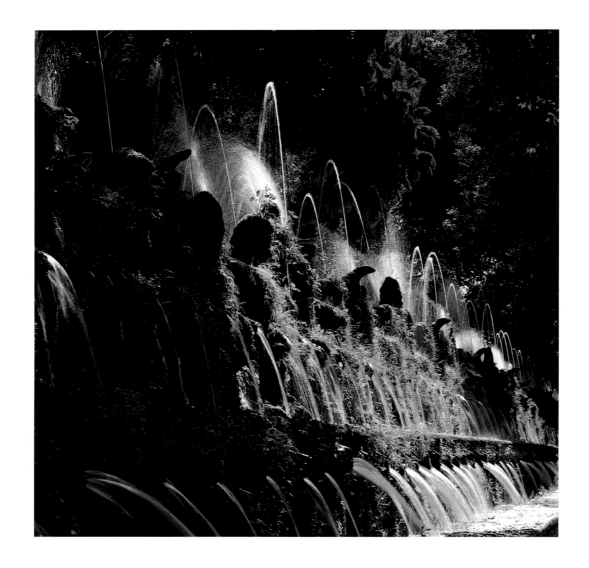

ABOVE: THE PATH OF THE HUNDRED FOUNTAINS, WHICH ALLUDES TO THE
ANIENE RIVER ON ITS WAY FROM TIVOLI TO ROME.

RIGHT: MASK SWALLOWING WATER ON THE PATH OF THE HUNDRED FOUNTAINS.

Above: Fountain of Rome, or "Rometta." In the foreground is the island/ship of the Tiber; at the top is the goddess of Rome.

Left: Grotesque masks on the Path of the Hundred Fountains.

ABOVE: FOUNTAIN OF THE EMPERORS (SO NAMED BECAUSE STATUES OF THE PATRONS OF ANCIENT TIBURTINE VILLAS STAND BEFORE IT). THE IVY-ENTWINED COLUMNS DERIVE FROM THOSE AT THE VATICAN.

RIGHT: DETAIL OF THE FOUNTAIN SHOWING PLUTO IN HIS CHARIOT (THE SEVENTEENTH-CENTURY STUCCO GROUP HAS LOST THE FIGURE OF PERSEPHONE).

Overleaf: Fountain of the Owl.

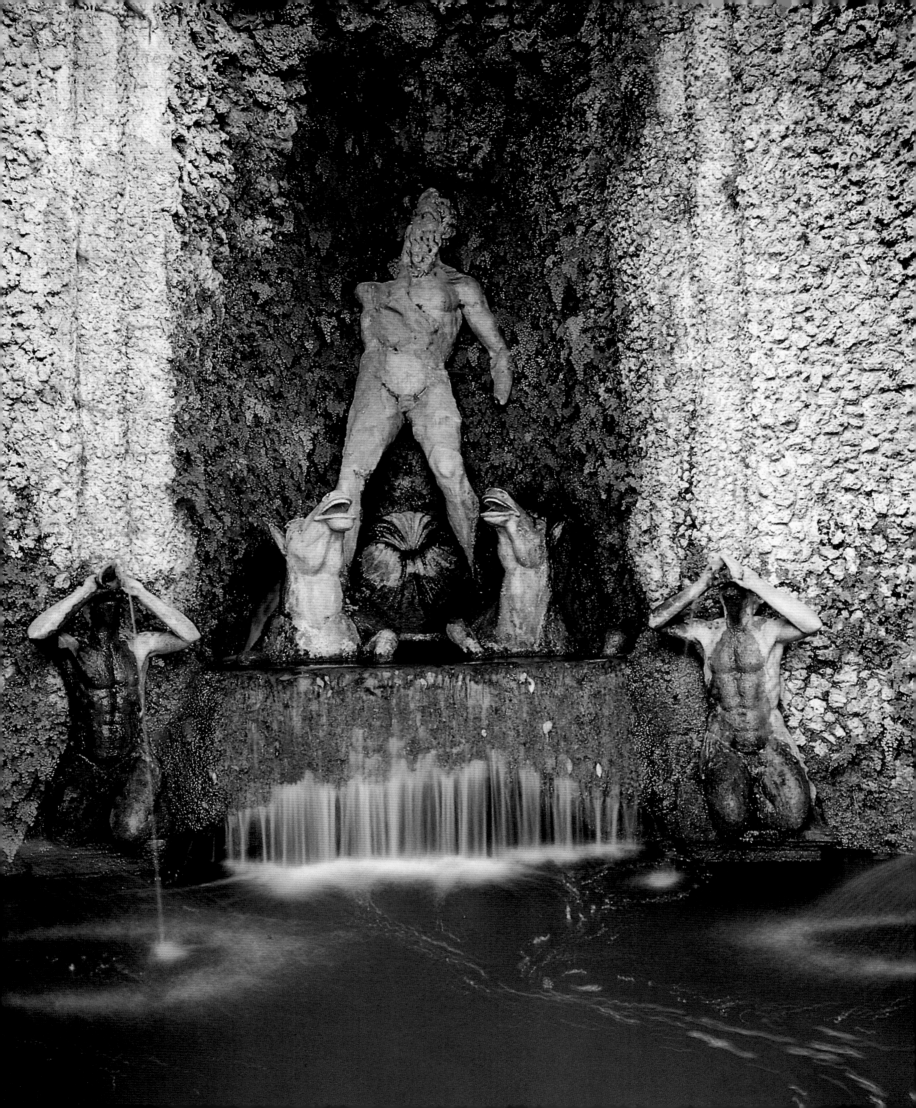

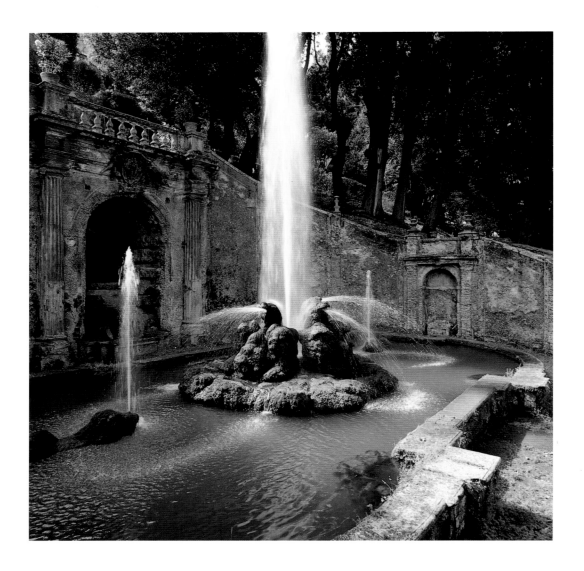

ABOVE AND RIGHT: FOUNTAIN OF THE DRAGONS.

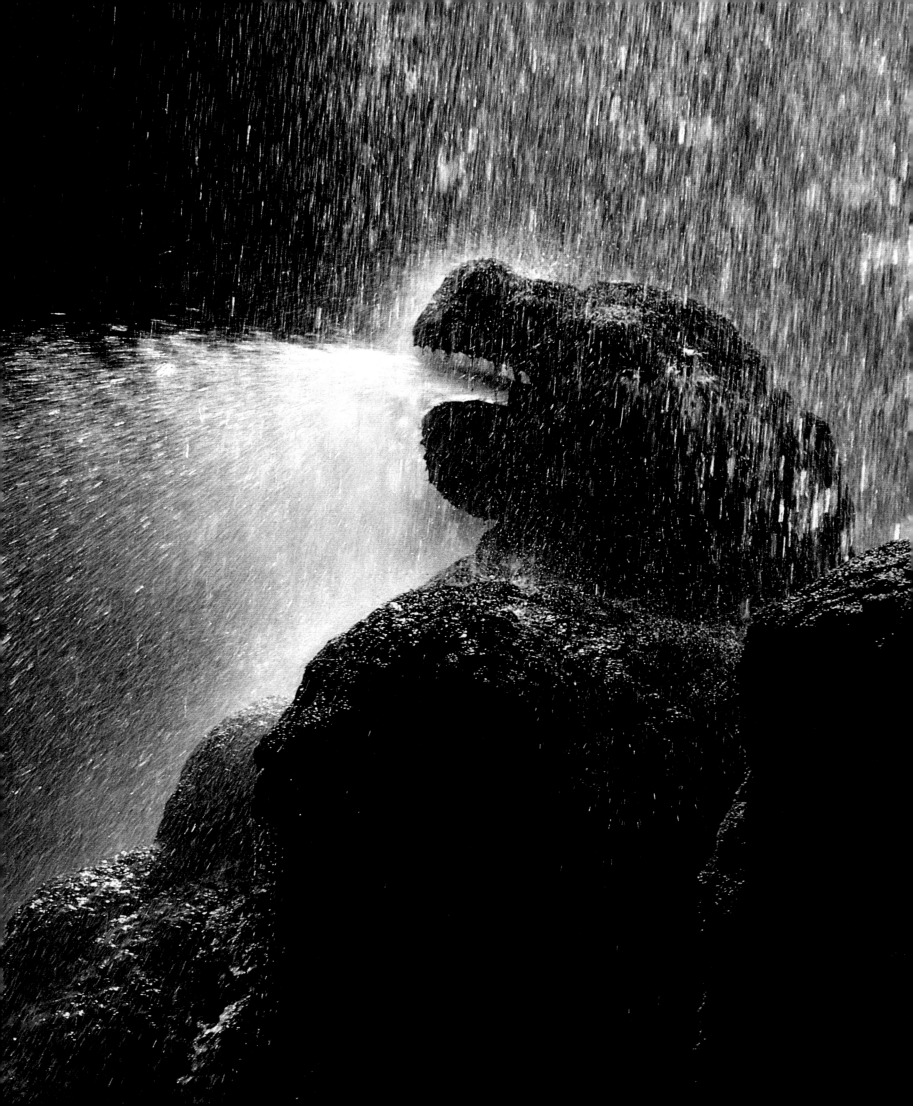

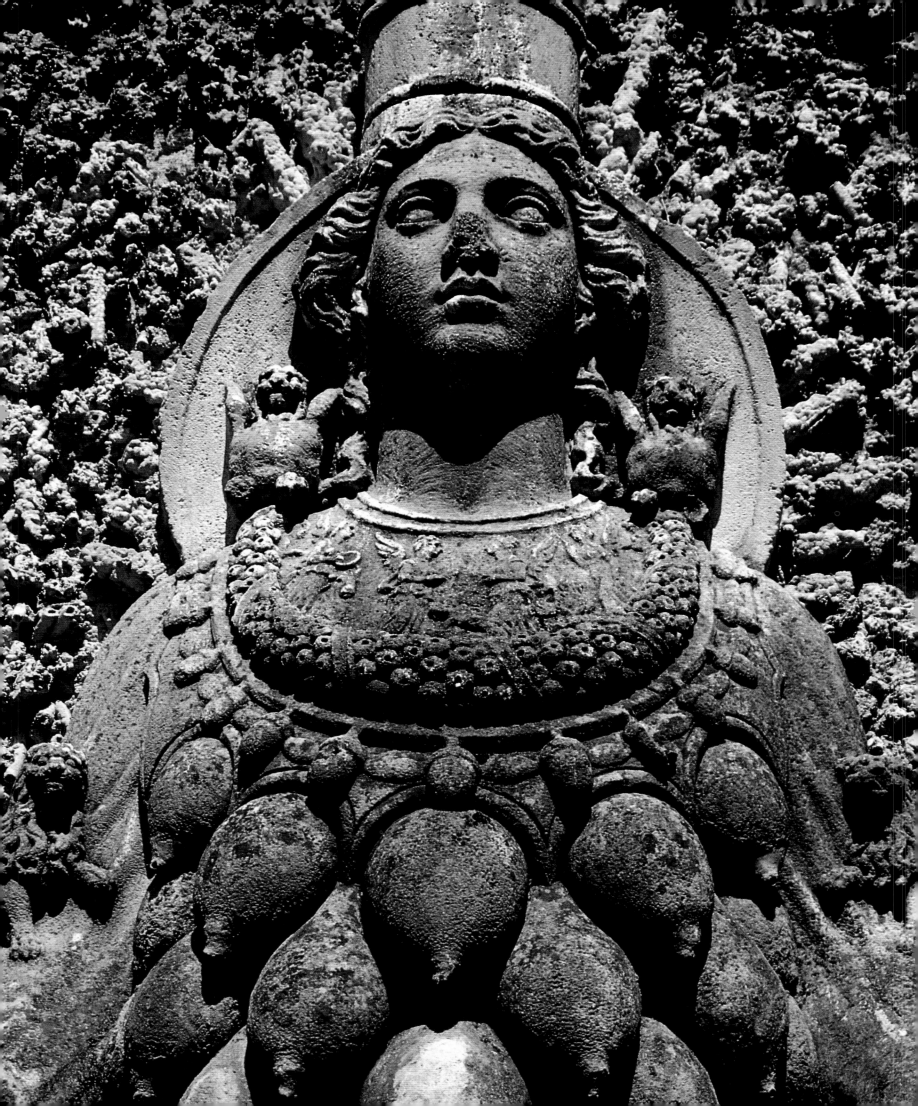

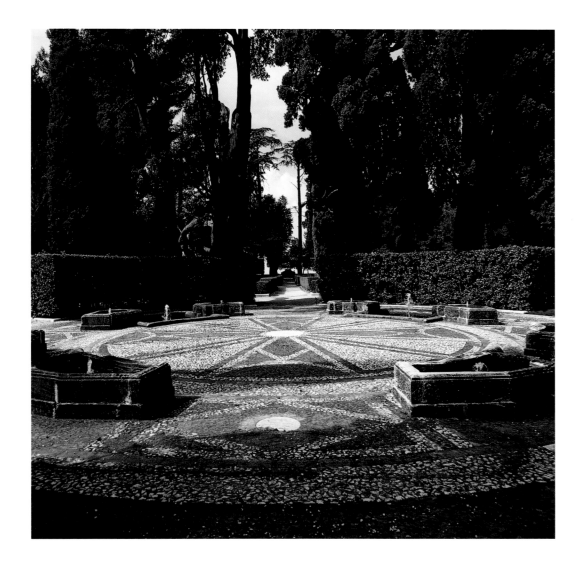

ABOVE: CYPRESS ROTUNDA, NEAR THE LOWER ENTRANCE.

LEFT: EPHESIAN DIANA, OR "GODDESS OF NATURE," SCULPTED IN TRAVERTINE BY G. VAN
VLIETE, ORIGINALLY AT THE CENTER OF THE FOUNTAIN OF THE DELUGE, OR OF THE ORGAN.

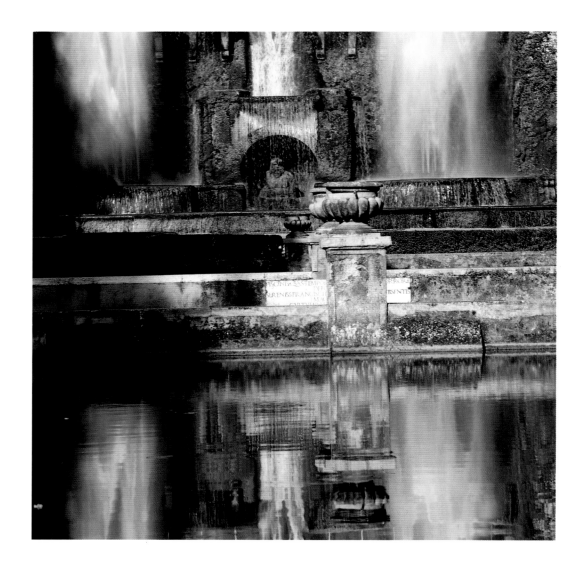

ABOVE: DETAIL OF THE FISHPONDS; IN THE BACKGROUND ARE THE REMAINS OF
THE UNFINISHED COLOSSAL STATUE OF NEPTUNE (THE OCEAN) IN A NICHE.

RIGHT: THE FOUNTAIN OF THE ORGAN WITH ITS SPECTACULAR WATER GAMES, AND
THE FISHPONDS IN THE FOREGROUND.

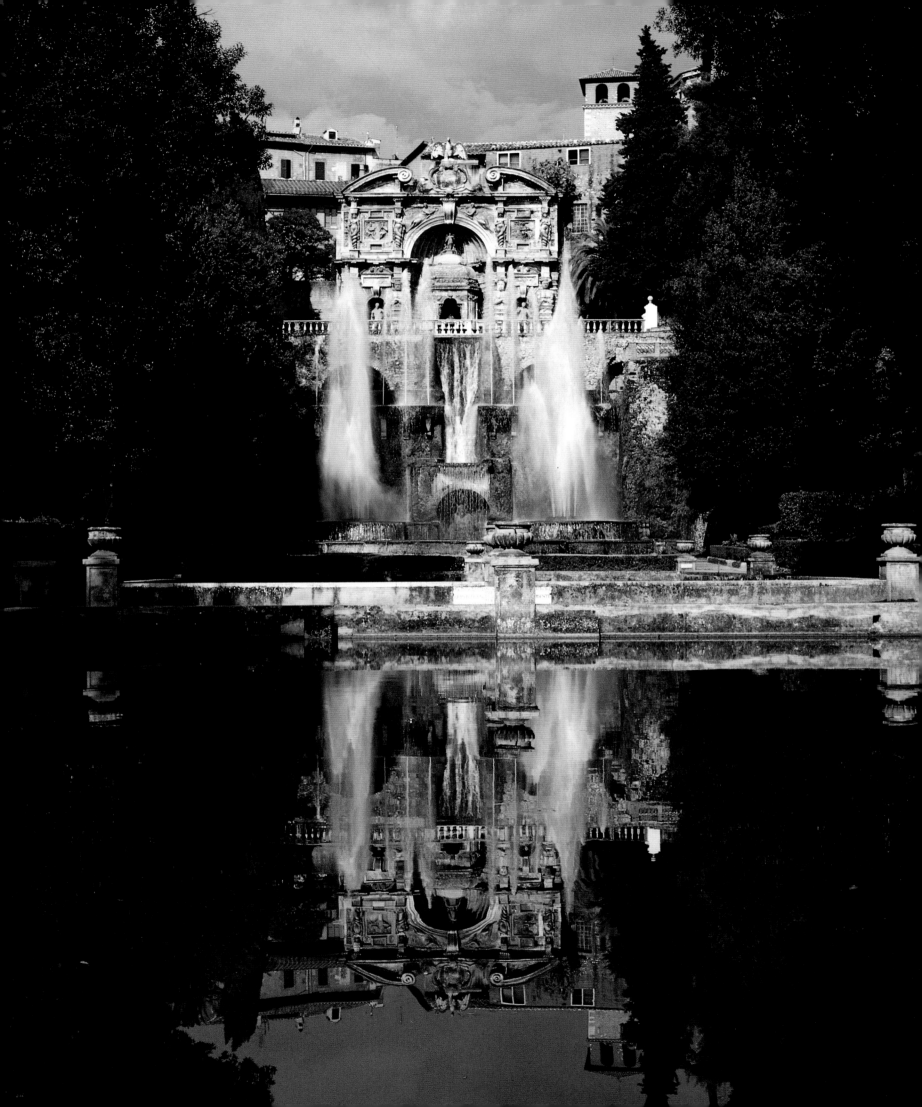

Alessandro Farnese Sr., who would become Pope Paul III (1534–49), purchased the little village of Caprarola in 1504, obtaining a feudal investiture for this property in 1521 for his children Ranuccio and Pier Luigi. In 1537, he created for Pier Luigi the Duchy of Castro and Roncilione, which included Caprarola. Around 1530, construction was started on the pentagonal fortress, with its five bastions and a pentagonal courtyard, based on the plan of Baldassare Peruzzi and Antonio da Sangallo the Younger. Work was interrupted for some years (only the walls and the bastions had been built) and was resumed only after 1555 by Cardinal Alessandro Farnese Jr. (son of Pier Luigi) who had a new program in mind: a palace "inserted" within the fortress to serve as a liaison between the newly restored town—almost a second capital of the duchy—and the park.

Between 1556 and 1558, Vignola drafted various plans for the building. (His intention was to convert the five-sided courtyard into a circular one in contrast to Francesco Paciotto's decagonal plan.) In 1559 work for the palazzo was resumed on all fronts: the tufa excavation for the underground rooms of the palazzo, the construction of the pentagonal residence above the bastioned ground floor, the demolition of parts of the town to clear the way for a straight road to the palazzo, and the creation of one of the two fenced gardens to be connected to the main floor by a bridge. From a distance, the entire area would have appeared similar to the stratification of an acropolis. Above the town's rooftops (the first level) was a series of large piazzas with terraces and stairways (second level), modeled after the ancient sanctuary at Palestrina and Bramante's Cortile del Belvedere. Above the bastioned fortress (third level) is the palazzo (fourth level), conceived after a suburban villa model like Peruzzi's Villa Chigi-Farnesina. Finally, on two different levels, are the two lower gardens and the later upper garden.

Cardinal Farnese was the director and inspirer of all the operations—whether urbanistic or pictorial—coordinating a vast team of artists, workers, and intellectuals. Starting in 1562, the interior of the palazzo was frescoed by the most important artists of the time. The decorative cycle appears to represent an encyclopedic world, which was categorized by I. Faldi (1981) according to five themes—civic history, sacred history, mythology, science, and erudition—and the heraldic culture of coats of arms, emblems, and allegories.

After Vignola's death in 1573, the direction of the project was taken over first by Giovanni Antonio Garzoni, then by Jacopo del Duca, and finally by Girolamo Rainaldi. During these years two gardens were built: the upper garden, or *barchetto*, containing the Casino del Piacere, or Pleasure Casino (attributed to Garzoni), the *via d'acqua*, or waterway, and the Fountain of the Rivers (modeled after the one at Villa di Bagnaia and attributed to del Duca), as well as the garden behind the casino, containing the Piazza of the Caryatids, the fountains, and the exedra (based on Rainaldi's project).

PALAZZO FARNESE

•

Caprarola

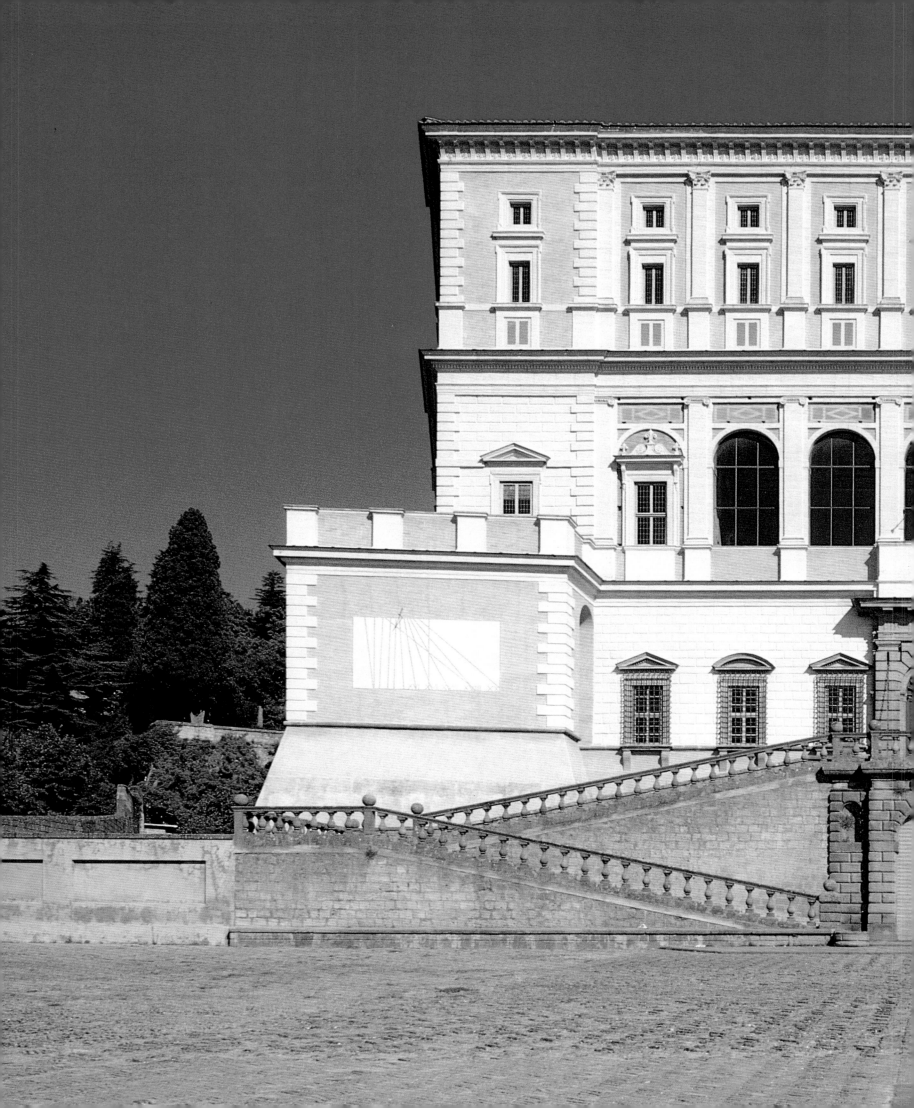

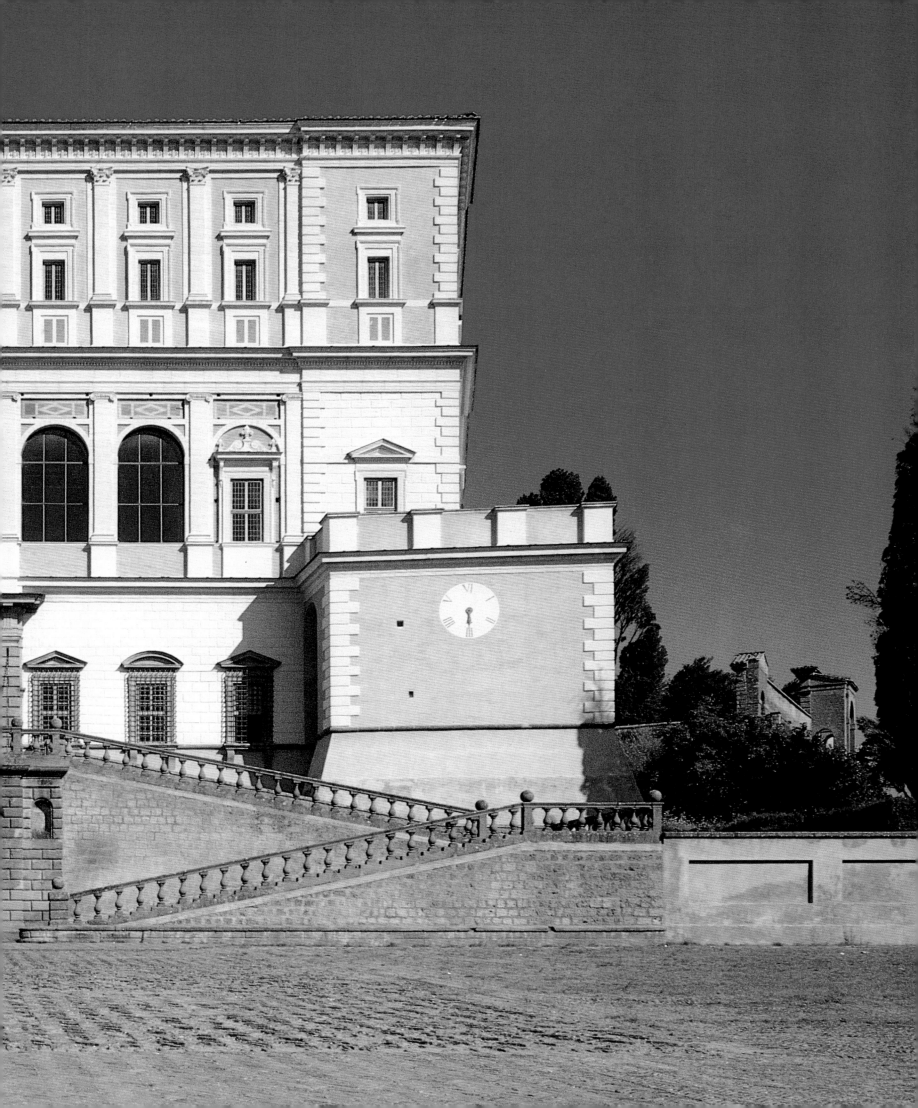

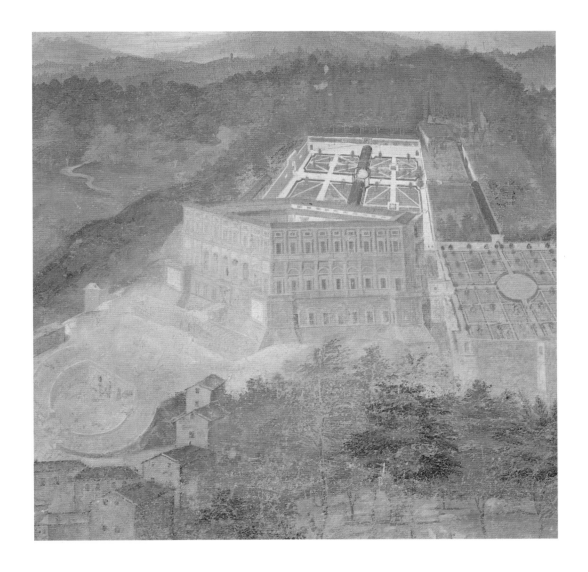

ABOVE: SIXTEENTH-CENTURY VIEW OF THE PALAZZO AS DEPICTED IN THE PALAZZINA
GAMBARA AT VILLA LANTE. VISIBLE BEHIND THE PALAZZO ARE THE TWO LOWER GARDENS.

LEFT: FRESCO IN THE ENTRANCE HALL WITH A GROTESQUE MASK.

Overleaf and second overleaf: Helicoidal staircase inside the villa (designed by Vignola).

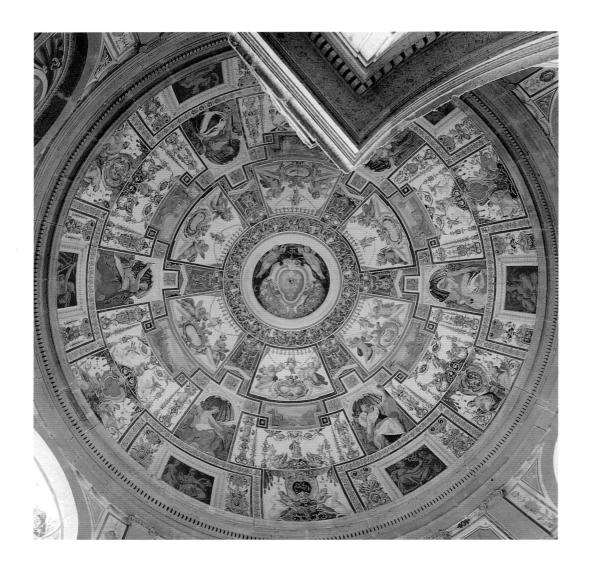

ABOVE: CEILING OF THE HELICOIDAL STAIRWAY.

RIGHT: FRESCO IN THE STAIRCASE SHOWING THE EPHESIAN DIANA COMBINED
WITH THE VIRGIN WITH THE UNICORN EMBLEM OF THE FARNESE FAMILY.

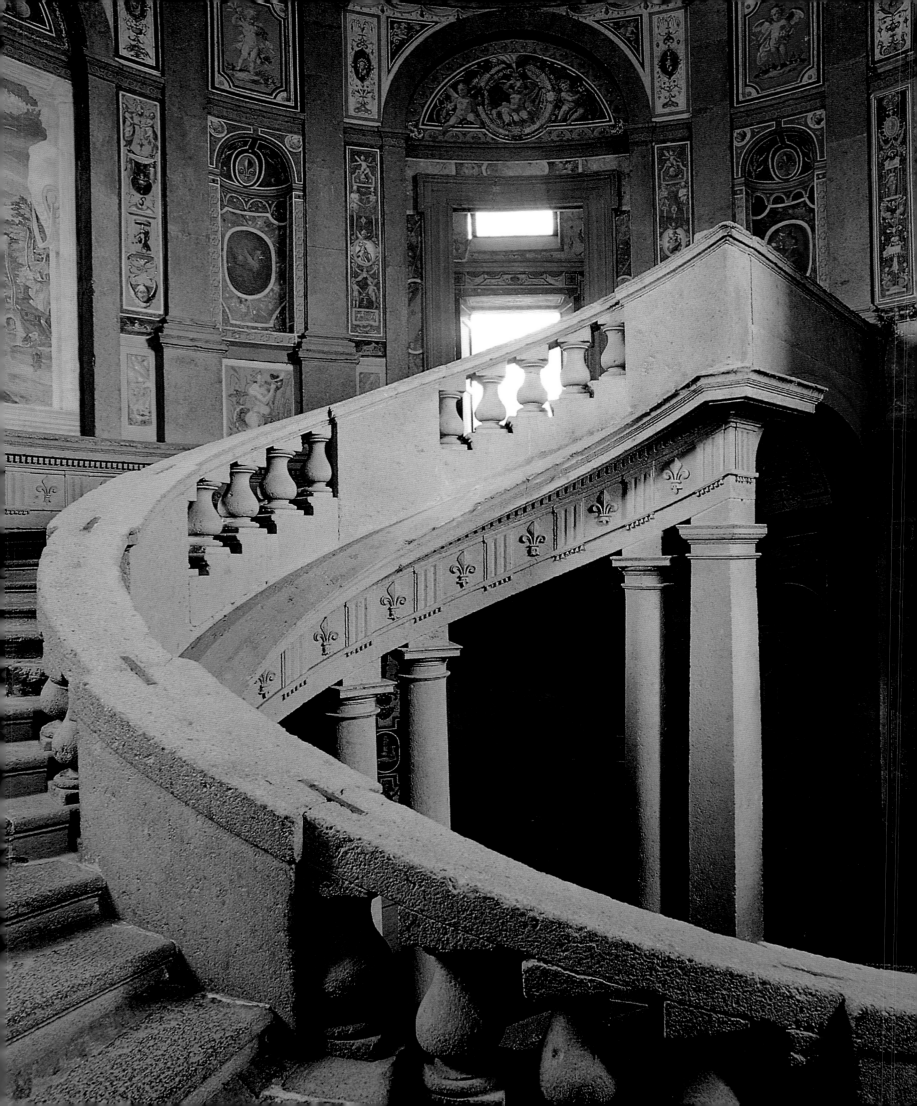

ABOVE: FRESCO IN THE STAIRCASE WITH THE HEAD OF A CHERUB.

LEFT: TOP OF THE HELICOIDAL STAIRCASE.

CIRCULAR COURTYARD VIEWED FROM BELOW.

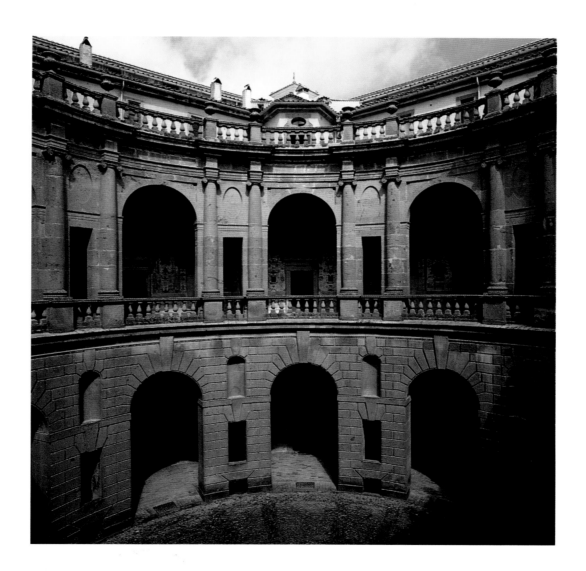

CIRCULAR COURTYARD (DESIGNED BY VIGNOLA).

ABOVE AND RIGHT: FRESCOES OF BIRDS AND PERGOLA IN THE COURTYARD VAULTS.

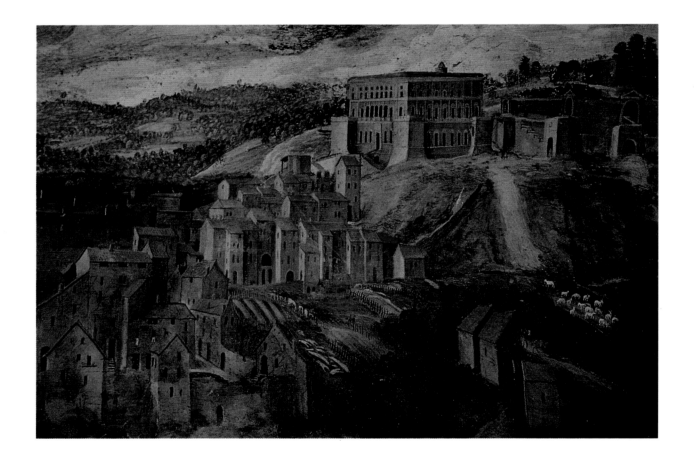

F RESCO IN THE ENTRANCE HALL OF THE PALAZZO SHOWING A SIXTEENTH-CENTURY VIEW OF C APRAROLA ,
WITH P ALAZZO F ARNESE AND ITS "SECRET" FORTIFIED GARDENS.

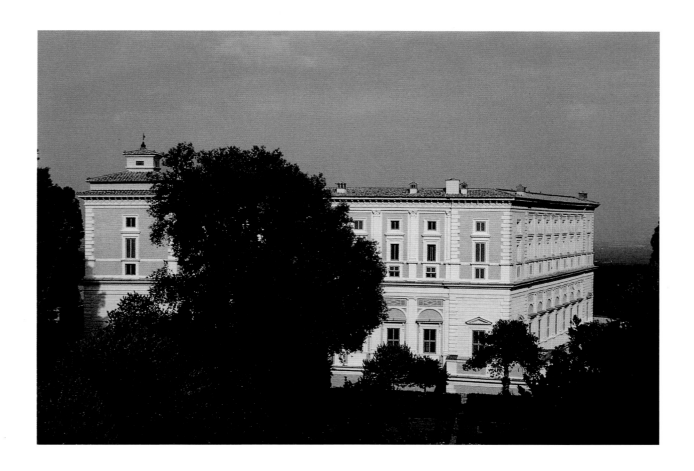

BACK FACADE AND THE SECRET GARDENS.

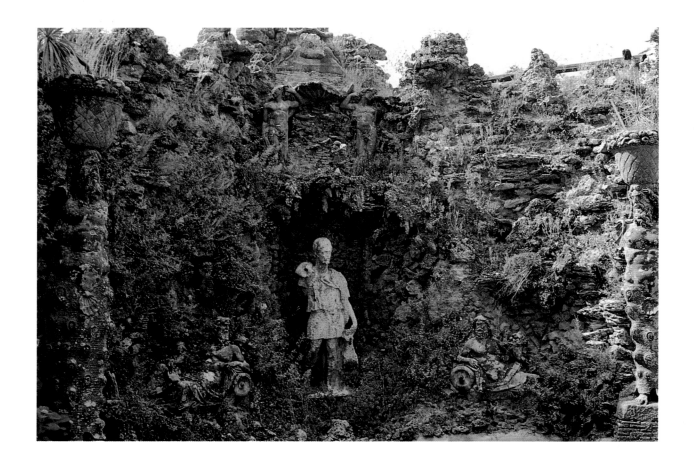

ABOVE: FOUNTAIN OF THE SHEPHERD, SITUATED BETWEEN THE TWO SECRET
GARDENS. THE CENTRAL FIGURE IS FLANKED BY TWO RIVERS AND TWO
BASKET-CARRYING TREELIKE HERMS.

RIGHT: DETAIL OF A HERM.

Overleaf: Grotto
of the Rain in the
secret gardens. Male
and female caryatids,
suspended between
Water and Earth,
support the vault of
the artificial grotto.

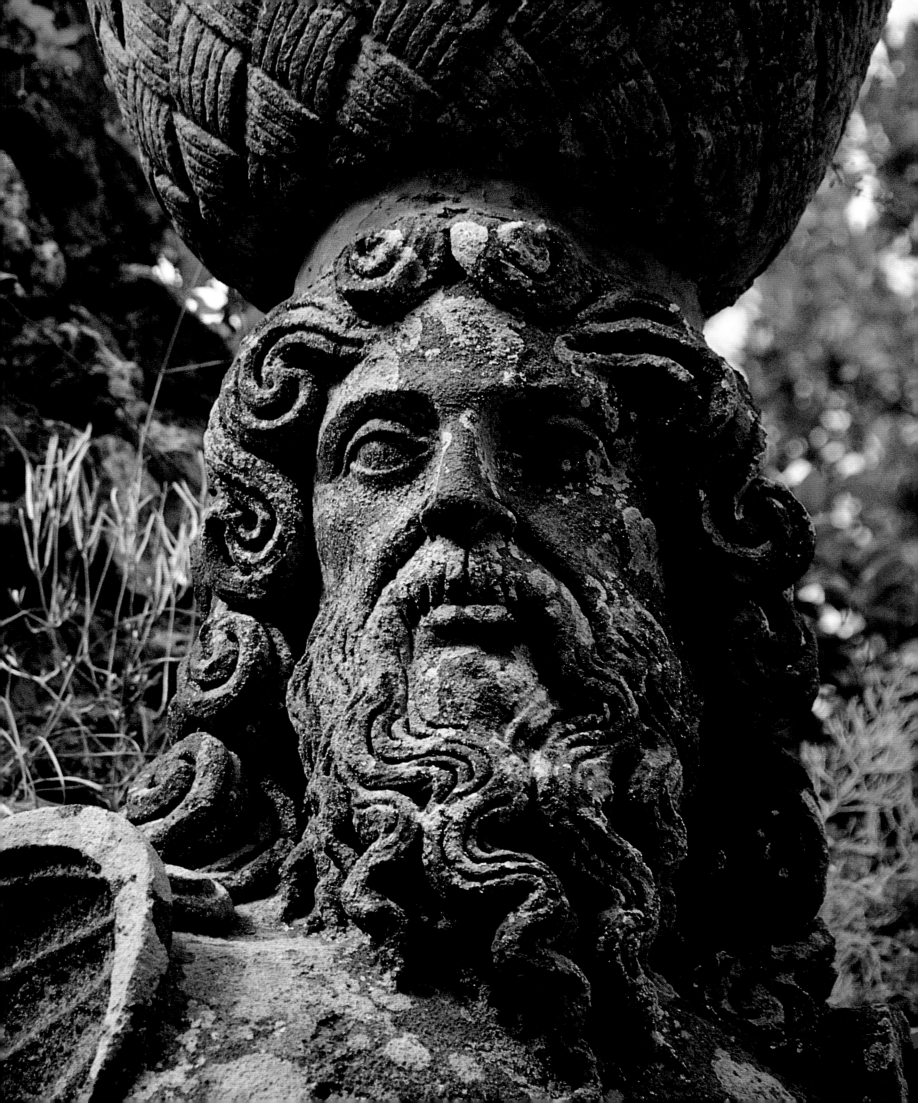

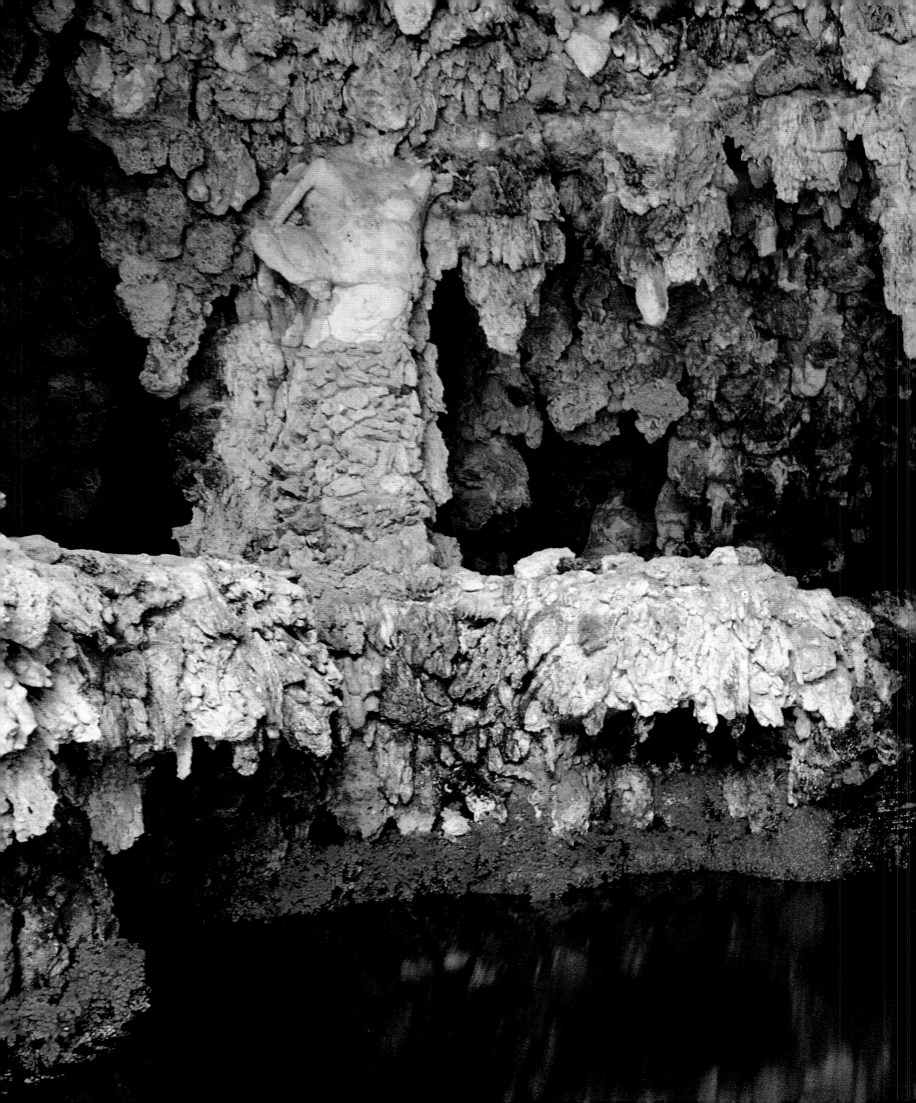

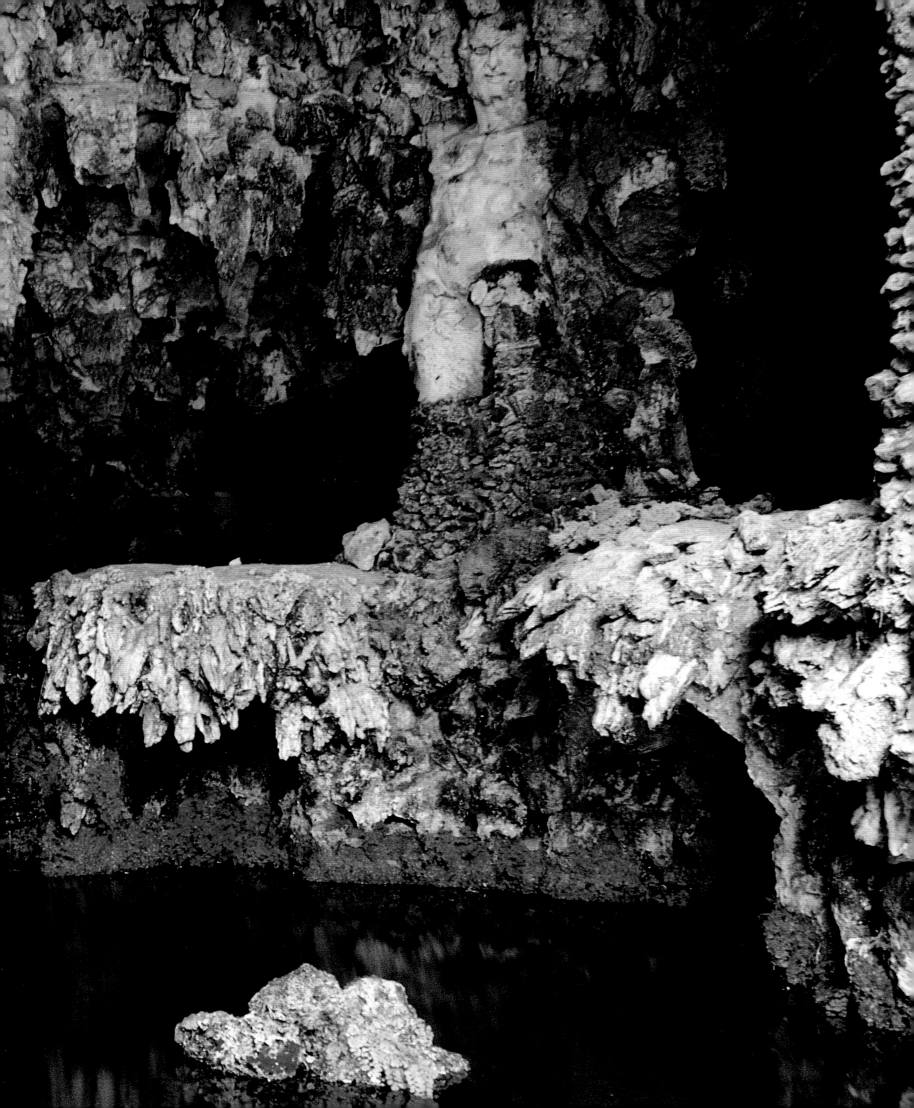

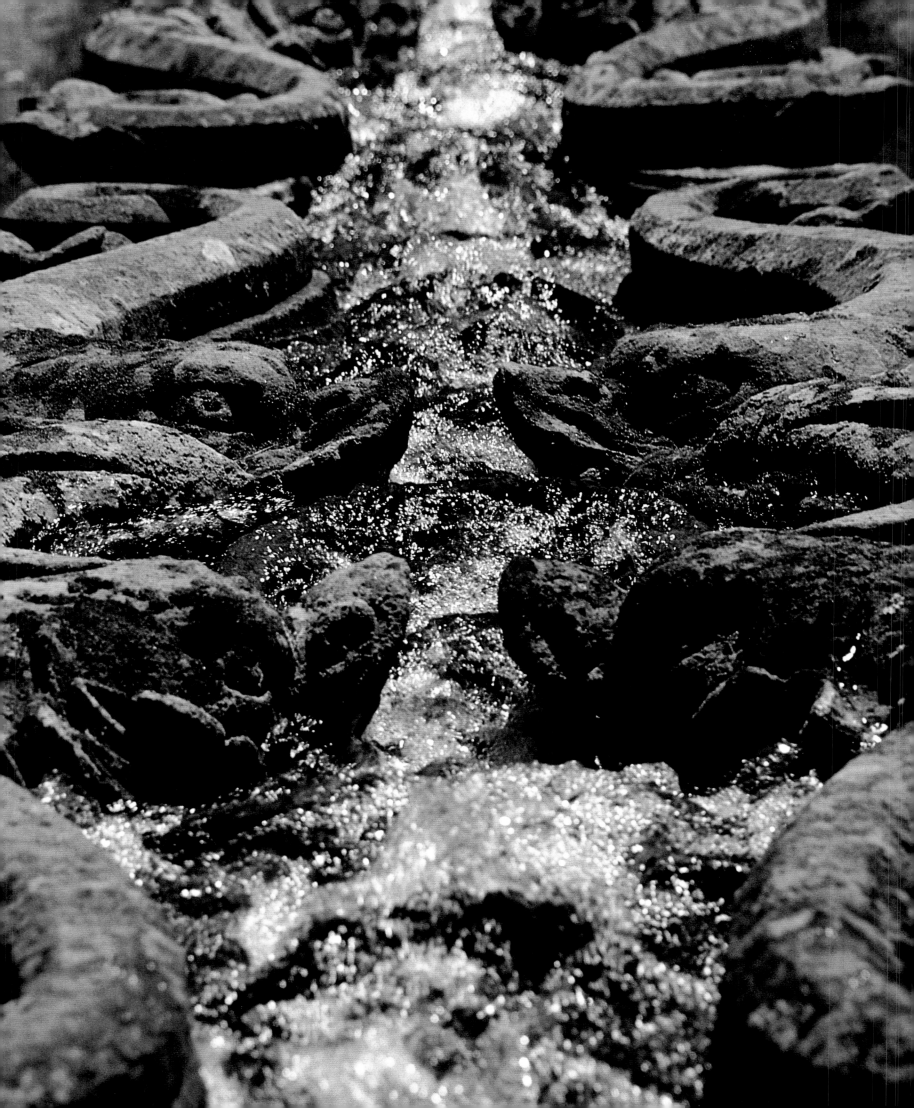

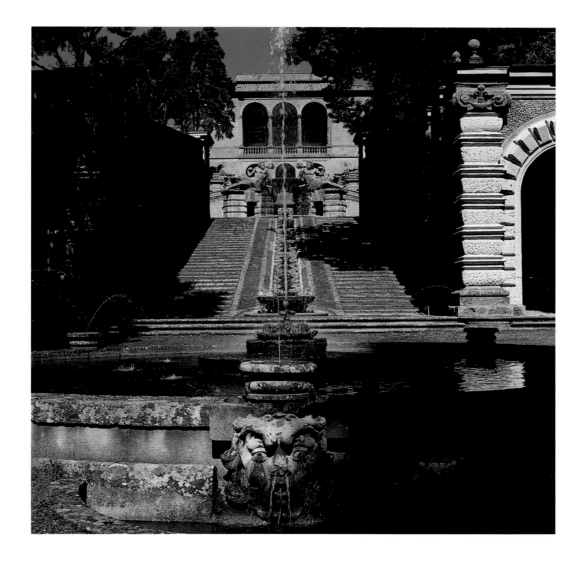

ABOVE: THE WATERWAY IN THE UPPER GARDEN (DESIGNED BY JACOPO DEL DUCA)
BEGINS FROM THE PLEASURE CASINO WITH THE FOUNTAIN OF THE RIVERS, CONTINUES
WITH THE DOLPHIN CHAIN, AND ENDS WITH THE FOUNTAIN OF THE MASK OF THE SENSES.
(THE WATER GUSHING FROM THE EYES, EARS, MOUTH, AND NOSE ALLUDES
TO FOUR OF THE FIVE SENSES.)

LEFT: DOLPHIN CHAIN.

ABOVE: GROTTO-PAVILION-PROPYLAEUM IN THE UPPER GARDEN
(DESIGNED BY JACOPO DEL DUCA).

RIGHT: WATER-SPOUTING MASK IN THE HEMICYCLE OF THE UPPER GARDEN
NEAR THE FOUNTAIN OF THE RIVERS.

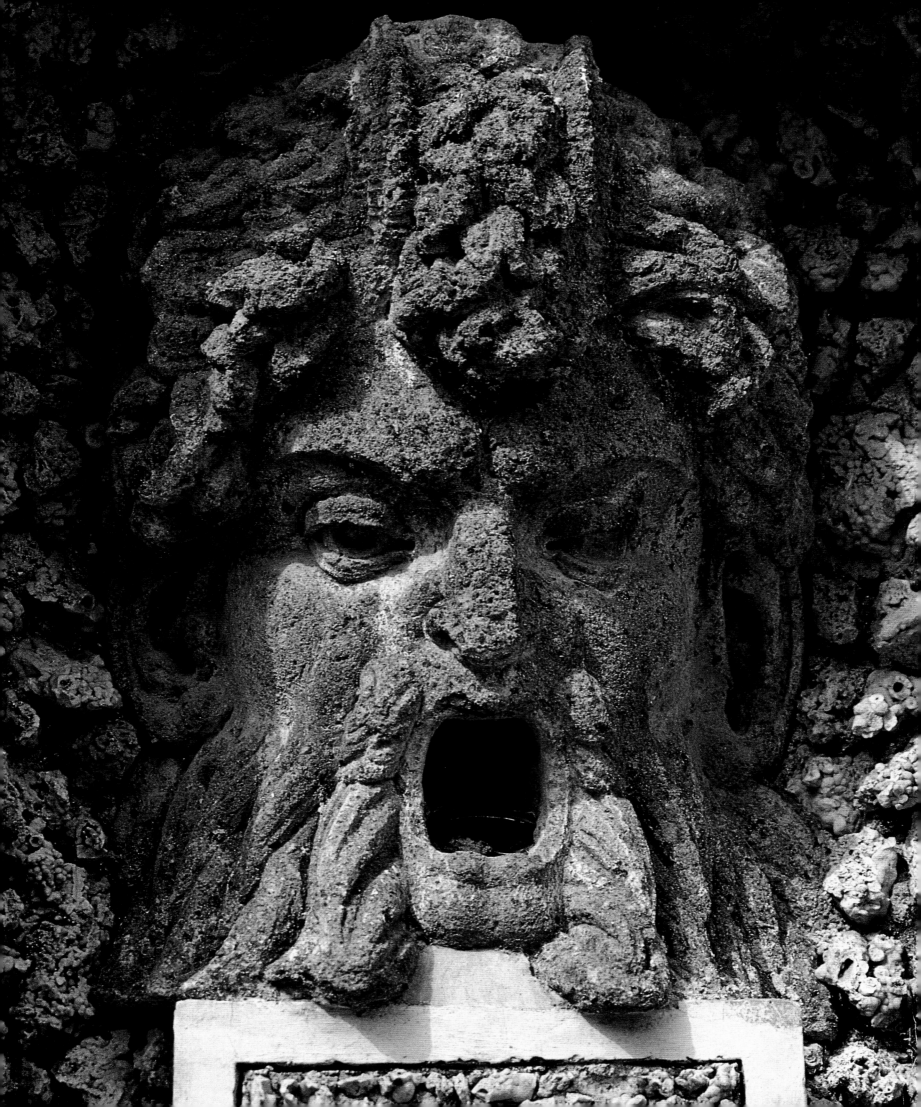

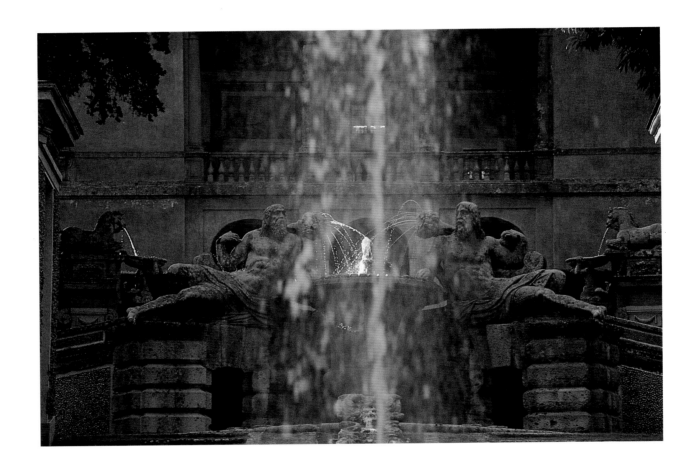

The Fountain of the Rivers in the upper garden.

THE VIRGIN WITH THE UNICORN FARNESE EMBLEM IN THE LAST EXEDRA
IN THE UPPER GARDEN, BEHIND THE PLEASURE CASINO.

Above: Fresco in the vault of the lower loggia of the Pleasure Casino
showing the Farnese emblem of the Virgin with the Unicorn.

Left: Fresco in the upper loggia of the Pleasure Casino showing a figure
with the heraldic lily of the Farnese family.

REPRESENTATION OF THE ORIGINAL PROJECT FOR THE UPPER GARDEN IN A FRESCO IN THE LOGGIA
OF THE PLEASURE CASINO. NEITHER THE ROOF TERRACE OF THE CASINO NOR THE AREA BEHIND
THE PERGOLA WERE EVER CONSTRUCTED. EVEN THE PLAN OF THE LOWER SECTION SEEMS TO DIFFER
FROM THE FINAL SOLUTION.

FRESCO IN THE UPPER LOGGIA OF THE PLEASURE CASINO SHOWING THE FARNESE
COAT OF ARMS INCORPORATED WITH THE EMBLEM OF AUSTRIA-BURGUNDY.

ABOVE AND RIGHT: BASKET-CARRYING HERMS IN THE SIDE TERRACES
OF THE PLEASURE CASINO.

Overleaf: Pleasure
Casino (designed by
G. A. Garzoni).

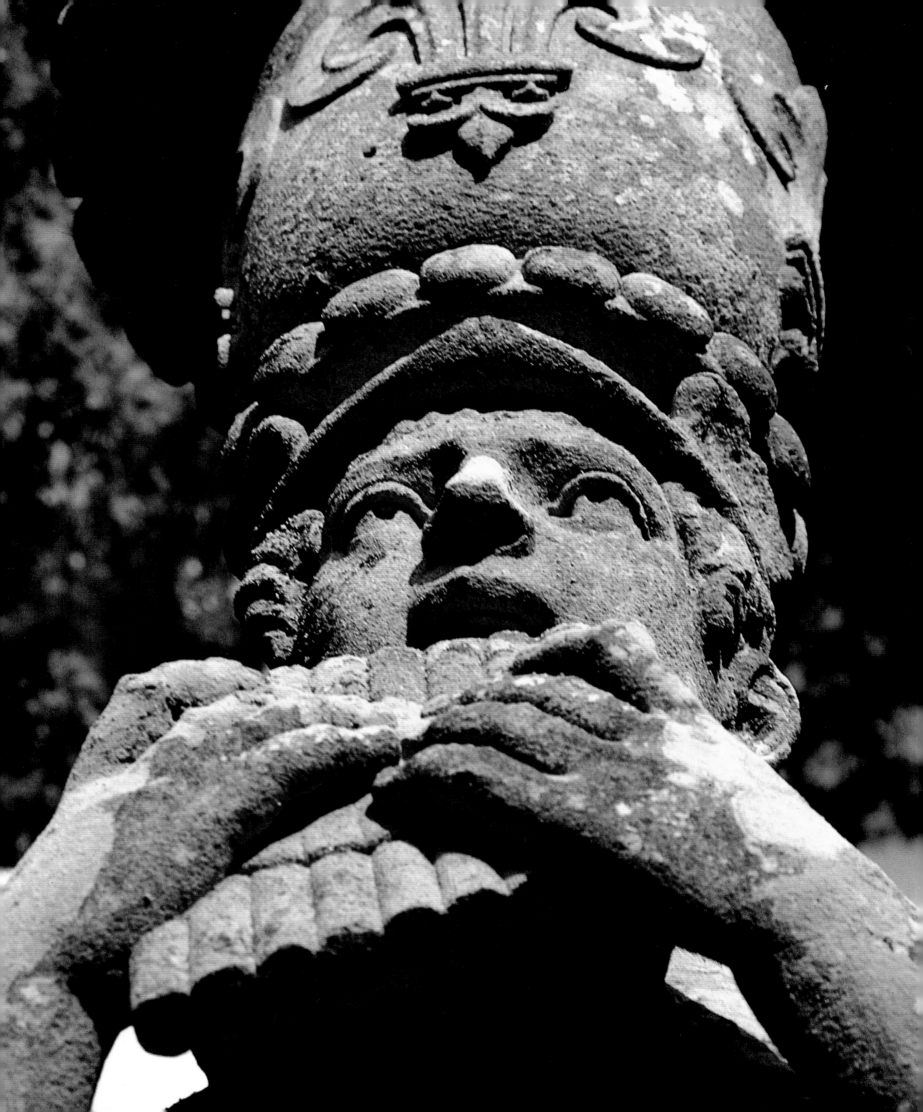

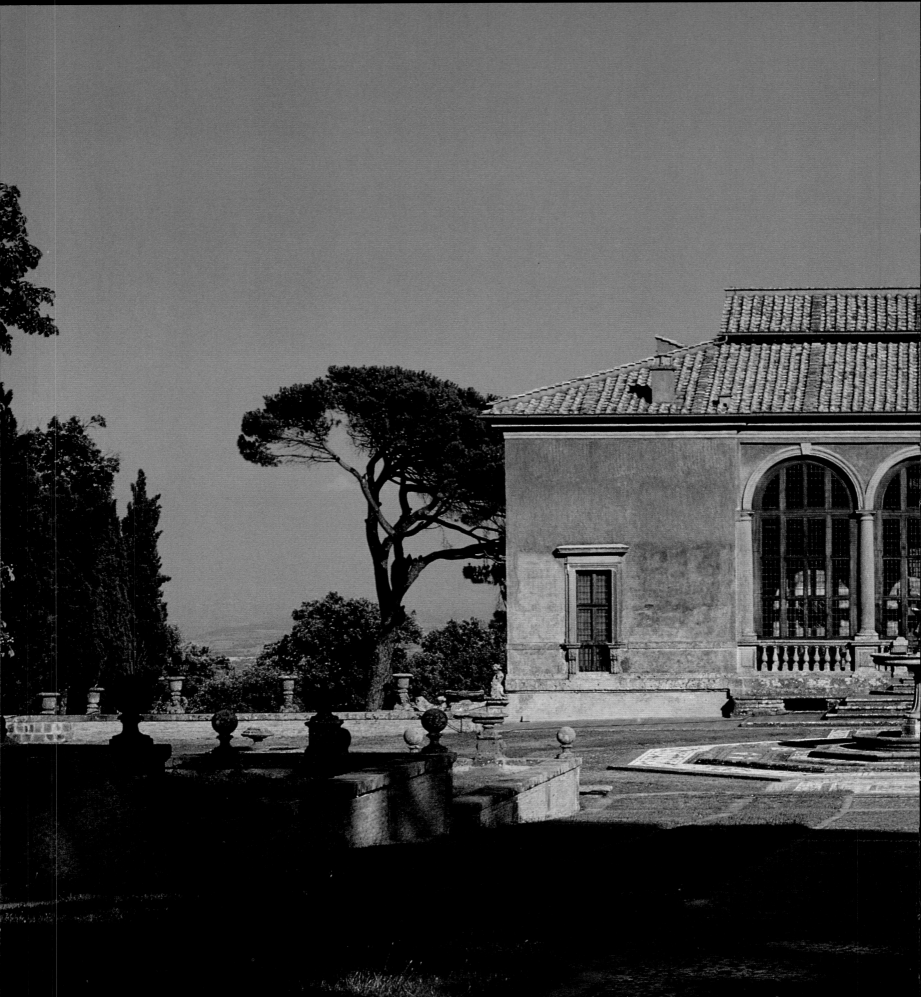

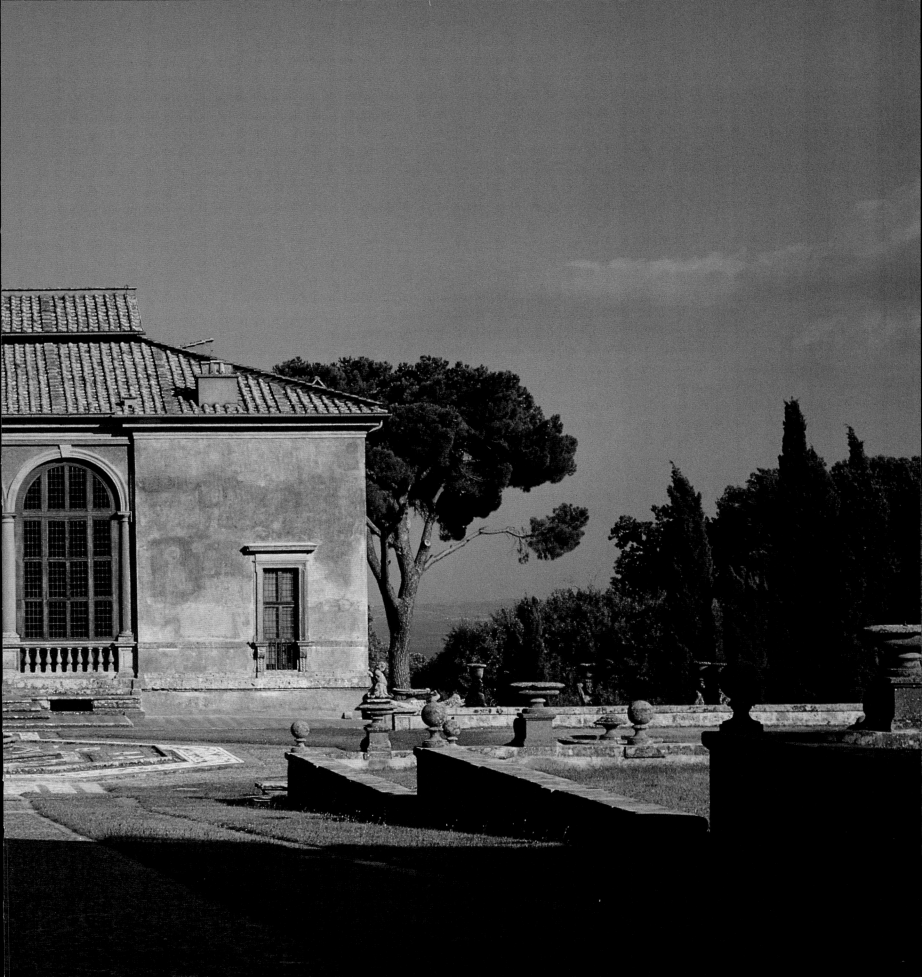

Since 1202 the town of Bagnaia has been designated the summer residence for the bishops of Viterbo. In 1514 Cardinal Riario established there a hunting park with a casino south of the fortress; his successor, Cardinal Nicolò Ridolfi, built an aqueduct to feed the park's fountains. The transformation of the villa was initiated by Cardinal Giovan Francesco Gambara (1533–87). Related to the Farnese family through his mother, Cardinal Gambara could count on Vignola's advice regarding the plan of the villa while the architect was working for Cardinal Alessandro Farnese at Caprarola (it was he, in fact, who allowed Vignola to work temporarily at Bagnaia in 1568). Vignola—if he was in fact responsible for the extraordinary design of the geometric garden—laid out an ideal north-south axis, beginning from the tower of the fortress, that functioned both as a kind of watershed and as a border dividing the "savage" nature of the original park and the "artificial" nature of the new one. This axis leads to the lower entrance of the villa, which leads to the garden's side entrance, still in use today.

VILLA LANTE · Bagnaia

The most important building projects were not begun until around 1574 under the direction of the architect Tommaso Ghinucci. By the time of Pope Gregory XIII's official visit in 1578, the construction work was quite advanced, enabling the pope to visit the entire garden. The journey started from the top, as at Villa d'Este, to render the visit less strenuous. Thus, the descending path also coincided with the true meaning of the waterway, which began from the Fountain of the Deluge, a nymphaeum-like structure where water gushed out of a mask. On both sides of the nymphaeum were small temples, or Case delle Muse (Houses of the Muses), which set forth the garden's bipolar theme—a theme that gradually discloses itself along the entire axis of the garden with the duplication of structures: the *uccellerie* (aviaries), the small villas that almost resemble stage sets framing the "scene" of the upper garden, the Fountain of the Cavea, the Fountain of the Giants, and the *catena d'acqua* (water chain).

West of the path is the Palazzina Gambara, completed in 1578, with painted interiors that include depictions of the most important villas of Lazio. To the east is the Palazzina Montalto built by Cardinal Alessandro Peretti Montalto, who also named the Fountain of the Moors, dominating the center of the lower garden. This fountain-island, resembling the fishponds at Villa d'Este, can be considered a true prototype for the water architecture of seventeenth-century gardens; it emulated three features of antiquity: the *aviarium*, or Varro's aviary, the maritime theater of Hadrian's Villa, and the naumachia (at the center of each of the four fishponds are *navicelle*, or barques, from which harquebusiers shoot their water-loaded weapons).

Several interpretations have been proposed for the fountains and the symbolic elements of this villa. C. Lazzaro has proposed an allegory of human progress from the golden age to the iron age to civilization. I have suggested, instead, a compendium of the four elements: water (deluge, dolphins, coral, sirens, and the heraldic *gamberi*), air (aviaries), earth (Mount Parnassus with Pegasus and the Muses), and fire (Fountain of the Lanterns).

The villa is now named after the Lante della Rovere family, in whose possession it remained for three centuries (1656–1933) before its transfer to the Italian government.

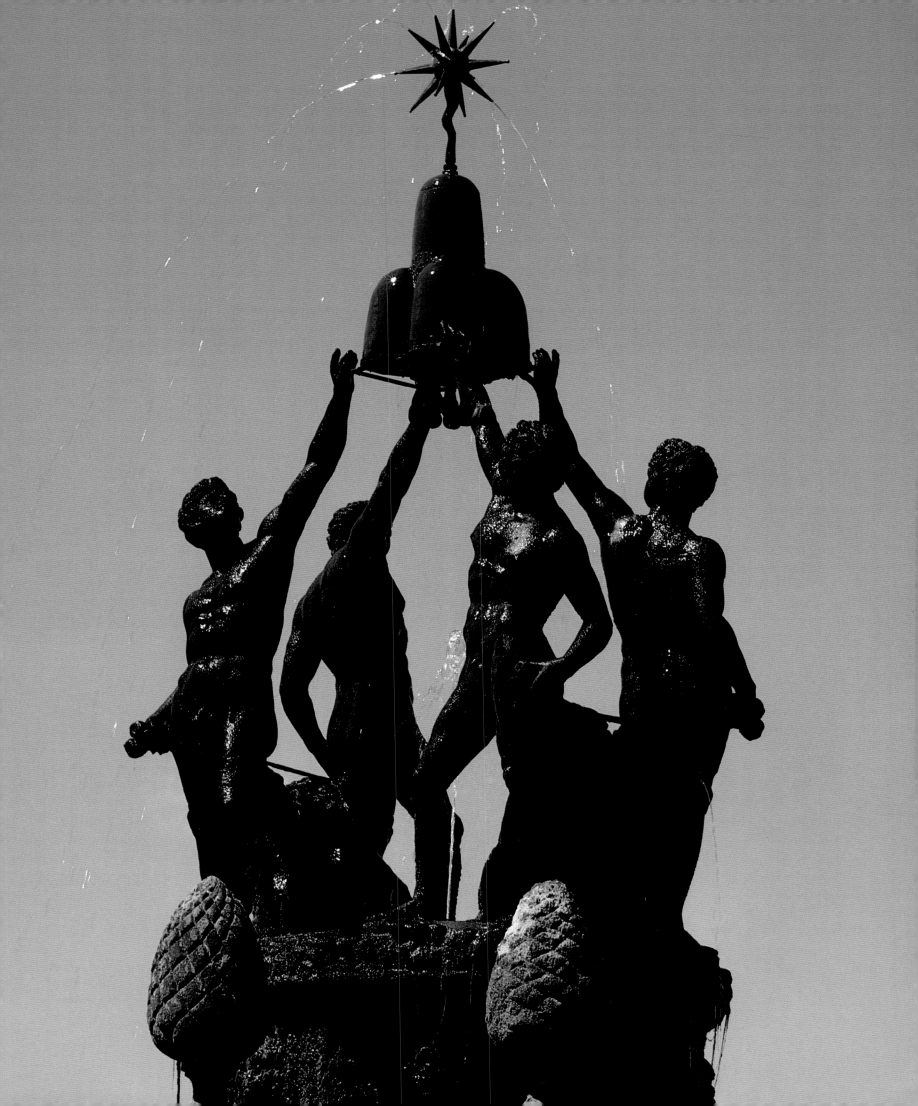

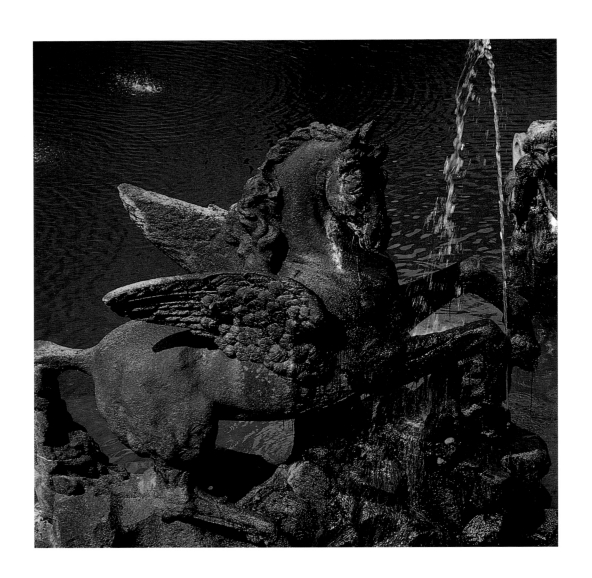

ABOVE AND RIGHT: FOUNTAIN OF PEGASUS AND OF THE MUSES IN THE BARCO.
THE WINGED HORSE METAPHORICALLY SPOUTS THE WATER OF POETRY.

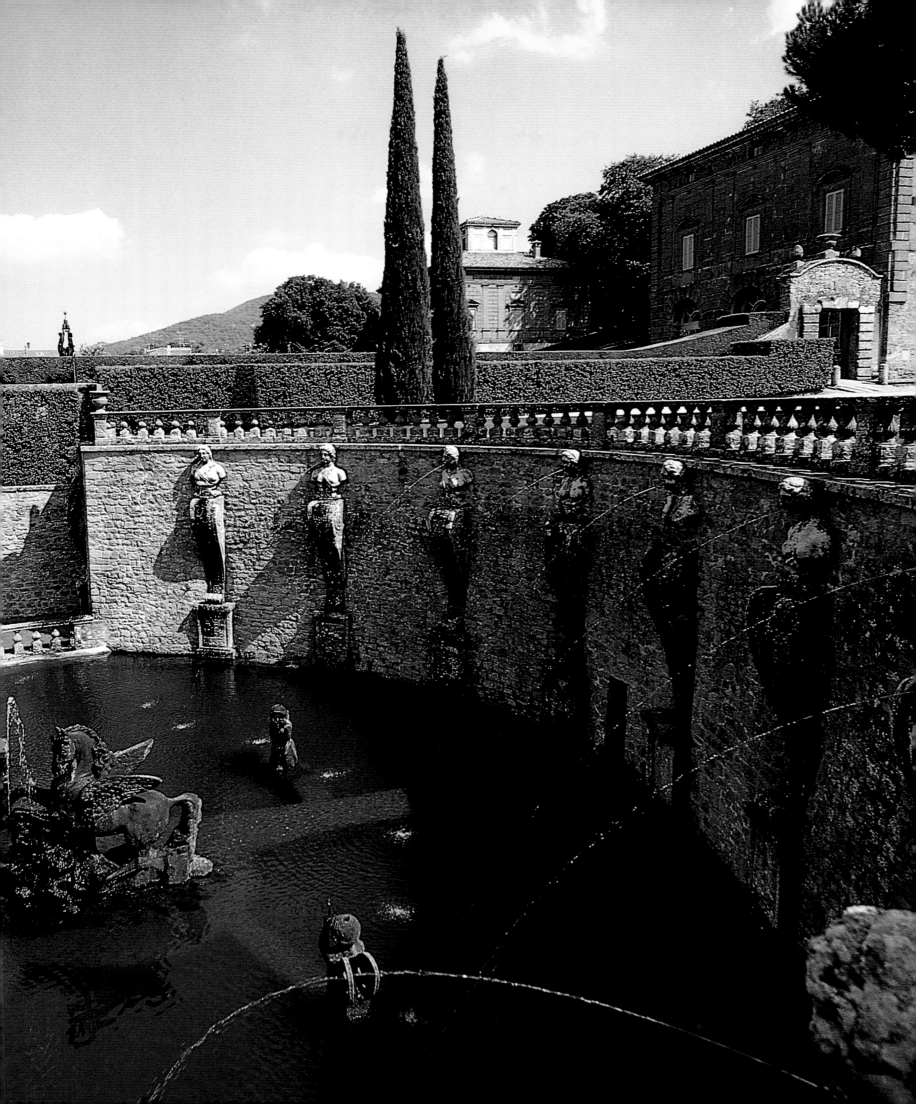

Detail of a Fresco in the loggia of Palazzina Montalto
showing an illusionistic birdcage (by Agostino Tassi).

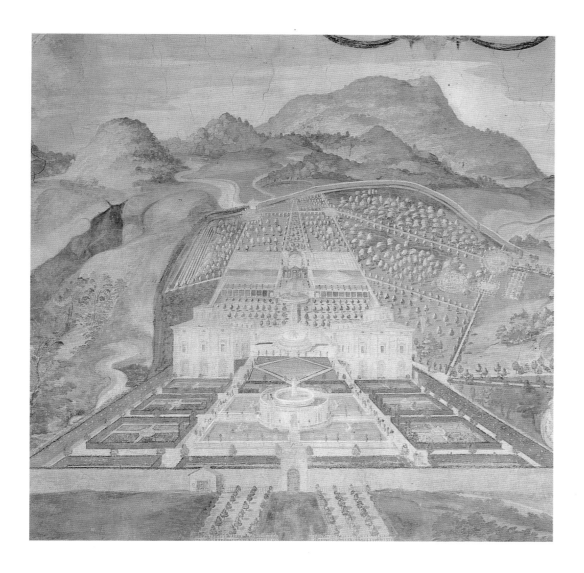

FRESCO IN THE LOGGIA OF PALAZZINA GAMBARA WITH
A SIXTEENTH-CENTURY VIEW OF THE VILLA. THE ORIGINAL POSITION
OF THE FOUNTAIN OF THE MOORS SHOULD BE NOTED.

Overleaf: Fountain
of the Moors in
the upper garden.
The Moors hold the
heraldic emblems of
Alessandro Peretti
Montalto.

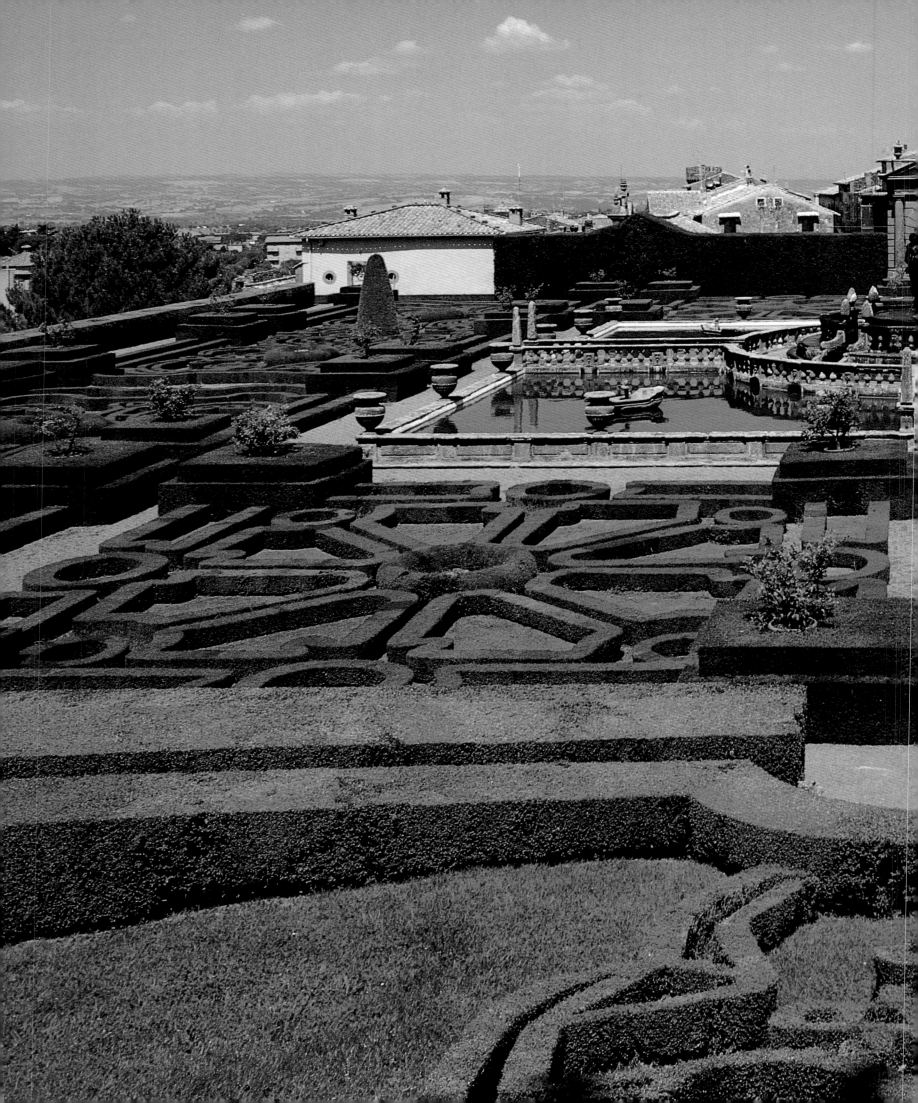

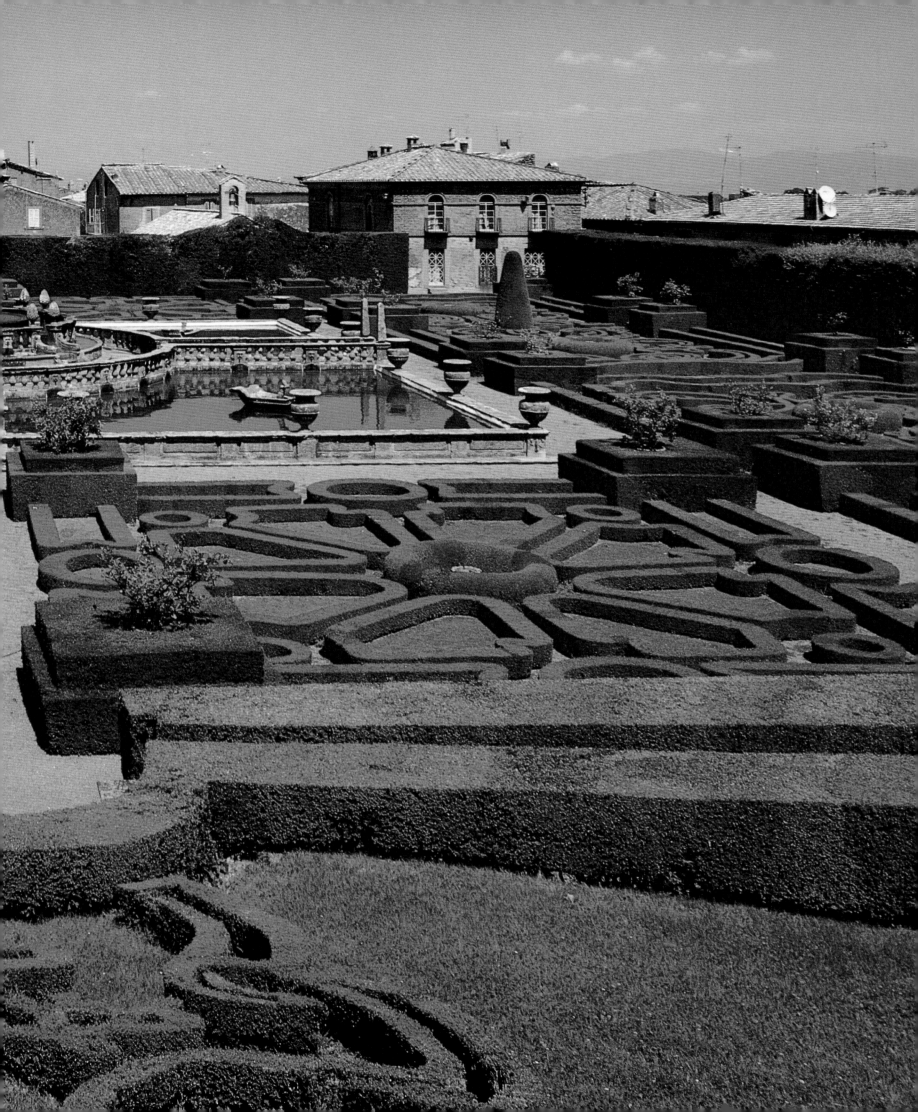

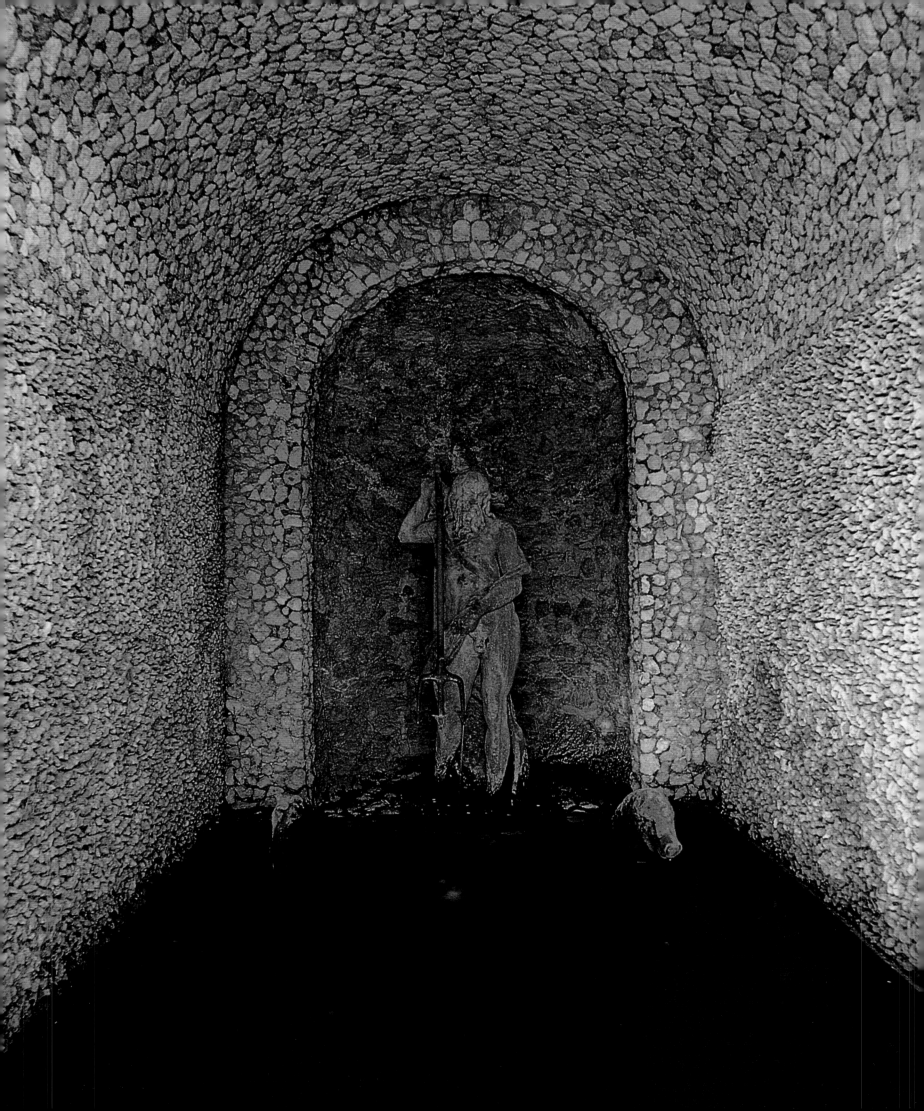

ABOVE AND LEFT: SMALL GROTTOES OF NEPTUNE AND VENUS, IN FRONT
OF THE TWIN *PALAZZINE*.

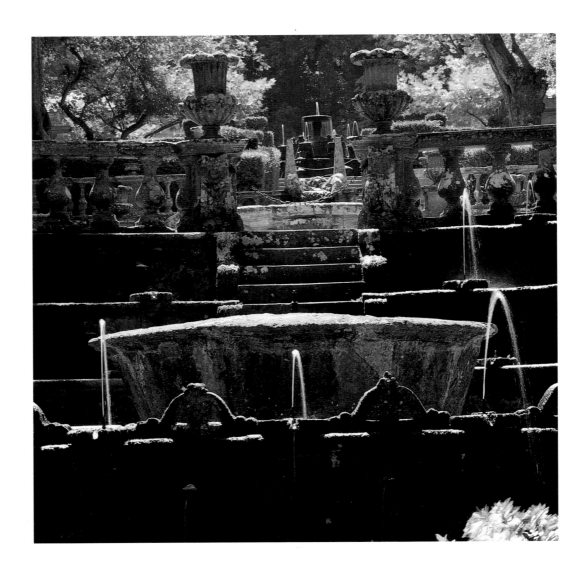

ABOVE: FOUNTAIN OF THE CAVEA OR THE LANTERNS, WITH THE FOUNTAIN
OF THE RIVERS IN THE BACKGROUND.

RIGHT: ONE OF THE TWO COLOSSAL STATUES OF THE TIBER AND THE ARNO
IN THE FOUNTAIN OF THE RIVERS.

Overleaf: The Table
of the Cardinal, with
flowing water in the
center.

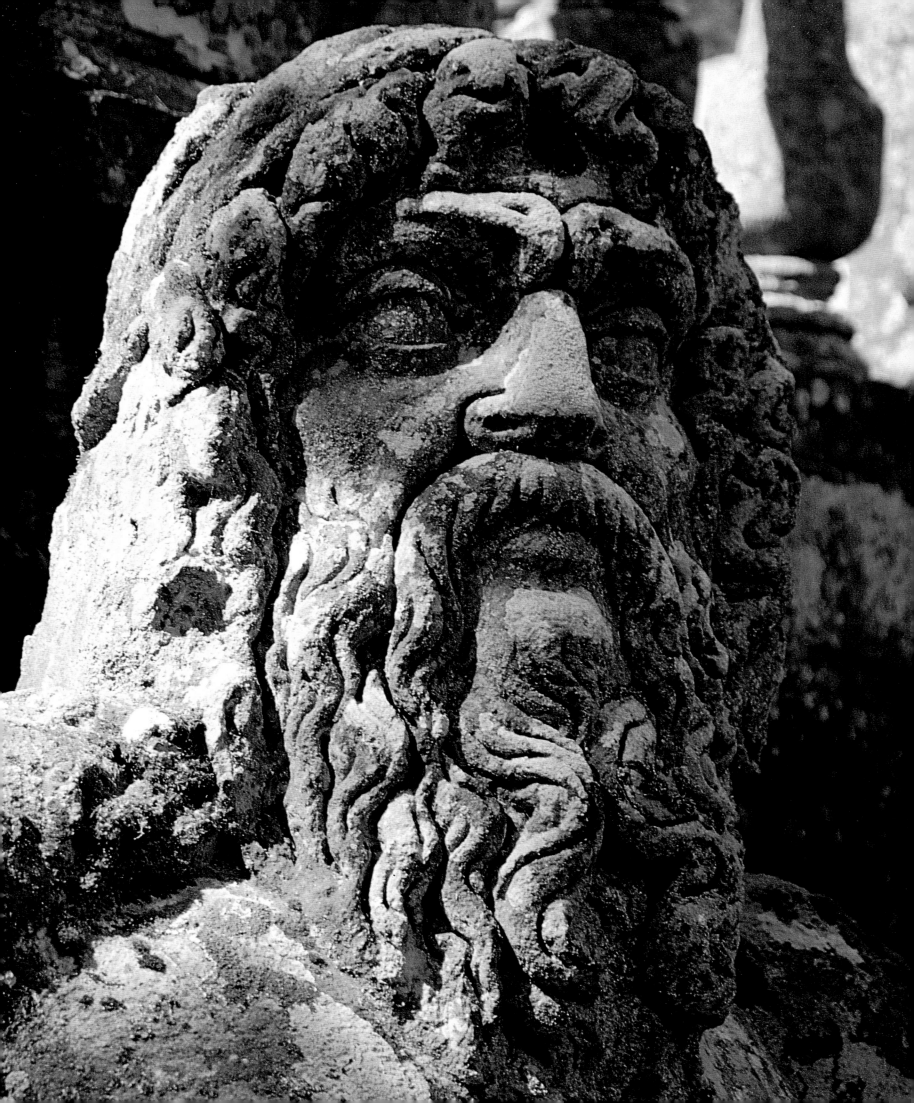

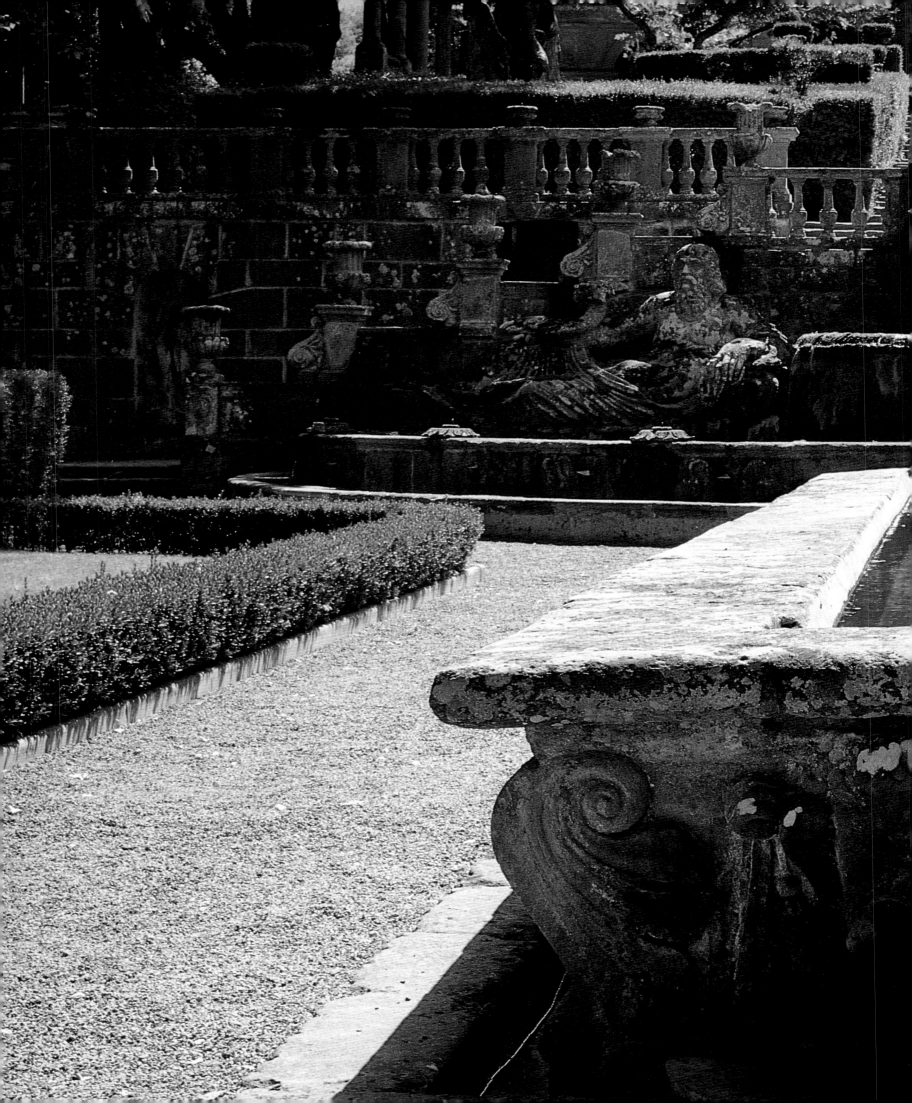

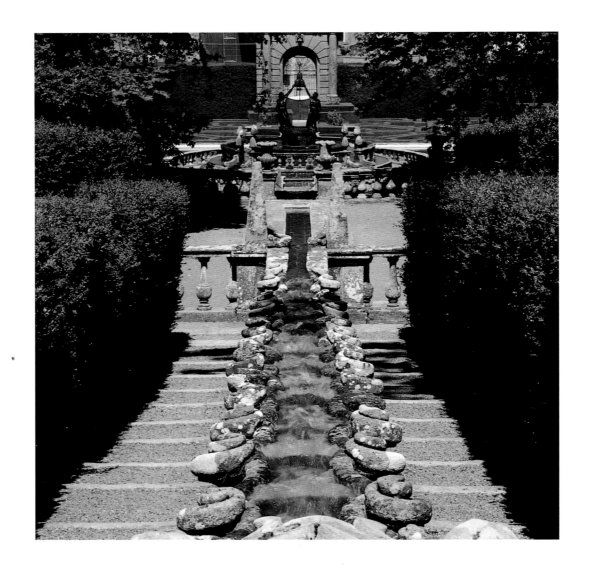

ABOVE: THE WATERWAY, WITH A SERIES OF WATERFALLS IN THE FOREGROUND (THE CHAIN
OF BIOMORPHIC VOLUTES ALLUDES TO THE HERALDIC CRAYFISH OF THE GAMBARA FAMILY),
THE TABLE OF THE CARDINALS, AND THE FOUNTAIN OF THE MOORS IN THE BACKGROUND.

RIGHT: THE GROTESQUE MASK IN THE FOUNTAIN OF THE DELUGE, FROM WHICH GUSH ALL
THE WATERS IN THE GEOMETRIC GARDEN.

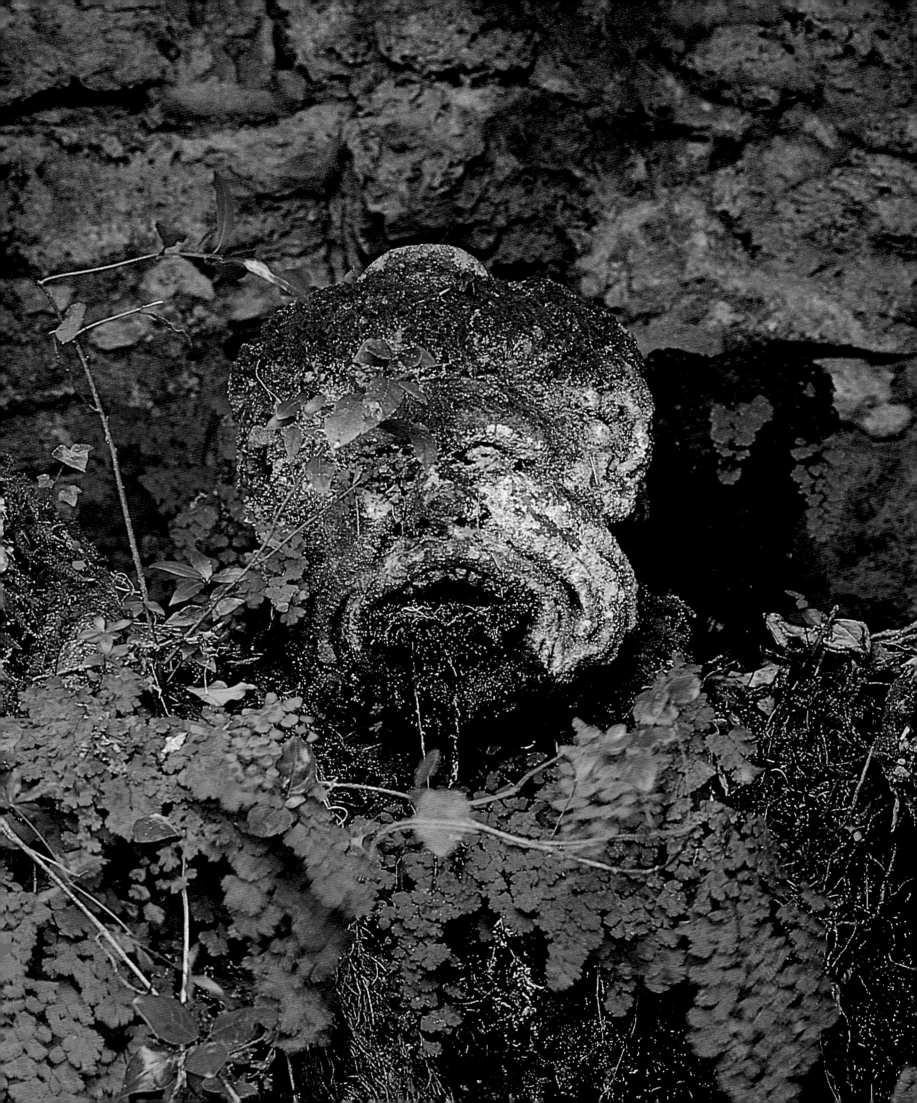

The construction of the Park of the Monsters, which occurred in four different and almost contrasting periods (H. Bredekamp, 1985, 1989), occupied almost the whole life of its patron and creator, Vicino Orsini. The first period (1548–52) included the works for the theater with concave and convex tiers (the Theater of Love, as designated by Darnall and Weil, 1984), while works of the second (1558–64) include the piazza in front of it and its axial aquatic system (the artificial lake, the Fountain of Pegasus, the fountain with the barque, and the fishpond). During the third period (after 1564), the upper levels, with the Piazza of the Giant Vases, the Piazza of Persephone, and the Tempietto, were built. Finally, in the next decade, perhaps continuing until 1580, the majority of the "monsters" were erected, which Vicino Orsini had brightly polychromed in the last years of his life.

The tour of the garden commences at an entrance gate flanked by two sphinxes, symbolizing enigma. The inscriptions at their bases allude to the magic of the site, suspended somewhere between *inganno* (deceit) and *maraviglia* (marvel). (It was hoped that the Sacro Bosco would rival the seven wonders of the world.) Abstruse meanings lie behind the numerous other inscriptions in the park, and the sculptures dispersed there, because of their terrifying and colossal appearance, seem to reside in a world outside classical tradition (one that inspired such figures as Demeter, Psyche, Persephone, Neptune, and others), sometimes originating in mythologies of distant times and places. The Egyptian world is evoked (the sphinx, Isis, Amon), as is the Etruscan or pseudo-Etruscan (Janus and the fake Etruscan tomb), the Oriental (dragon and elephant), and even the Aztec (the mask with the globe and coat of arms of the Orsini family). The garden appears to be a great composition immersed (and sometimes directly

sculpted) in nature, almost a sequence of gigantic cryptic emblems, with its marriage of images and words. This is precisely the extremely curious sphere of an aristocrat who translated into images the atmospheres of ancient fables and chivalric poetry and who appropriated and corrupted the citations of poets such as Dante, Petrarch, Ariosto, and Tasso.

The first feature encountered is the Leaning House, dedicated to Orsini's friend Cardinal Madruzzo (paradoxically, the house was an emblem of quiet and prudence rather than instability). Then the Theater of Love, with the inscription "Sol per sfogar il core" ("just to pour out one's heart"), introduces the garden as a metaphor for poetry (the Fountain of Pegasus is an allusion to Mount Parnassus). The poetic world experienced is that of the chivalric epic of Roland (by Boiardo and Ariosto), and to a smaller extent that of Francesco Colonna's *Hypnerotomachia Polyphili*; this is confirmed by the giant Roland, who dismembers the Amazon, by the presence of many "horrible faces, elephants, lions, bears, ogres, and dragons," or by the enchanted forest that "resembles only itself and nothing else at all" (according to an epigraph), producing only gigantic magic and petrified fruits (pine nuts and acorns, typically Mediterranean symbols of the Bosco Sacro). Finally, there are also two apparent symbols of death: the Tempietto-Mausoleum (dedicated to the death-rebirth-apotheosis of Orsini's wife, Giulia Farnese) and the Bocca dell'Inferno (Mouth of Hell), the grotesque mask that, once entered, is revealed to be a convivial prank: inside is a dining room that, in light of the inscription on the outside, "Lasciate ogni pensiero o voi ch'entrate" ("Abandon every thought, o ye who enter"), paraphrases and undramatizes the famous line from Dante's *Inferno*.

Left: Colossal vase and mask with globe and Orsini coat of arms (Albertina).

Right: Head of a faun (or satyr).

VILLA ORSINI

•

Bomarzo

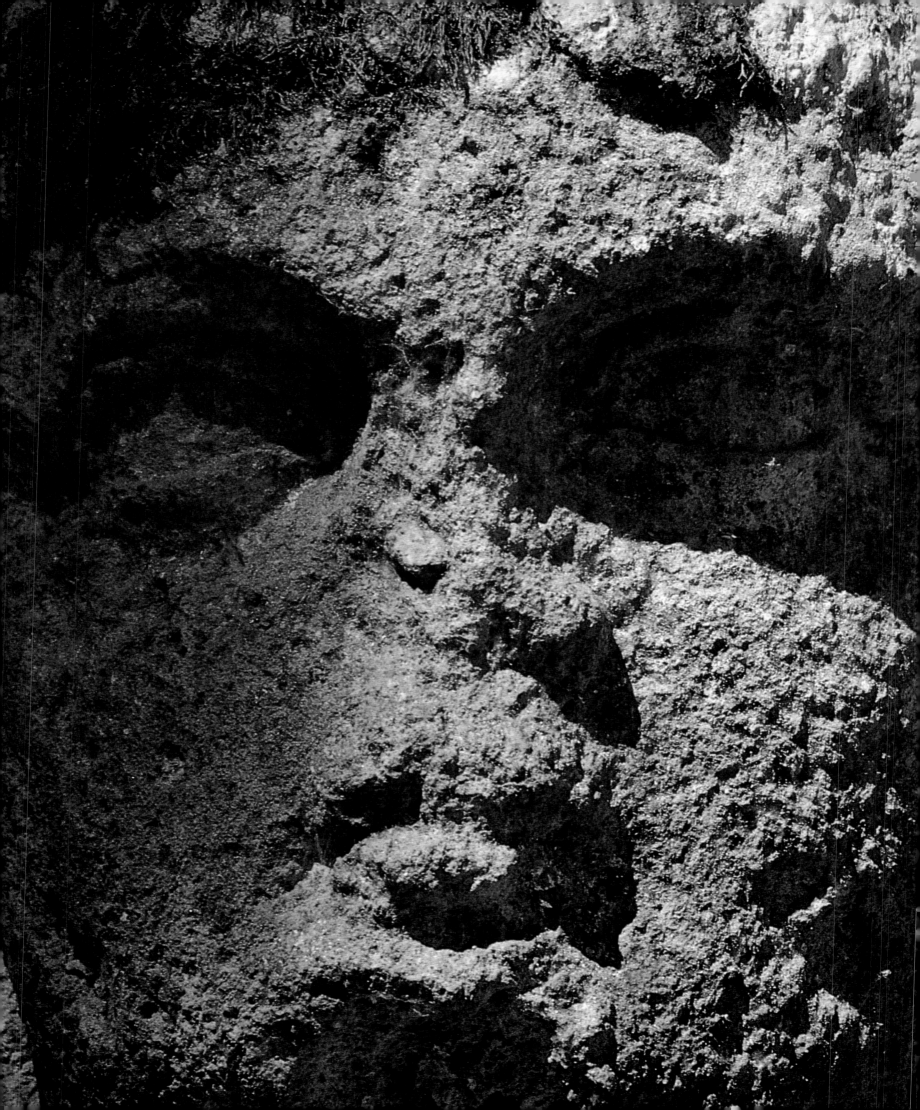

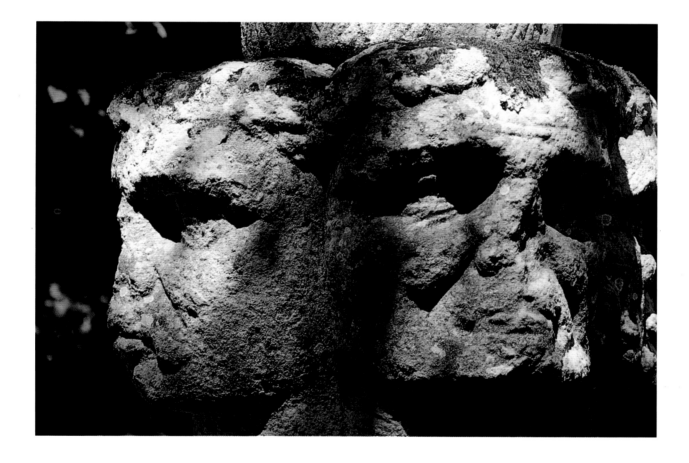

ABOVE: FOUR-HEADED BASKET-CARRYING HERM.

LEFT: HEAD OF PERSEPHONE.

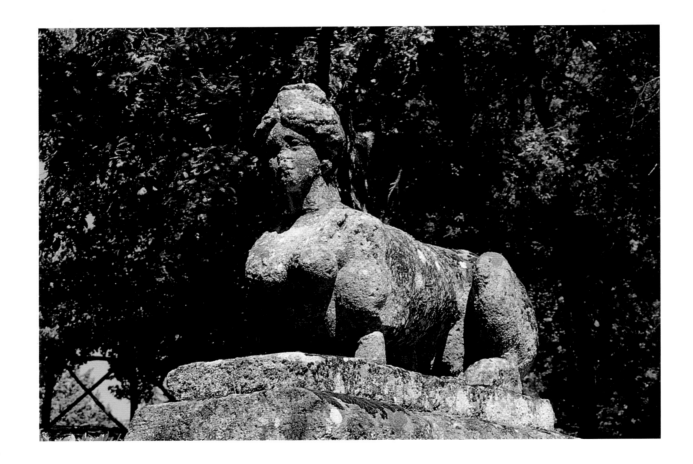

Above: One of the two sphinxes guarding the entrance.

Right: Aztec mask with globe and coat of arms of the Orsini family.

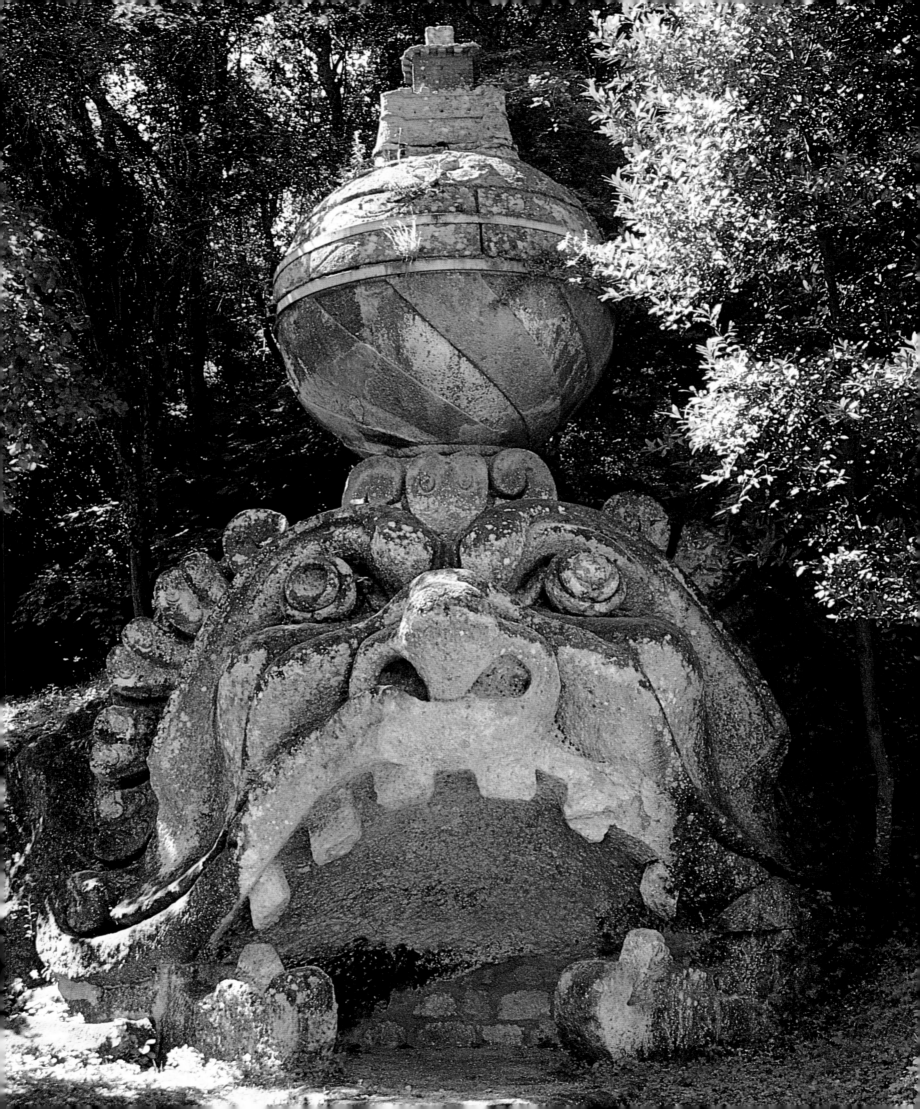

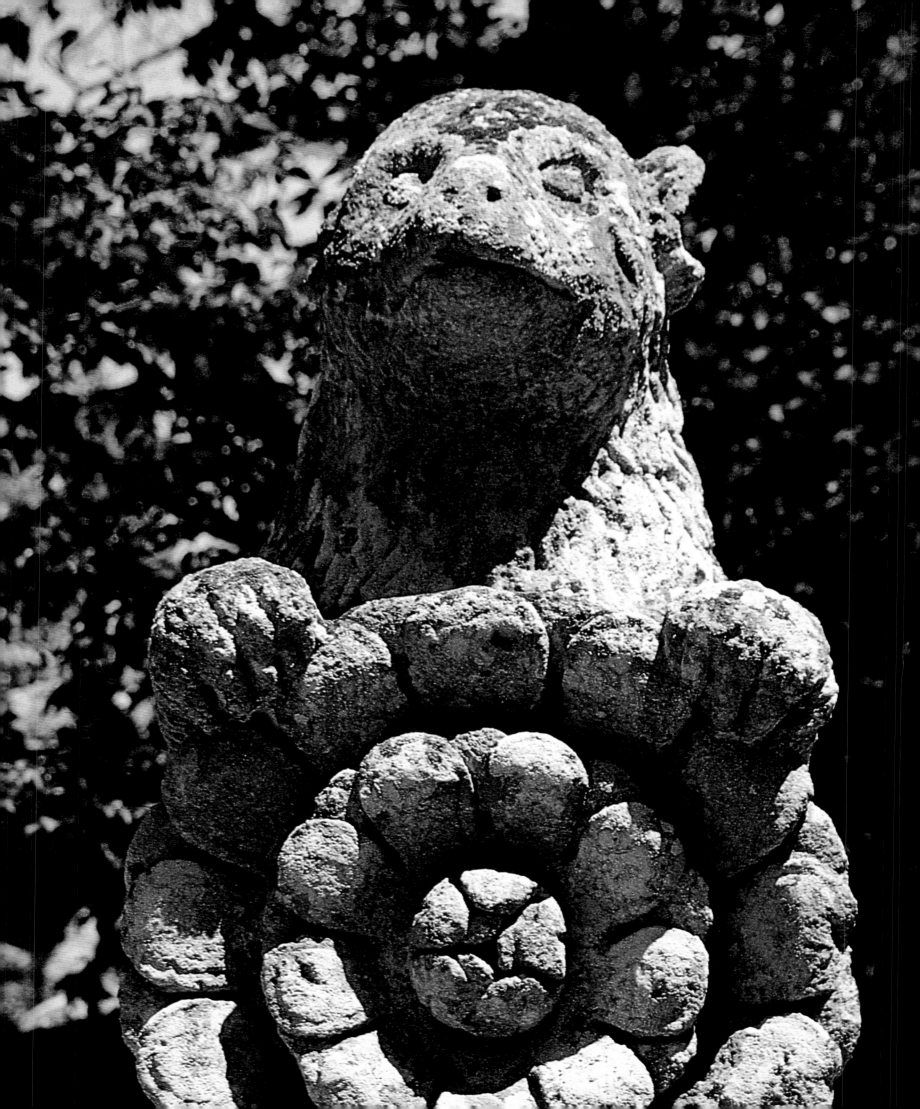

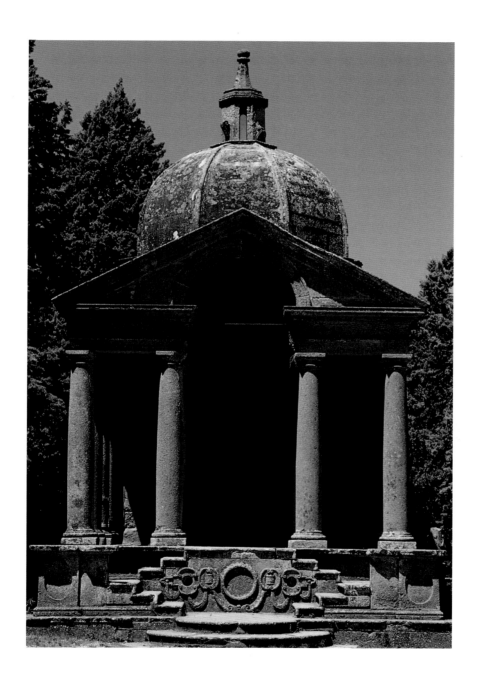

ABOVE: The temple in memory of Giulia Farnese.

LEFT: Heraldic bear with the Rose of the Orsini family.

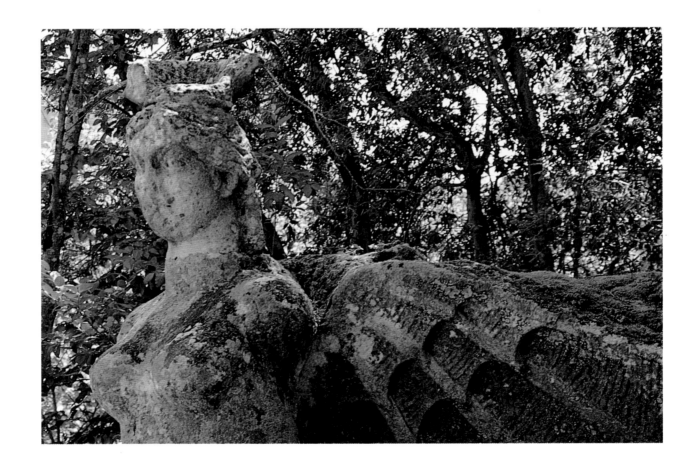

ABOVE: HARPY WITH BAT WINGS.

RIGHT: PERSEPHONE.

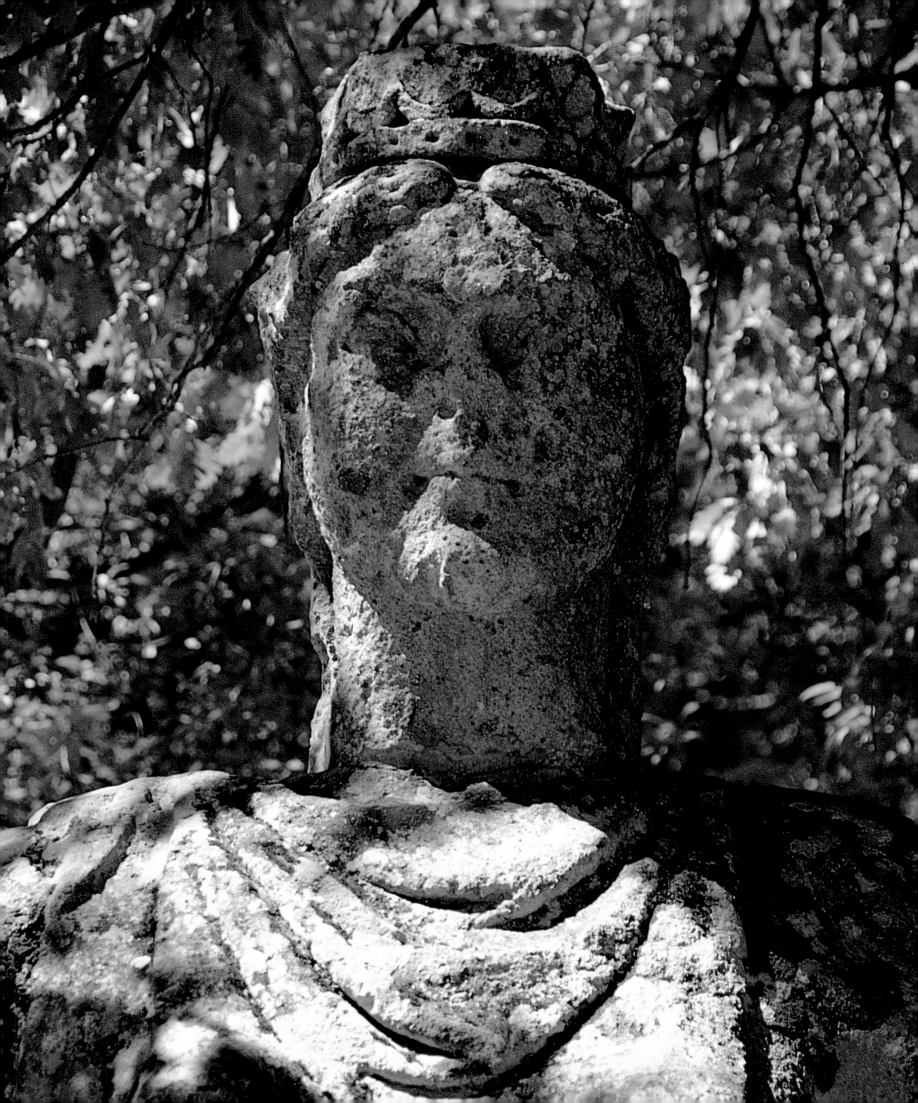

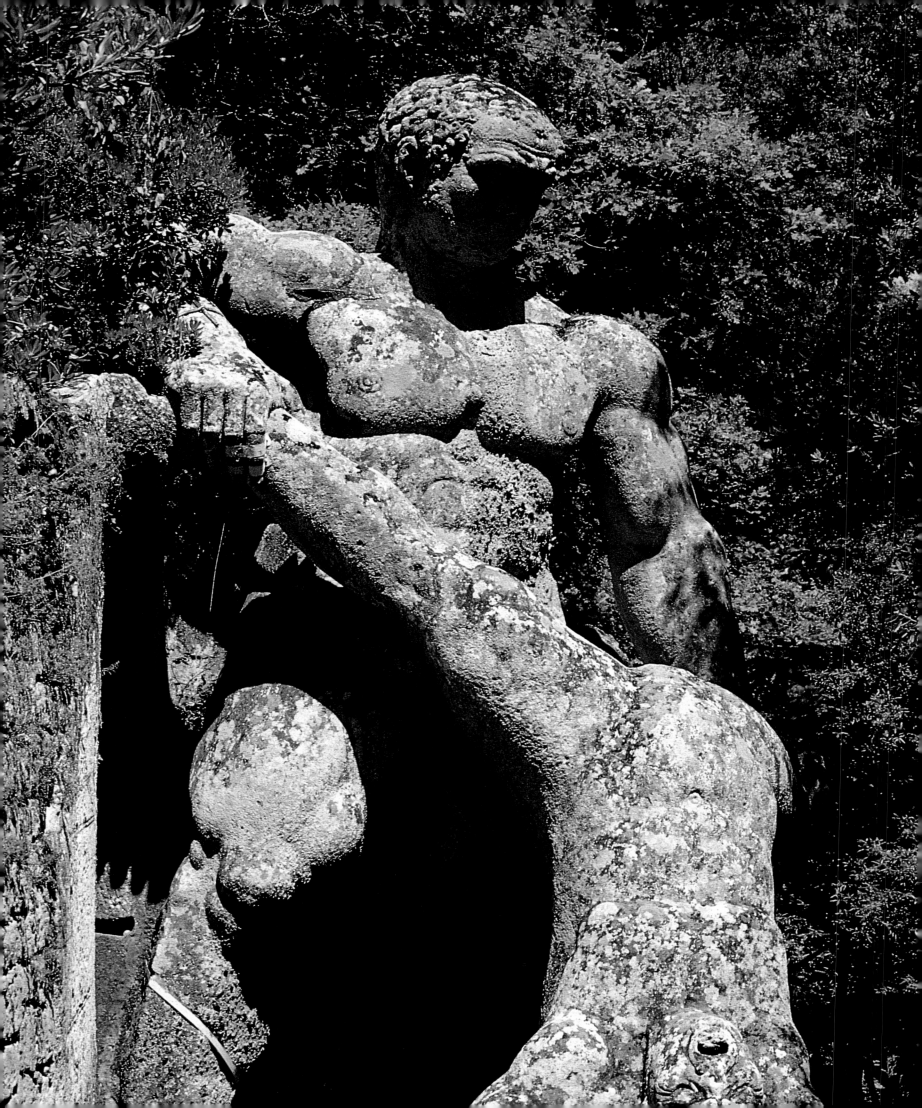

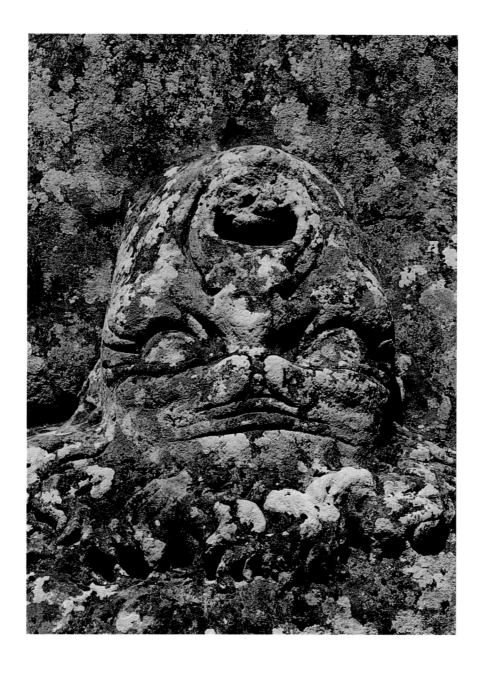

ABOVE AND LEFT: A GENERAL VIEW AND THE SCREAMING, DISMEMBERED
HEAD OF THE AMAZON IN THE MAD ROLAND SCULPTURAL GROUP.

ABOVE: THE LEANING HOUSE.

RIGHT: THE MILITARY ELEPHANT.

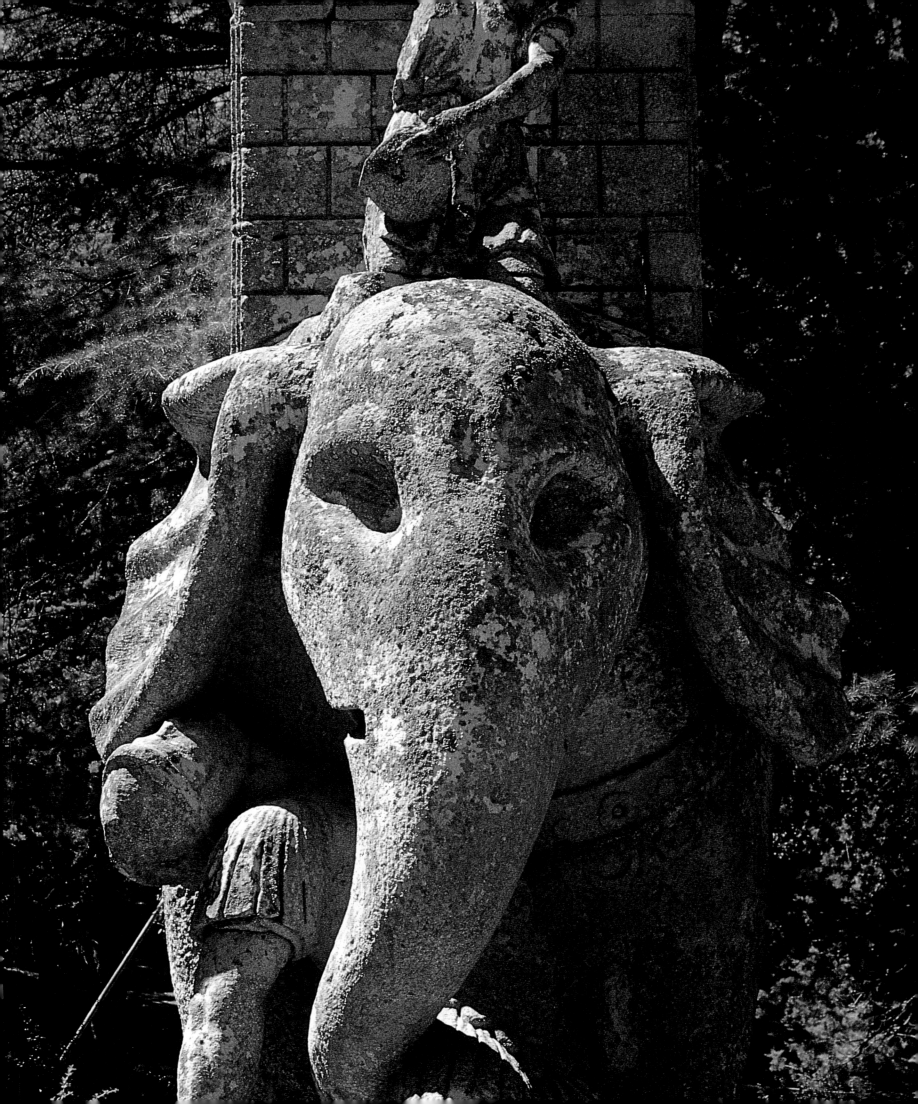

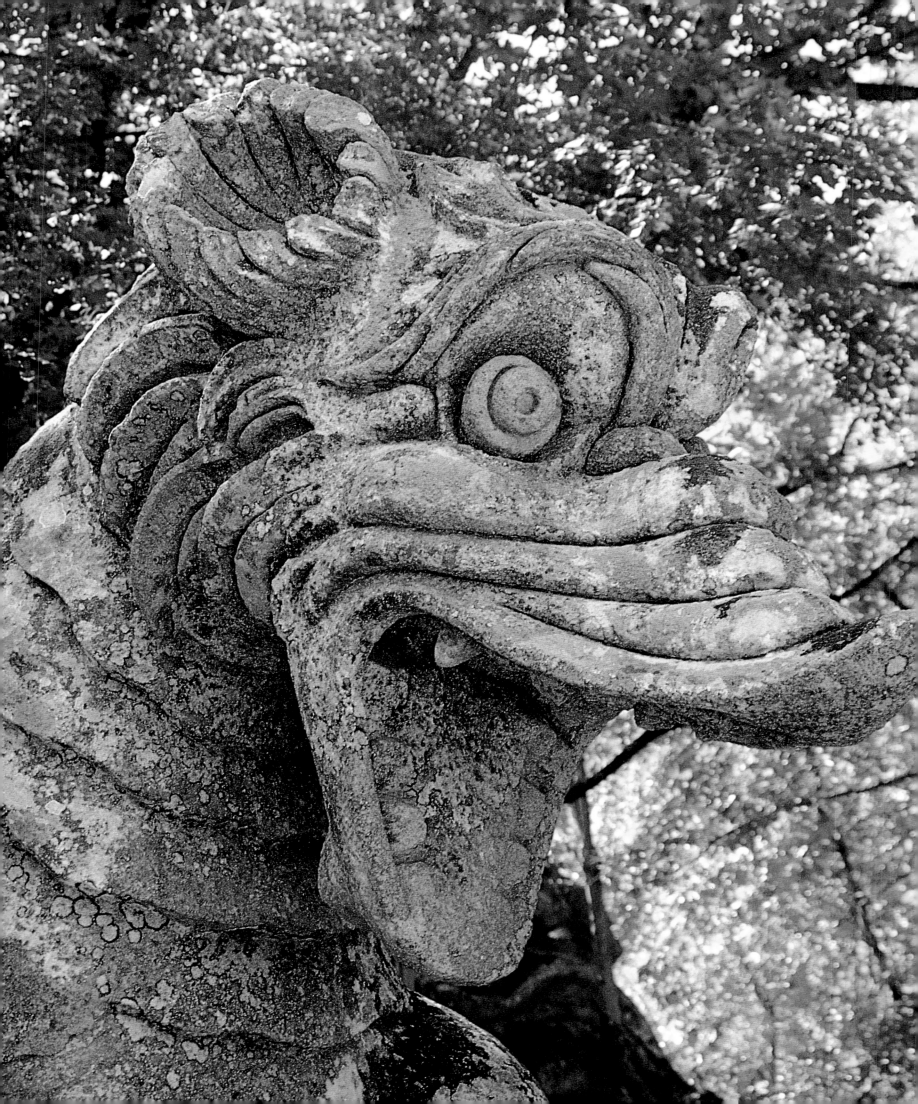

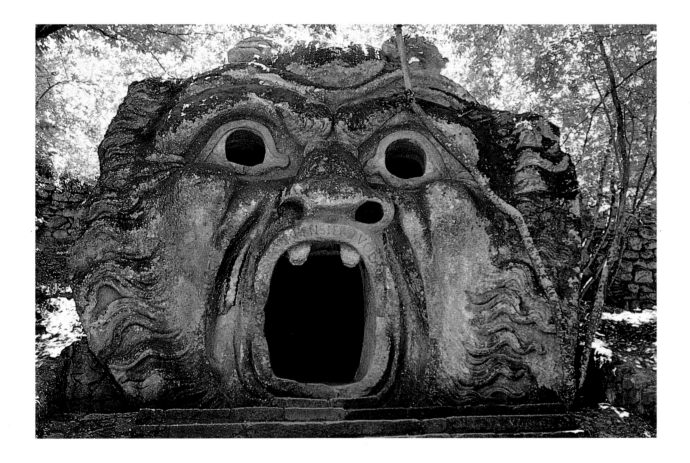

Above: The Bocca dell'Inferno (Mouth of Hell), with the ironic inscription "Lasciate ogni pensiero o voi ch'entrate" (Abandon every thought, o ye who enter).

Left: The dragon battling the lion.

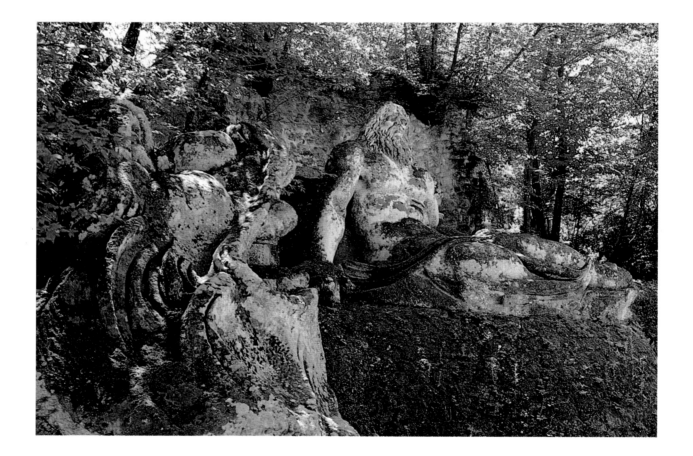

ABOVE: RECLINING NEPTUNE WITH SEA MONSTER IN FOREGROUND.

RIGHT: THE SEA CREATURES WITH BUTTERFLY WINGS AND THE BASKET-CARRYING
DEMETER IN THE DEMETER GROUP.

Cardinal Cristoforo Madruzzo, bishop of Trent and key figure in the Counter-Reformation council that presumably ended in 1564, purchased for his nephew Fortunato the Marquisate of Soriano in 1560–61. The first improvement at Soriano was the construction of the Fonte Papacqua at the entrance of the town, described in a letter published by J. Theurillat: "A very pure and fresh spring gushes down with a gentle murmur. It is because of this spring that this place is called Soriano and *Acqua di Papa*. It is here that the illustrious cardinal of Trent has built a fountain for his delight and leisure." The enigmatic Dionysian-satyric sculpture seems to reincarnate the mysteries of Etruria, the rule of classical antiquity, or even the fabled Arcadia. Another letter, written by the patron in 1563, introduces this kingdom that is at once solemn and playful: "Among these fauns that occupy themselves with deriving from Janus' sister [from *sor*, sister, and *ianus*], and that I am about to receive here with all sorts of reverences, with their earthly name, I urge these satyrs and this nymph to evolve from the vegetal state to a rational one. . . . Those who understand the secrets of the springs know which forms they will take."

The true meaning of the nymph and its companions remains unclear: the scene could be related to the myth of Jupiter and the goat (or nymph) Amalthea, which is

FONTE PAPACQUA

•

Soriano nel Cimino

connected with the cult of Jupiter Cimino, that is, the cult of Janus. In fact, the name "Soriano" does not derive so much from "sister of Janus" but from "Zur Jani," the rock of Janus. "The myth of Janus, god of the year, is associated with the myth of Saturn—time—who in order to escape Jupiter's revenge, hid in a cave. . . . Also, *Soranus* is a designation of Pluto, god of the underworld, and therefore these sculptural representations might allude to infernal divinities. The deep cave of the giant (Pluto) symbolizes the underworld of Hades, and the reclining nymph is Persephone, associated with the Great Mother whose tiny children are attributes of fertility" (M. Festa Milone, 1976). During the Counter Reformation, this disquieting representation of the water of mystery and of hell, suffused with fables of the underworld and chthonic myths, was counterbalanced with the water of goodness and regeneration through the nearby representation of Moses in the act of striking the rock to draw water, thereby quenching the thirst of the Jews (here employed as an allegory of the regenerative virtue of the sacrament of baptism).

Near the fountain, Cardinal Madruzzo built a casino in 1563. This was not intended as a residence, having only a few rooms enclosed between two structures designed as four-faced triumphal arches. It has been suggested that this building was also intended as a belvedere for naumachia spectacles, which took place at the end of the valley where the waters of the fountain pooled, and thus had a function analogous to Bramante's so-called Nymphaeum of Genazzano. Around 1730, the building was raised and enlarged by its new owner, Cardinal Annibale Albani, who built an Italian garden just behind the casino.

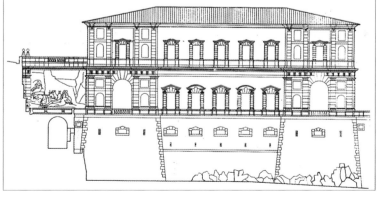

Left: Elevation of Casino Madruzzo-Albani with the Fonte Papacqua on the left (by M. Festa Milone, 1976).

Right: The giant.

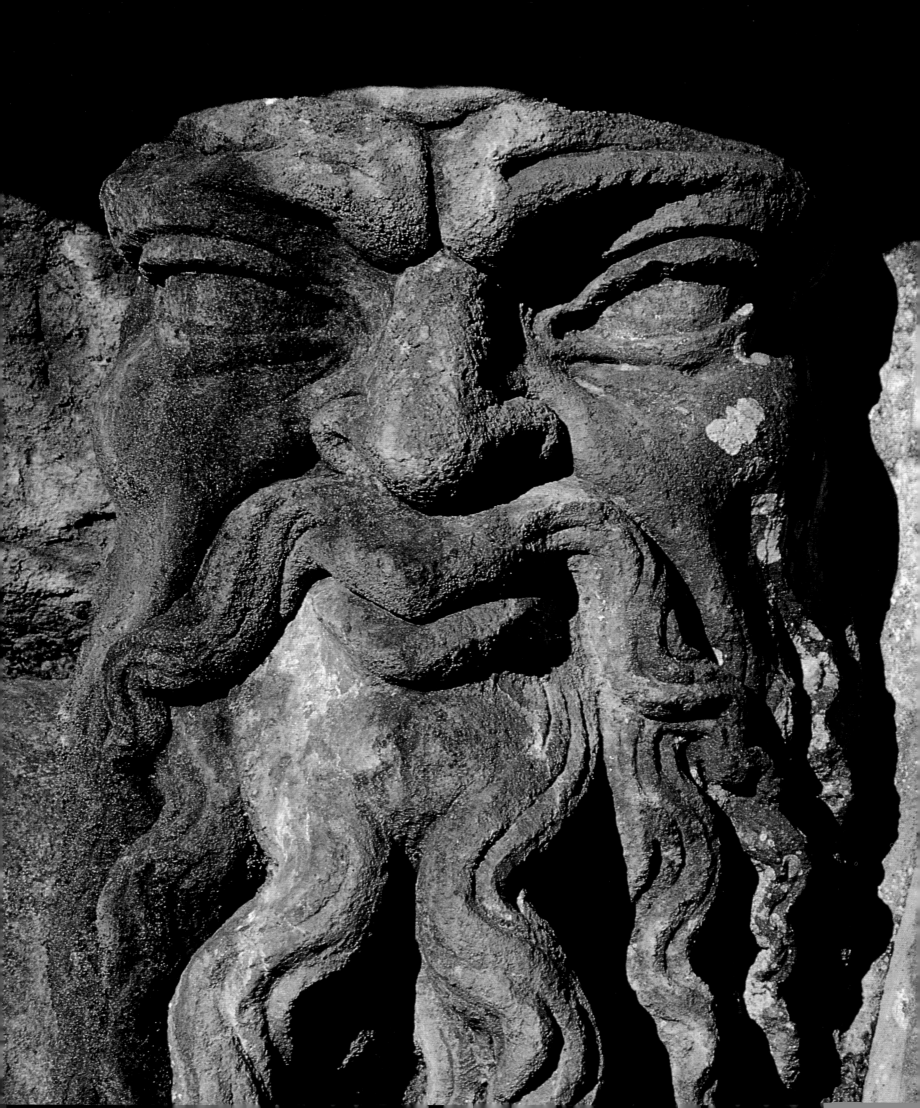

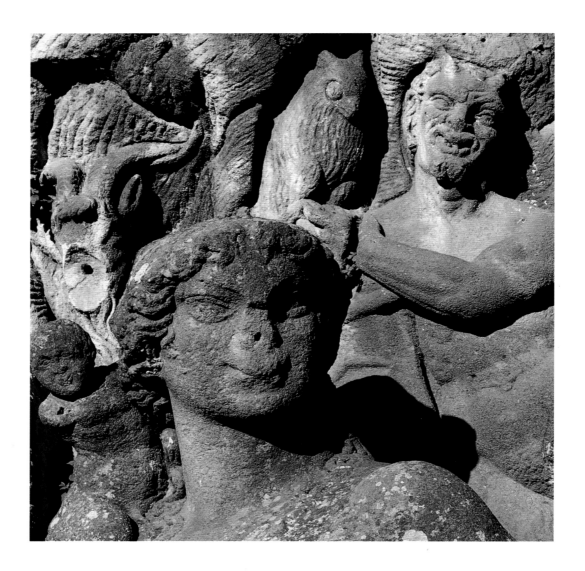

THE NYMPH AND THE SATYR.

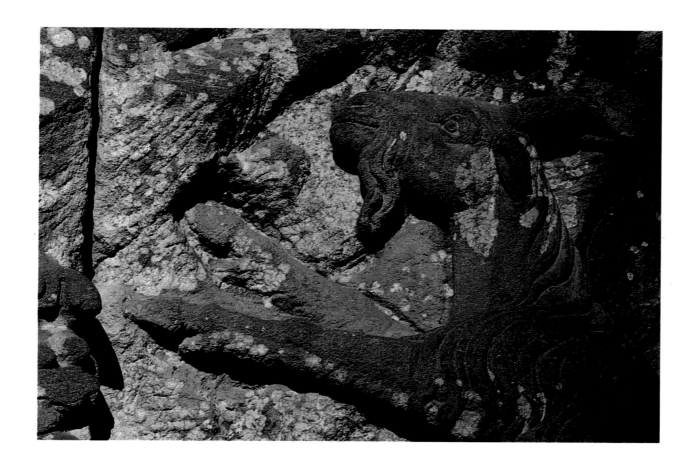

GOAT FROM THE SATYR GROUP.

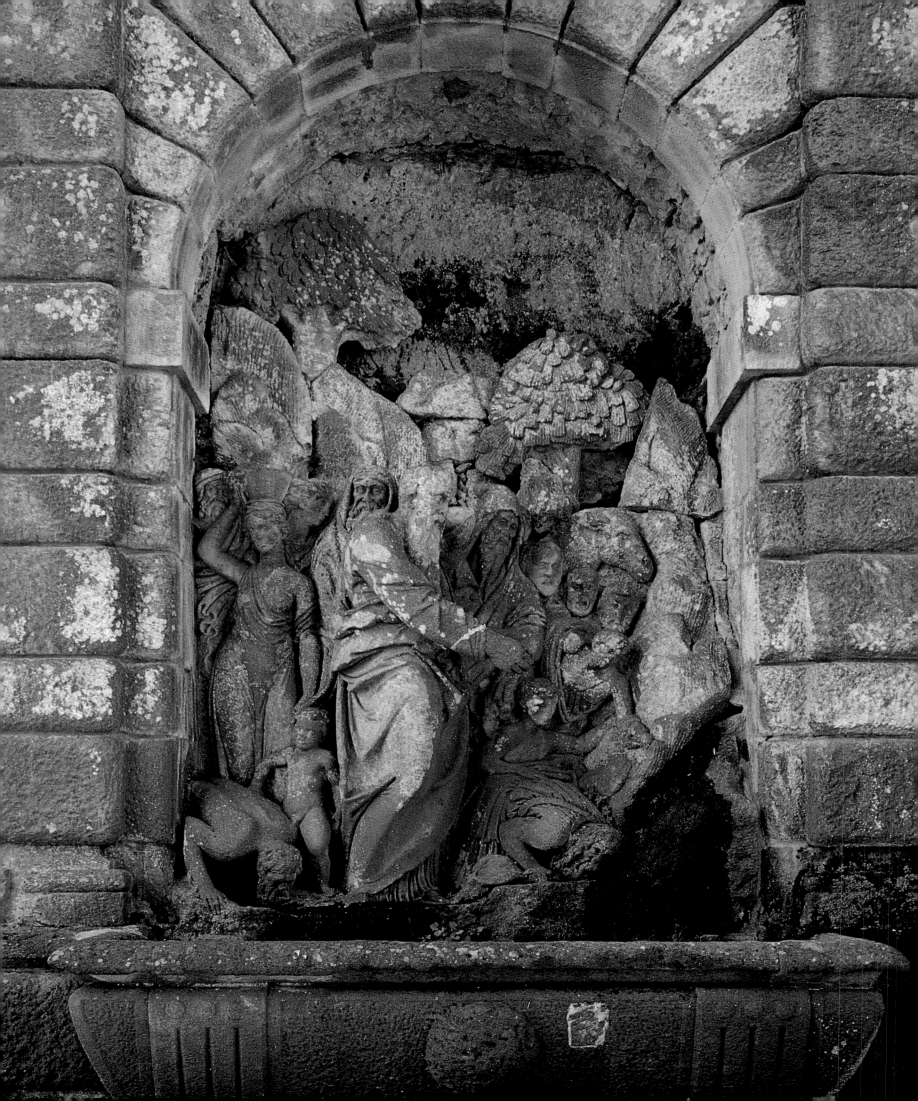

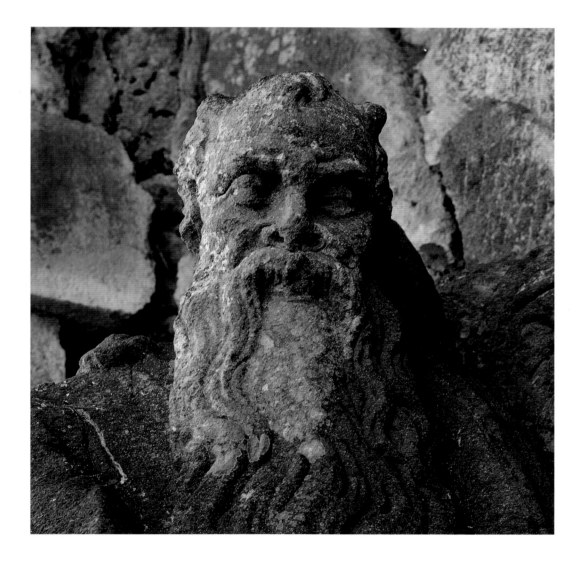

ABOVE AND LEFT: THE HEAD OF MOSES AND A GENERAL VIEW OF THE
MOSES GROUP, WITH MOSES RELEASING THE WATERS FROM THE ROCK.

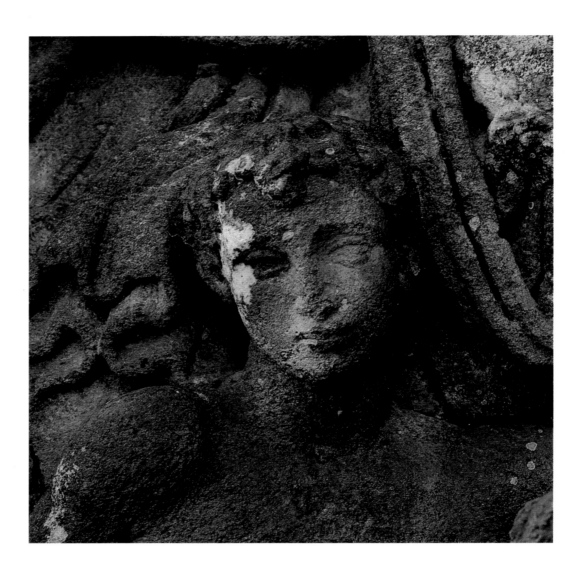

THE THIRSTY HEBREW BOY IN THE MOSES GROUP.

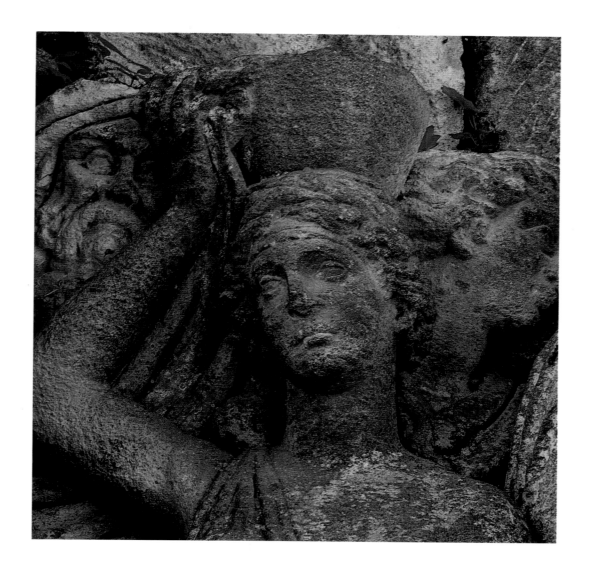

WOMAN CARRYING AN AMPHORA IN THE MOSES GROUP.

ABOVE AND LEFT: WATER SPOUTS SHAPED AS GROTESQUE MASKS.

Overleaf: General view of the two rustic groups.

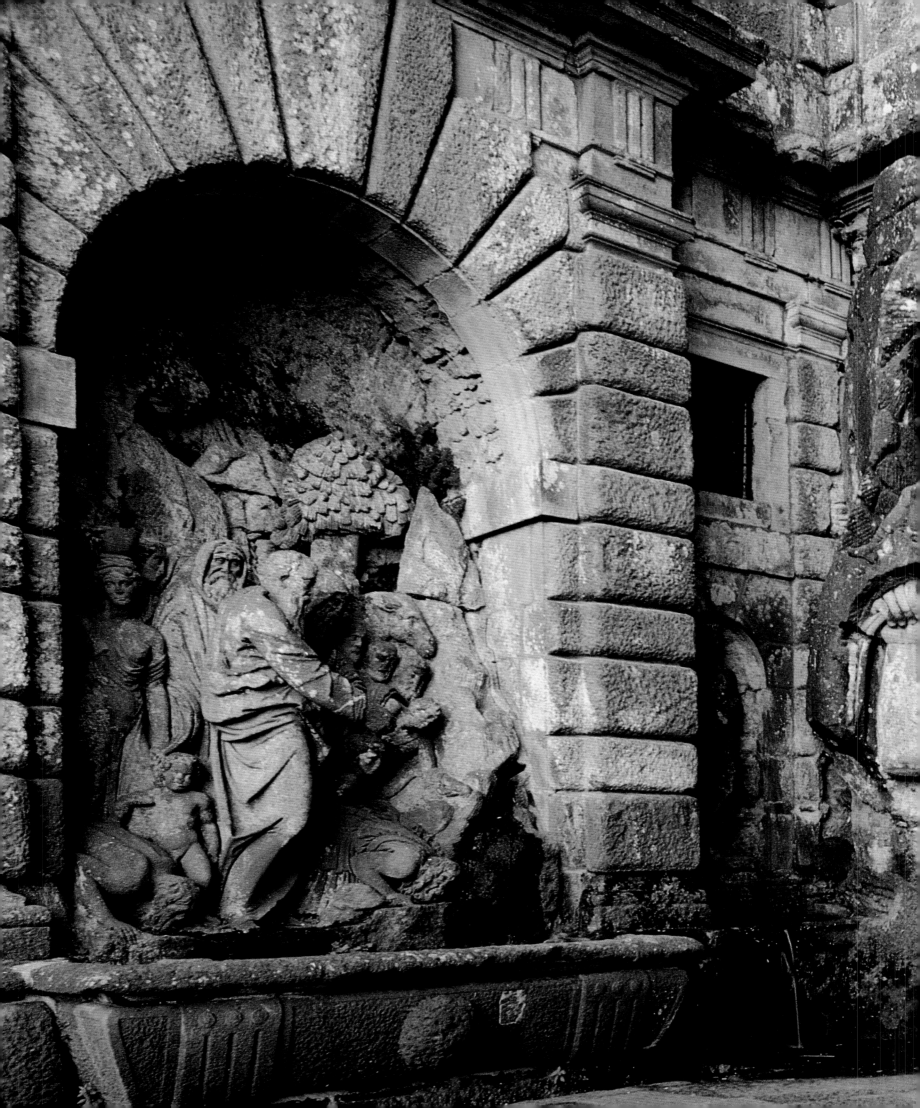

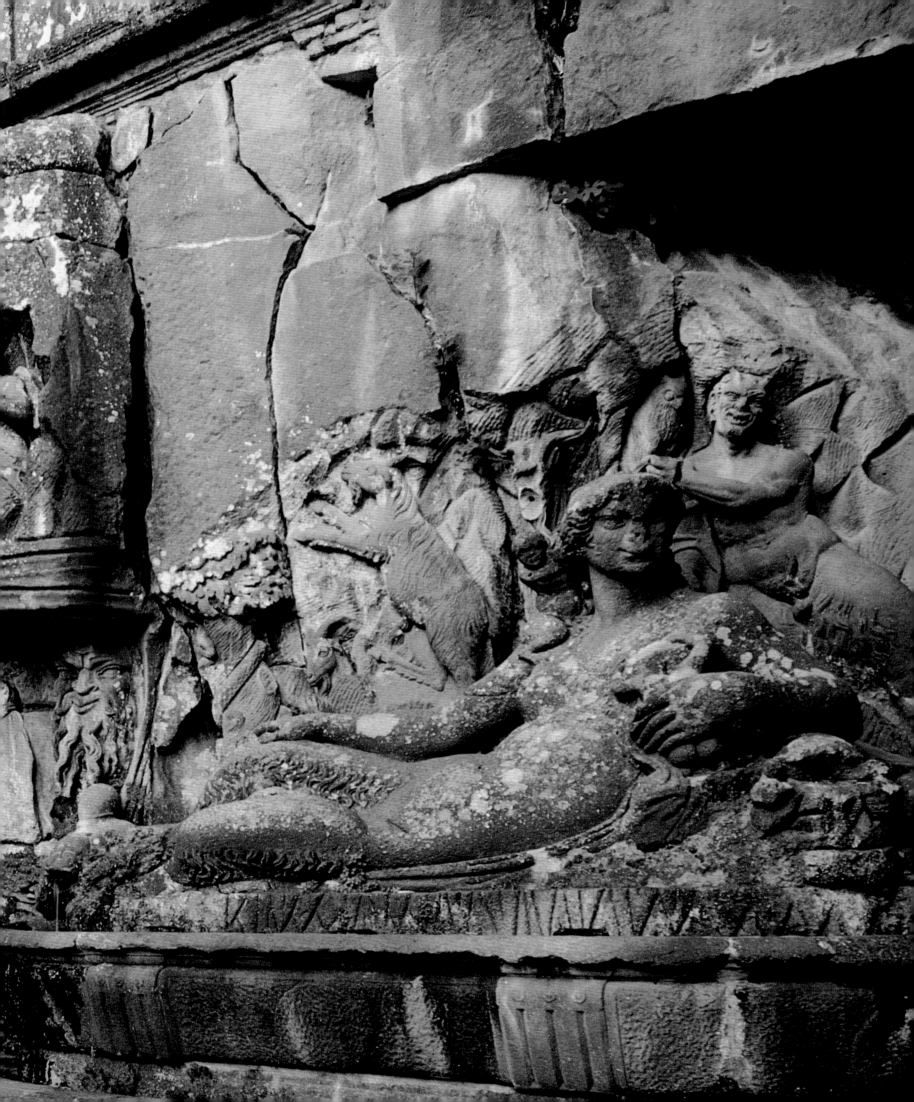

Built in the ninth century and demolished in the thirteenth, the castle at Vignanello was rebuilt in 1491, having passed through the hands of many feudal lords: the Orsini, Borgia, Farnese, Marescotti, and Ruspoli (this data, based upon new archival research, was furnished by A. Campitelli, 1989). Around 1538, perhaps based on a project by Antonio da Sangallo the Younger, Count Sforza Marescotti, husband of Ortensia Farnese, restructured the rooms, still marked with the lilies of the Farnese. His son, Alfonso Marescotti, had two apartments refurbished and a moat constructed.

But the most crucial works are attributed to Ottavia Orsini, widow of Marc'Antonio Marescotti and daughter of the famous Vicino Orsini of Bomarzo: between 1610 and 1615 the castle was connected to the east garden by a drawbridge and to the park by an elevated covered passageway. The walls of the park were constructed according to the plan of Carlo Lombardi. The walls were "ornamented with niches and other perspectival features. The flower beds were disposed according to the conventions of the traditional Italian garden, that is, following elaborate geometrical patterns. Even today the box elder tree is in the shape of the initials of Ottavia

CASTELLO RUSPOLI

•

Vignanello

and her children, Sforza Vicino and Galeazzo Marescotti. Between 1623 and 1628, new interventions were added to the garden. Along the park walls, sculpted handrails and benches carved out of rock were placed for the rest and solace of the guests. . . . At the beginning of the eighteenth century, Count Francesco Marescotti, who by that time had adopted his mother's name, Ruspoli, initiated a vast and complex urban program for the town. In 1725, Pope Benedict XIII visited it and consecrated the new church and the Molesino hamlet. The following day, after an 'abundant feast, with sweets and delicacies of ample and noble quantity, pheasants, capons, liquors, French wines, and *rosoli*,' the pope took a walk in the garden, admiring the straight pathways decorated with statues, and arrived at the fishpond and at the majestic *barco*, which was the ultimate destination after exhausting hunting excursions because of its cool shade" (A. Campitelli).

The current proprietors, Claudia and Giada Ruspoli, have carefully maintained the park's parterres, delineated by box hedges (originally sage and rosemary), in splendid condition and have opened the garden to the public.

Left: Family tree of the Marescotti-Ruspoli.

THE MARESCOTTI COAT OF ARMS IN THE PARK.

Overleaf:
The geometric
garden with
hedges in the
form of the
Ruspoli family
monogram.

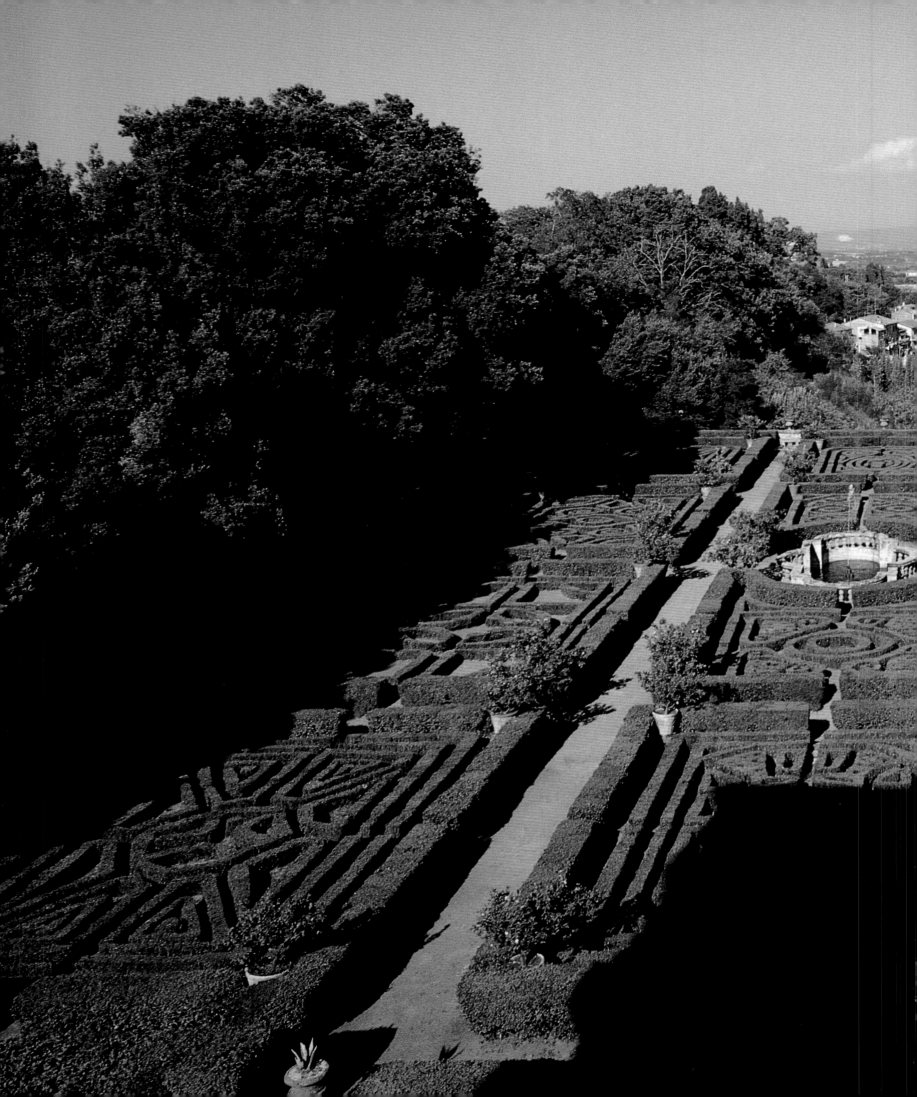

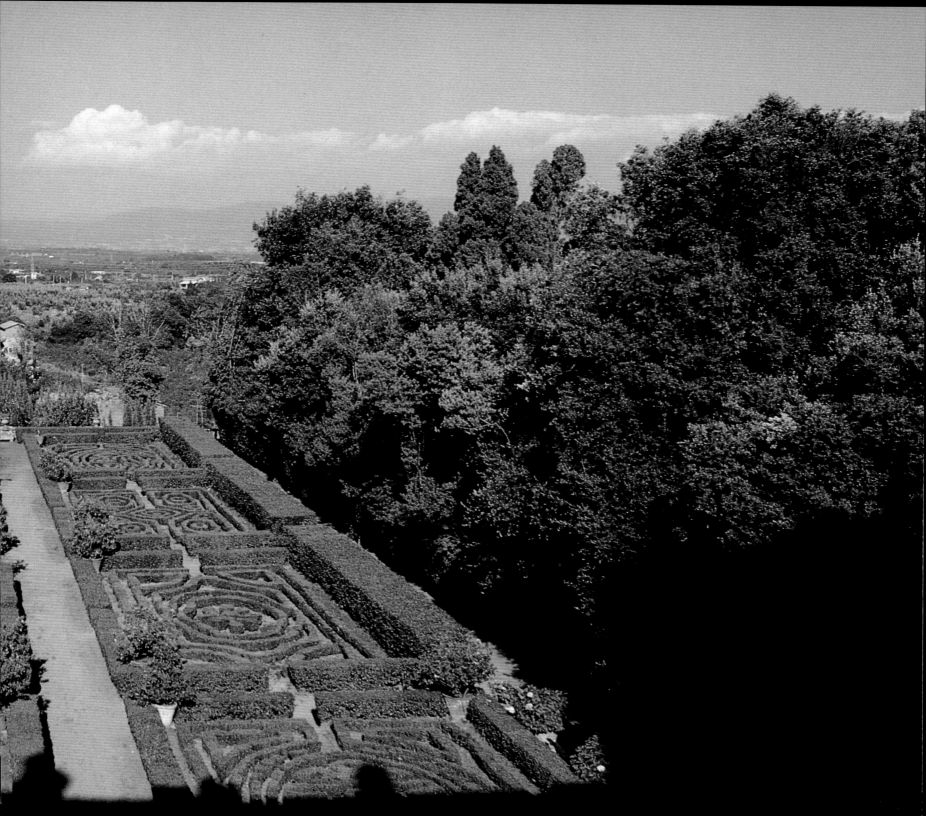

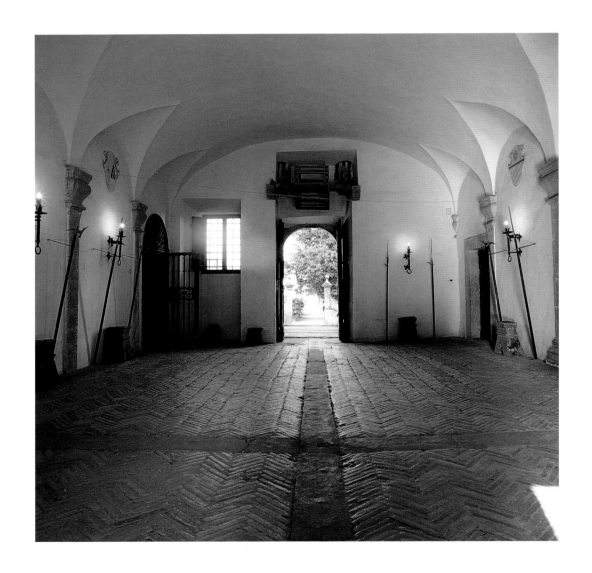

Entrance hall to the garden, with the drawbridge in the background.

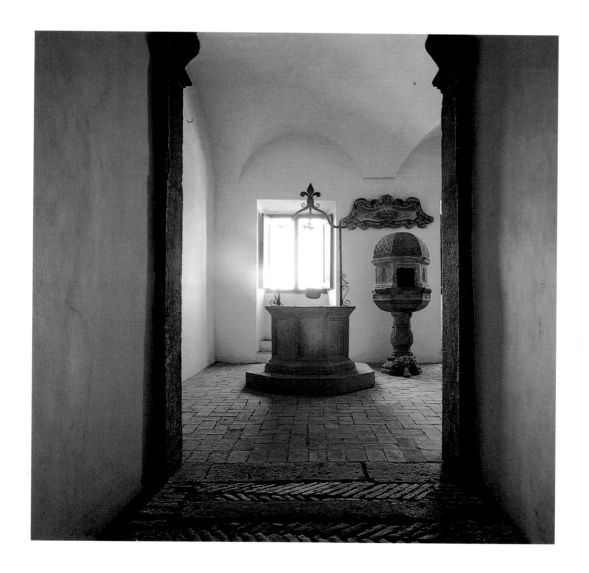

ROOM WITH FIFTEENTH-CENTURY WELL.

Overleaf: Room on the main floor; the wall decoration shows the heraldic hills and grapes of the Ruspoli family.

ABOVE: DETAIL OF A FRIEZE WITH HERALDIC EMBLEMS. ON THE LEFT IS THE
COAT OF ARMS OF THE MARESCOTTI-RUSPOLI FAMILY.

LEFT: WALL DECORATION OF THE ROOM ON THE MAIN FLOOR.

Detail of a fresco on the main floor.

FRESCO ON THE MAIN FLOOR SHOWING THE ALLEGORY OF CHARITY.

Overleaf:
Main hall.

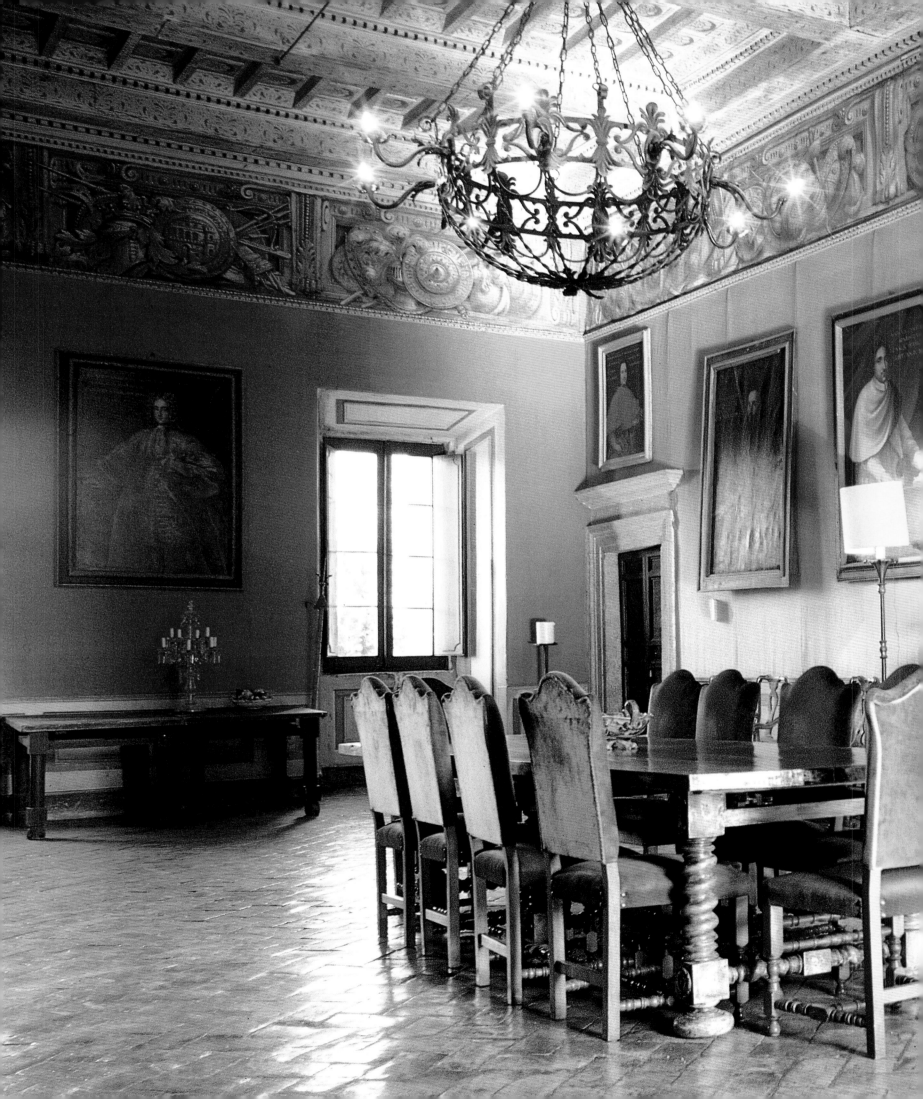

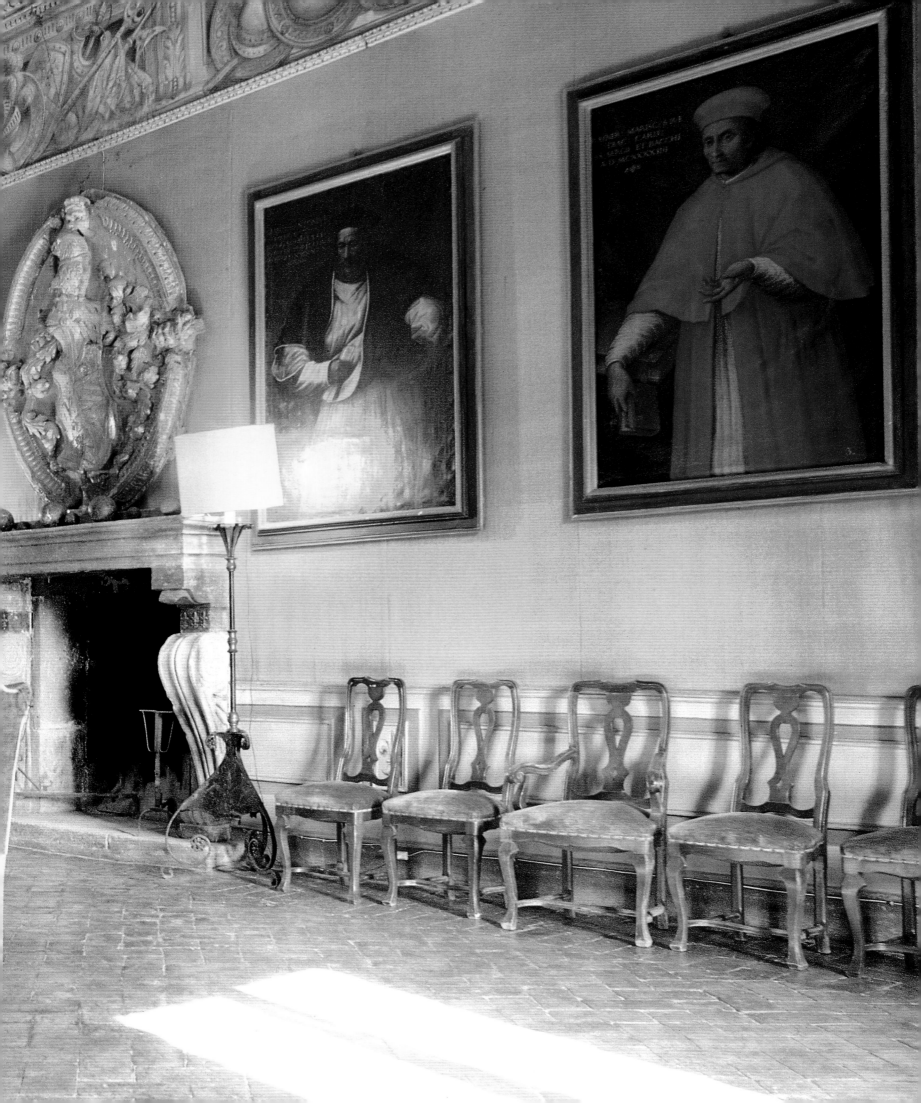

ABOVE: DETAILS OF THE FRIEZE IN THE MAIN HALL SHOWING TROPHIES
AND SHIELDS WITH EMBLEMS AND CASTLES.

RIGHT: CEILING OF THE MAIN HALL.

Purchased by the Giustiniani family in 1595, from 1601 on the Bassano territory underwent an intense reconstruction program commissioned and supervised closely by Marchese Vincenzo Giustiniani, who remodeled the old castle into a palazzo-villa in the style of other great urban and landscape programs in the Lazio region (e.g., Caprarola). According to P. Portoghesi (1957), a new southern wing was added, and the northern wing, which housed the gallery, was enlarged. Initially, a new, more organic arrangement was adopted for the palace and for its facade on the main piazza (in which baronial, civic, and ecclesiastic orders were all assembled). The massive castle structure—both rough and severe— was preserved with its austere arcaded courtyard structure; this exterior greatly contrasted with the interior, richly frescoed by artists from Italy's most diverse regional schools of painting. These distinguished and variegated pictorial testimonies constitute a sort of *Galleria Giustiniana* of the art of the early seventeenth century (to borrow the title of the elaborate two-volume opus Giustiniani sponsored in order to illustrate his extraordinary collection of antique sculpture and other images from the palace). Artists such as Bernardo Castello (Room of Psyche), Francesco Albani (gallery with *Fall of Phaeton*), and Domenichino (Room of Diana) worked here, as well as Paolo Guidotti Borghese, whose ominous and visionary *Allegory of Eternal Bliss* with its extreme foreshortenings and ghostly appear-

PALAZZO ODESCALCHI

•

Bassano Romano

ance of telamons evoke "a Blakean atmosphere" (I. Faldi, 1957).

A letter written by Giustiniani to Theodor Ameyden describes how the terrain had to be substantially improved before the garden was constructed, according to a program devised by the marchese himself (who dabbled in architecture): "I have ordered the leveling of hills, the filling of valleys, the straightening of piazzas and roads where they were irregular and steep." Furthermore the marchese built a series of porticoed paths "where one can walk during the heat of summer, which I have seen in France where they are very popular and are called 'allées.'" He enumerated specific sites of the garden: "the Navona Theater, the Piazza of the Rocca, Mount Parnassus, the Path of Euscalepius, the Forest of the Barrel, the Path of the Fishpond, the small hill, the square piazza. . . . " After many years of alterations and transformations, the Rocca (i.e., the casino situated at the end of the garden's major axis, conceived as a colossal heraldic emblem of the family) still exists today, as do two porticoed paths and a series of square, round, and rectangular piazzas. These are "delineated by laurel and myrtle hedges as well as by plastic elements like small sculptures of animals. All these geometric references increase along the official path, but if one should walk astray, one is thrust into a very different atmosphere: an escape into the world of nature and instinct" (P. Portoghesi).

Left: Plan of the palazzo showing bridge to the garden (by Percier-Fontaine, 1824).

Right: Fresco on the main floor showing part of the Giustiniani coat of arms.

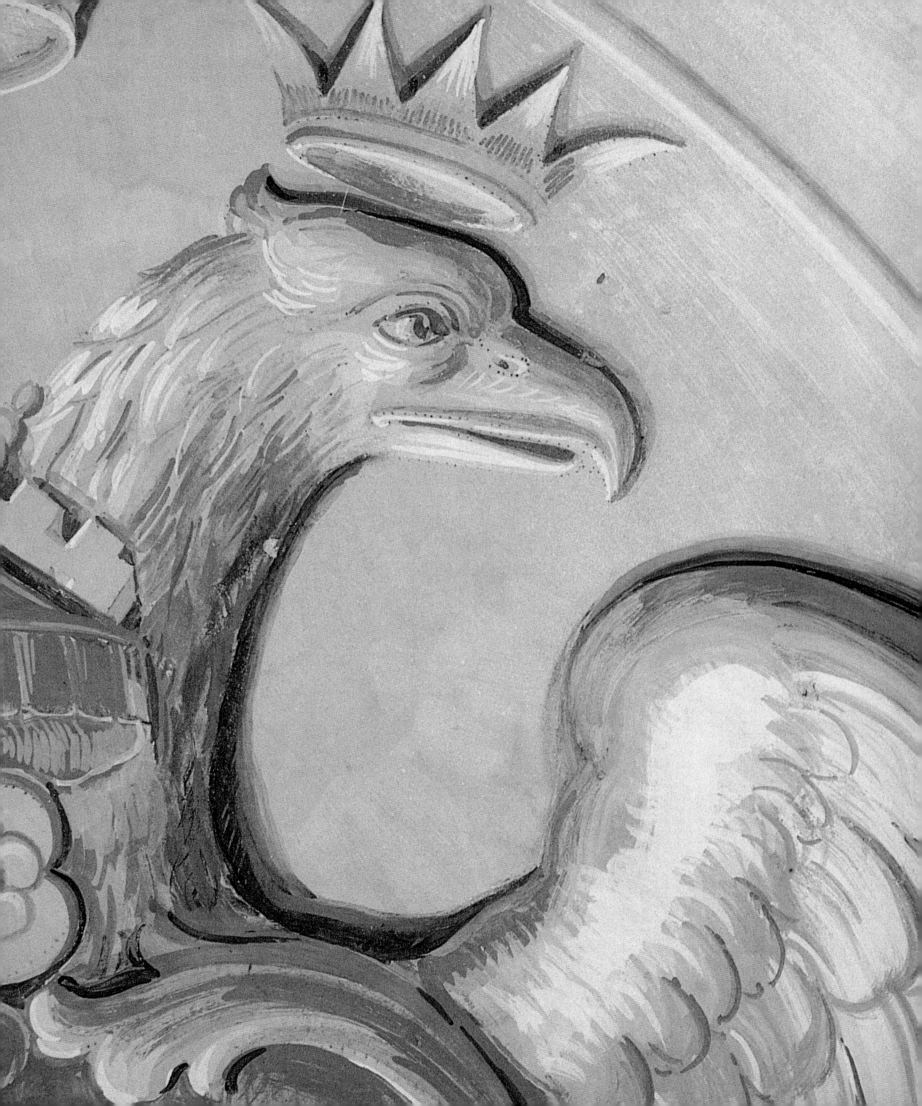

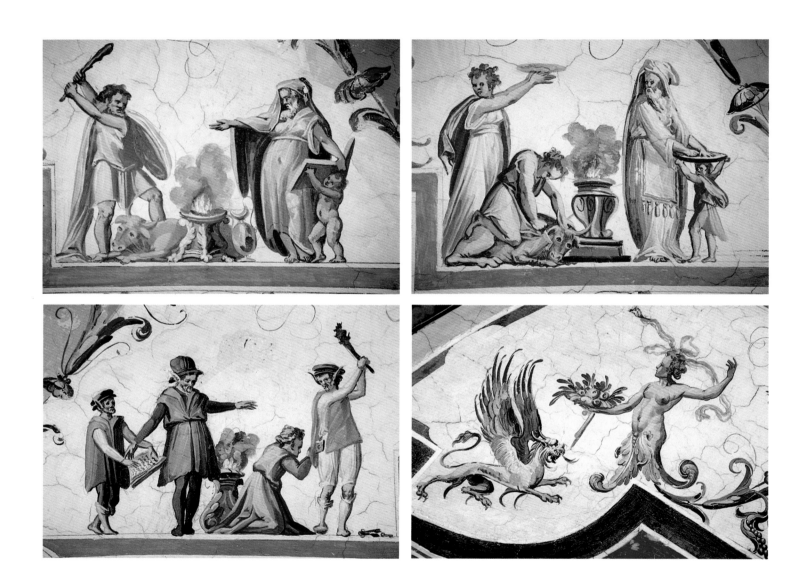

ABOVE: FRESCOES IN THE ROOM OF SPRING SHOWING SCENES OF
ANCIENT SACRIFICES AND GROTESQUES.

RIGHT: FRESCO ON THE MAIN FLOOR WITH A DIONYSIAN FIGURE.

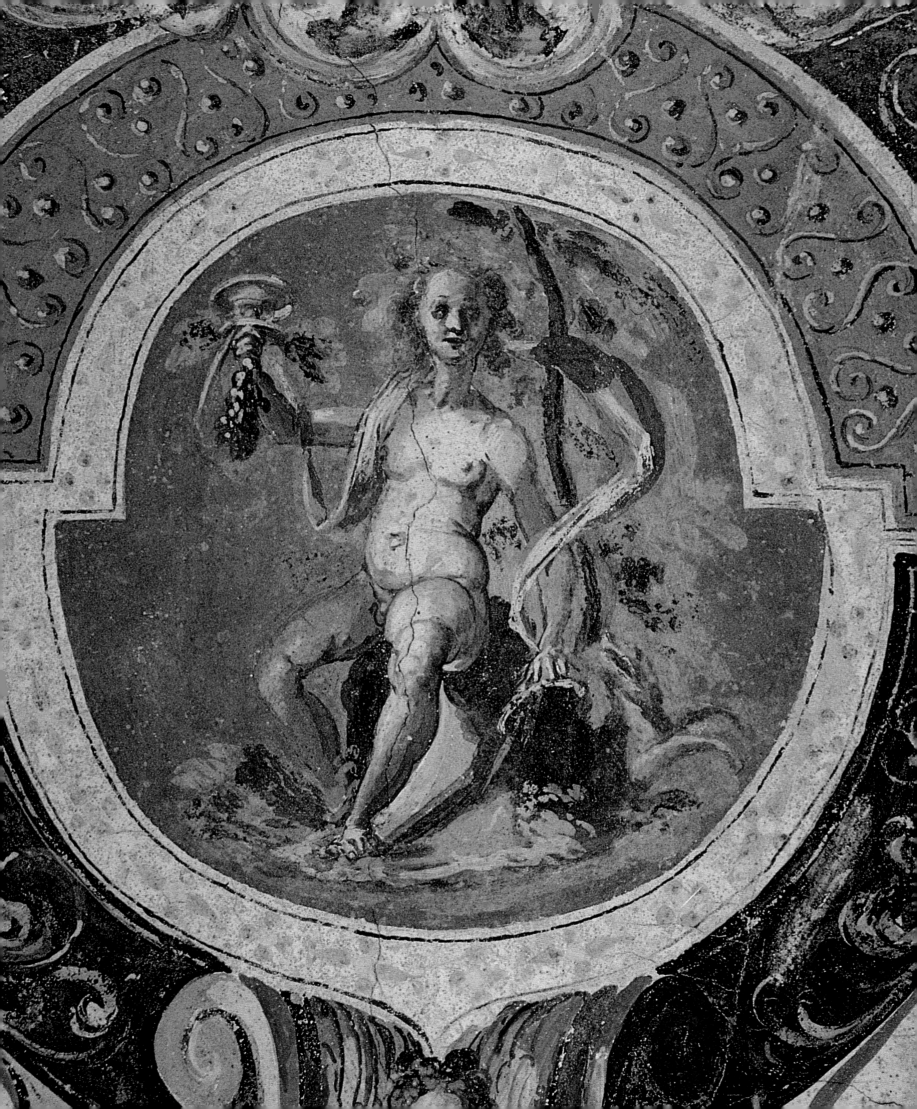

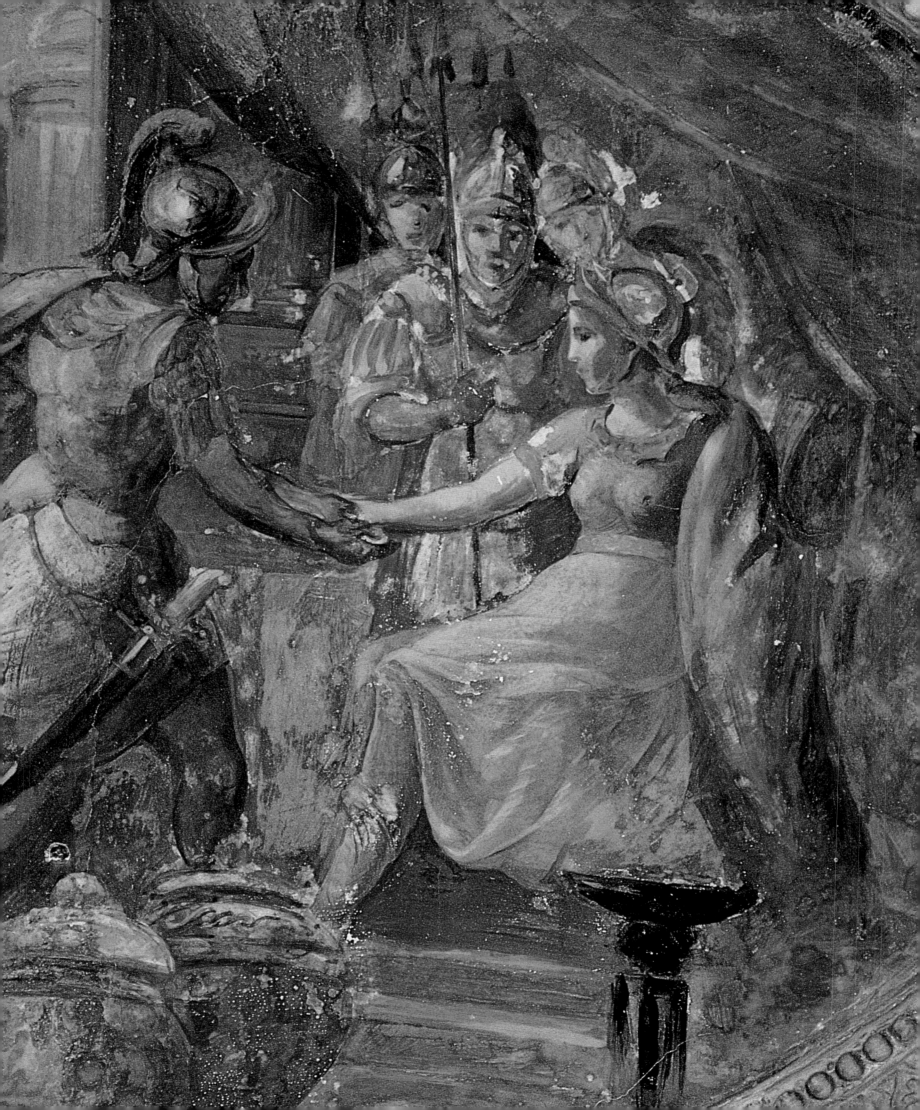

ABOVE: FRESCO ON THE MAIN FLOOR WITH A SLEEPING NYMPH.

LEFT: FRESCO ON THE MAIN FLOOR SHOWING A SCENE FROM ROMAN HISTORY.

Fresco on the main floor showing Fame with a double trumpet.

FRESCO ON THE MAIN FLOOR SHOWING THE COAT OF ARMS OF
VINCENZO GIUSTINIANI FLANKED BY ALLEGORICAL FIGURES OF VIRTUE.

Overleaf: Fresco
in the Room
of Psyche (by
Bernardo Castello)
showing the
marriage of Eros
and Psyche.

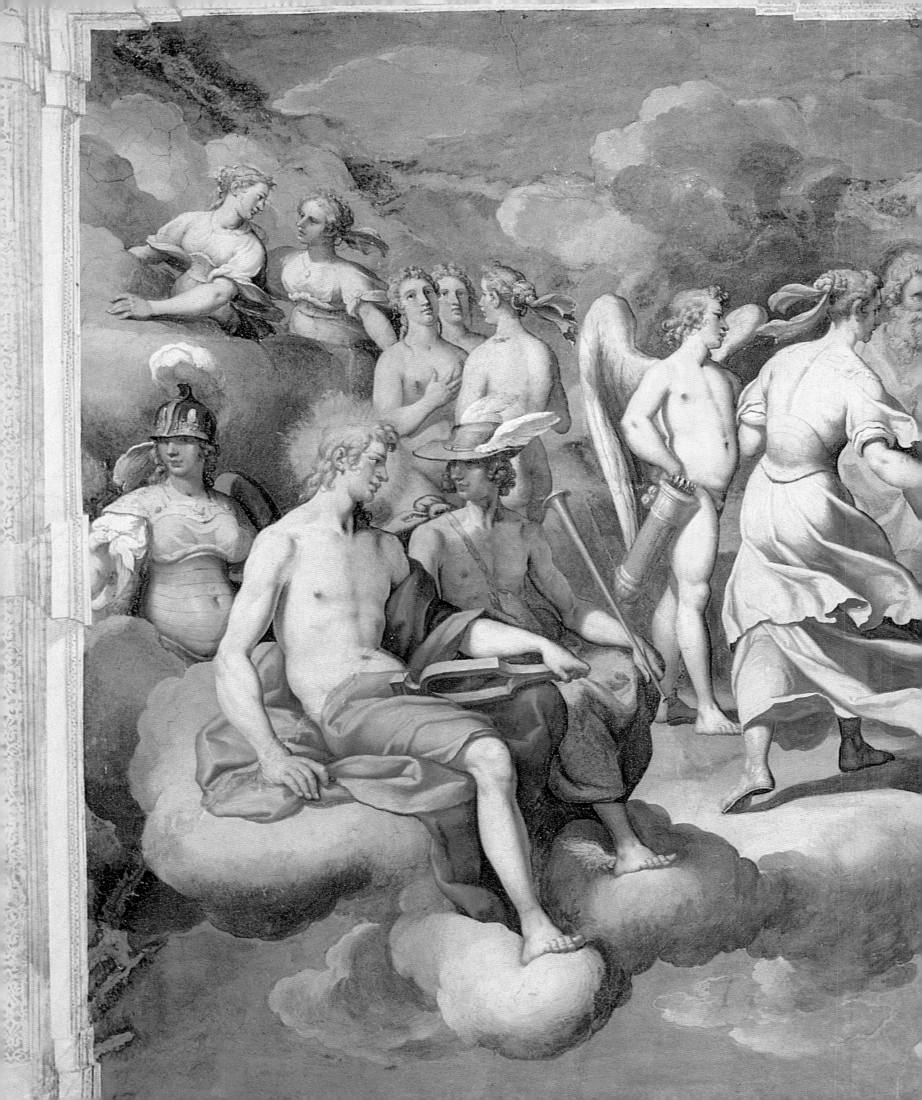

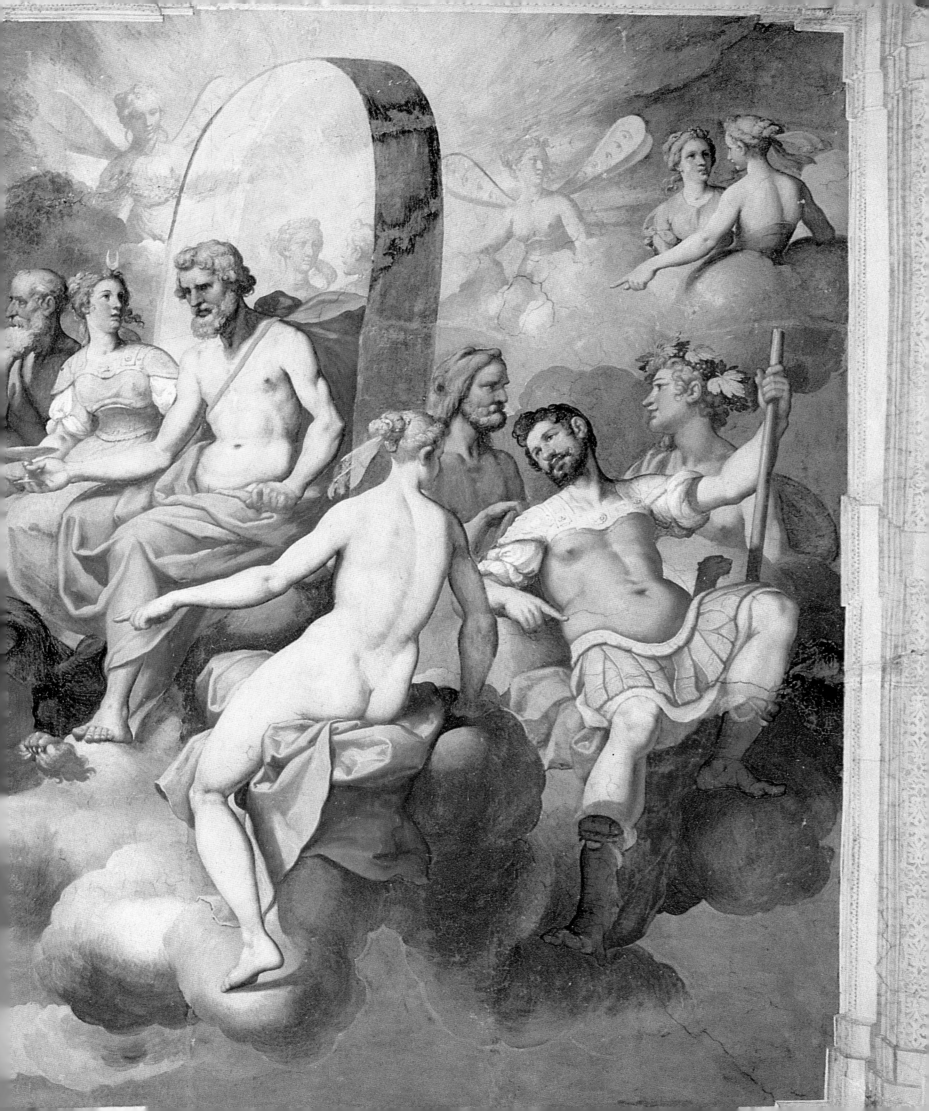

ABOVE AND RIGHT: FRESCOED VAULT AND PANEL WITH A MYTHOLOGICAL
SCENE IN AN ARCADIAN LANDSCAPE IN THE ROOM OF SPRING.

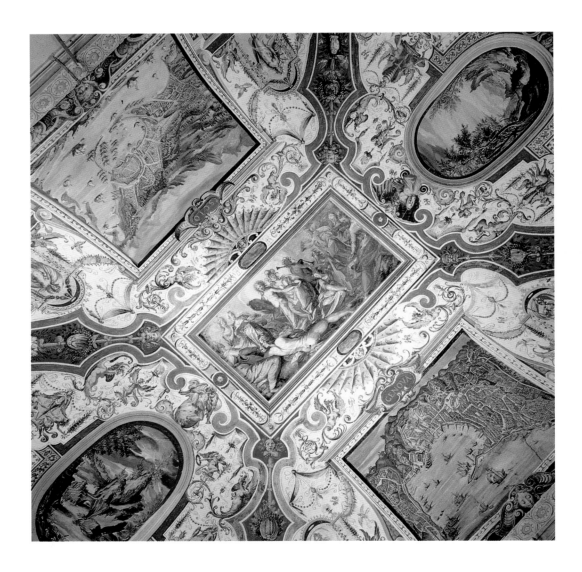

ABOVE AND RIGHT: FRESCOED VAULT AND DETAILS OF TROPHIES WITH
MUSICAL INSTRUMENTS IN THE ROOM OF PARNASSUS.

FRESCO ON THE MAIN FLOOR WITH HEAD OF MIDAS AND GROTESQUES.

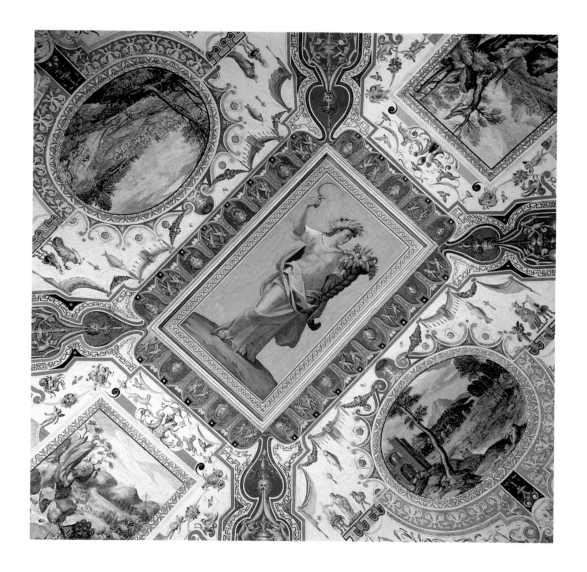

FRESCOED VAULT OF THE ROOM OF SUMMER.

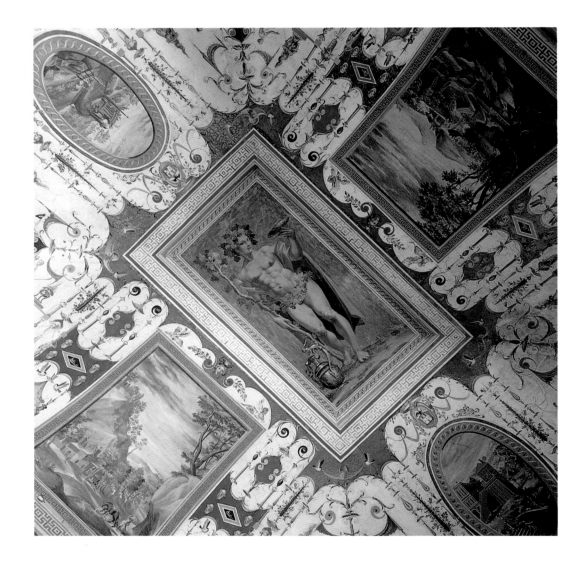

ABOVE: FRESCOED VAULT OF THE ROOM OF AUTUMN.

RIGHT: FRESCO IN THE ROOM OF PARADISE SHOWING THE EPHESIAN DIANA.

ABOVE: DETAIL FROM A FRESCO ON THE MAIN FLOOR.

LEFT: FRESCO ON THE MAIN FLOOR SHOWING THE HEAD OF A RAM,
PERHAPS WITH ASTROLOGICAL SYMBOLISM.

ABOVE: FRESCOES IN THE ROOM OF AUTUMN SHOWING A MYTHOLOGICAL
SCENE AND A GRAPE HARVEST SCENE.

RIGHT: FRESCOED VAULT IN THE ROOM OF AUTUMN SHOWING
GROTESQUE FIGURE WITH BUTTERFLY WINGS.

ABOVE AND LEFT: FRESCOED VAULT IN THE ROOM OF ETERNAL BLISS
(BY PAOLO GUIDOTTI BORGHESE) WITH TELAMONS.

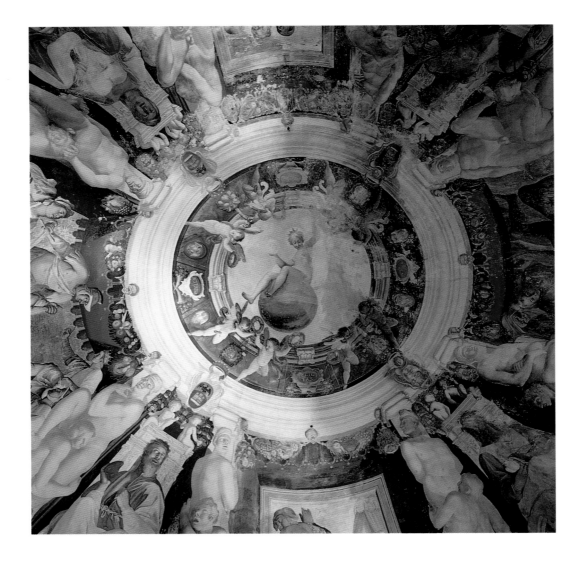

ABOVE: FRESCOED VAULT (BY PAOLO GUIDOTTI BORGHESE) WITH ALLEGORY OF
"AETERNA FELICITAS" SITTING ON THE GLOBE.

RIGHT: FRESCOED VAULT IN THE ROOM OF ETERNAL BLISS (BY PAOLO GUIDOTTI
BORGHESE) SHOWING "HALLUCINATING" TELAMONS.

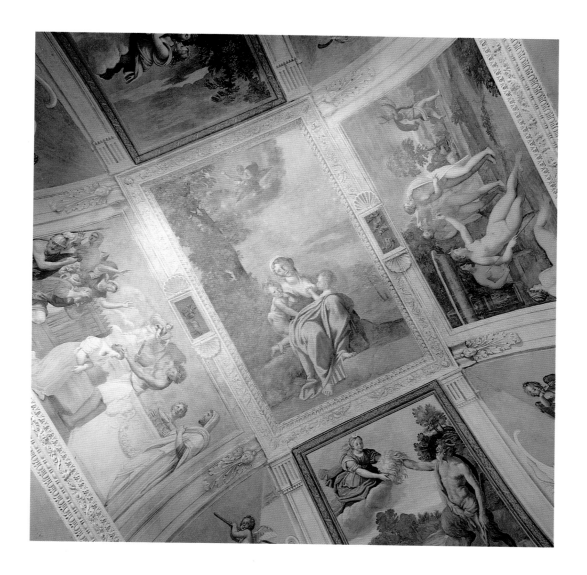

ABOVE AND LEFT: FRESCOED VAULT AND DETAIL OF CUPID
IN THE ROOM OF DIANA (BY DOMENICHINO).

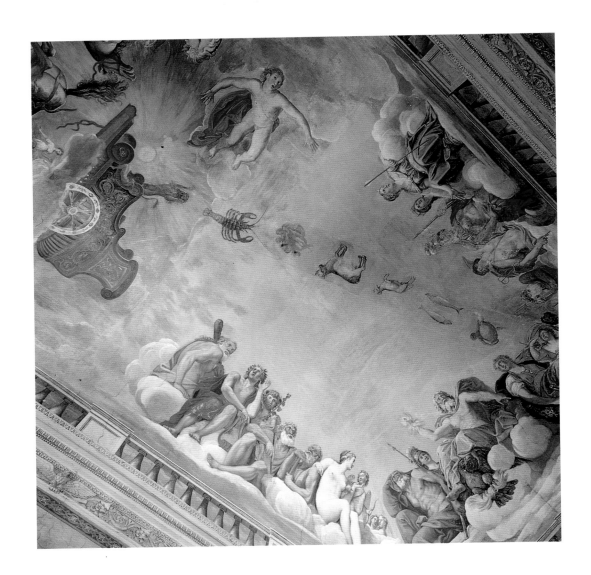

FALL OF PHAETON GALLERY BY FRANCESCO ALBANI.

NYMPHS IN THE FALL OF PHAETON GALLERY.

ABOVE: HORSES OF THE CHARIOT OF NEPTUNE IN THE
FALL OF PHAETON GALLERY BY FRANCESCO ALBANI.

RIGHT: RECEDING WATERS REVEAL THE MONSTROUS LEGS OF THE
SEDUCING SIRENS IN THE FALL OF PHAETON GALLERY.

After demolishing the preexisting sixteenth-century villa, Cardinal Pietro Aldobrandini, nephew of Pope Clement VIII, began the works for the villa in 1598 based on a project by Giacomo della Porta. The severe facade facing toward Rome is balanced by a more spirited garden facade, with a central section composed of three superimposed Serlian loggias, perhaps built by Carlo Maderno after the death of della Porta in 1602. Between 1602 and 1603, Cavalier d'Arpino frescoed five rooms of the main floor with stories of the Old Testament, centered around the theme of the Garden of Eden, as suggested by Cardinal Silvio Antoniano.

Perhaps already planned by della Porta, the spectacular water theater was built (following the construction of a special aqueduct) according to a design of Carlo Maderno and Giovanni Fontana. This work served to glorify both the pope and the cardinal as restorers of peace and champions of the Christian world. Embodying this second meaning is the central figure of Atlas, toward whom Hercules leans as he exchanges the labor of supporting the celestial globe. At the foot of Atlas is the giant Tantalus, while at its sides are Polyphemus and the centaur, allegories of the struggle between reason and animal instinct.

In symmetrical positions at each side of the theater are the Chapel of the Holy Spirit and

VILLA ALDOBRANDINI

•

Frascati

the Room of Apollo, a kind of nymphaeum dominated by a polychrome sculpture group featuring Apollo and the nymphs on Mount Parnassus. (The area, with an illusionistic pergola frescoed on the vault, included a series of frescoes by Domenichino illustrating the stories of Apollo; these were later detached and are now on display at the National Gallery in London.)

The theater was dedicated to Water, here personified by a nymph, and thus made to seem almost a living creature, as proposed by the creator of the villa's program, Monsignor G. B. Agucchi. The nymph, Water, is born spontaneously from the hilltops, growing both physically and symbolically as she makes her way through the harshness of nature. In the first fountain, Water has a savage character, emerging from a rustic waterfall that originates from the mouths of two animal-like masks. In the next fountain, the rustic character (an homage to the rural nature of the villa) is emphasized by the presence of two peasants. After another artificial waterfall—the arch of rocks is almost a "naturalistic" triumphal arch—Water passes through the Pillars of Hercules and then cascades over the cochleated columns in a downward spiral. It then precipitates into the small waterfalls of the waterway, reappearing finally in the heraldic Aldobrandini star and in the cosmological configuration of the globe of Atlas.

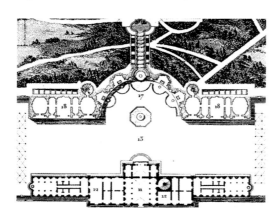

Left: Plan of the palazzo and the water theater.

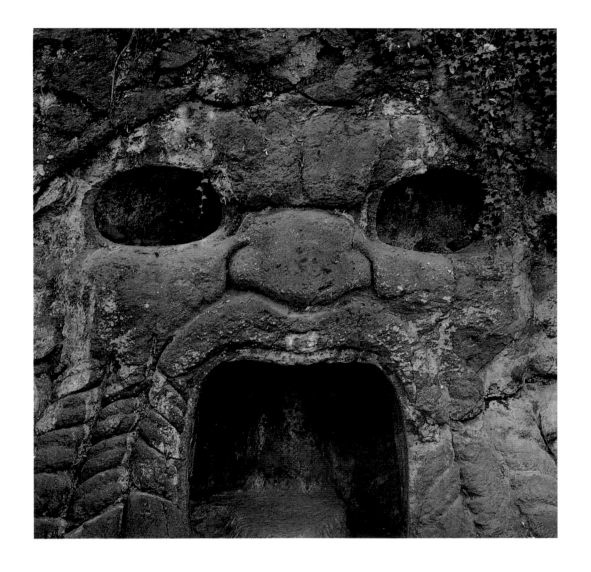

Mask in the garden.

Overleaf: Garden facade with triple loggia (by G. della Porta and C. Maderno).

Second overleaf: The terrace between the garden facade and the water theater; the "minaret" is actually a kitchen chimney.

Third overleaf: Water theater (designed by C. Maderno and G. Fontana).

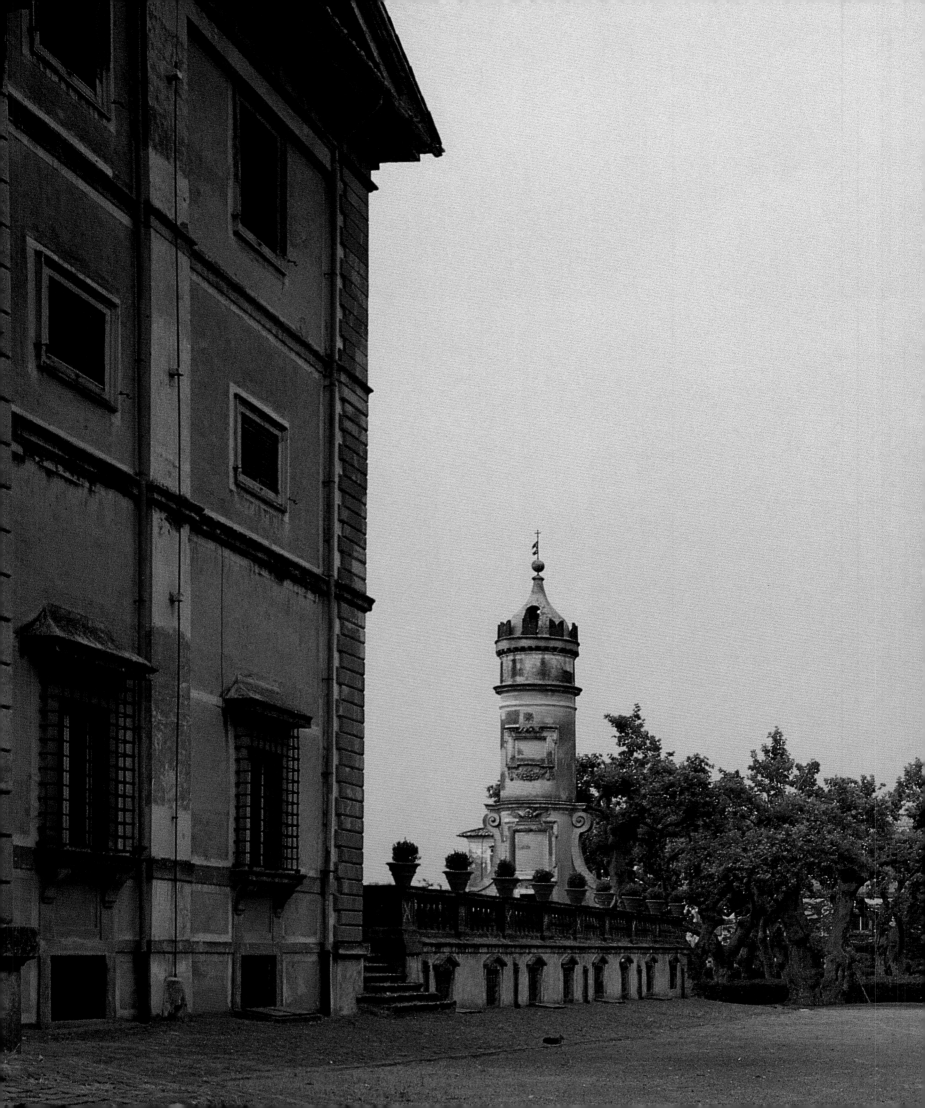

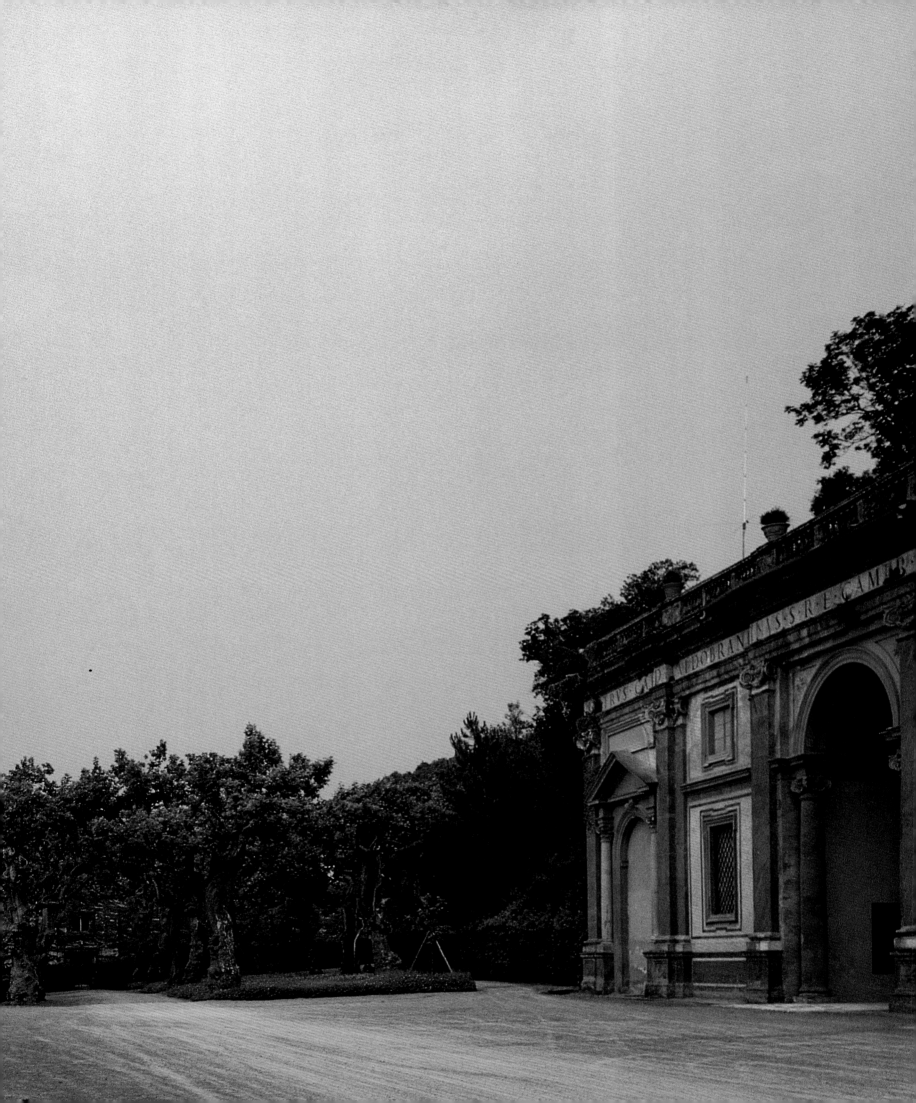

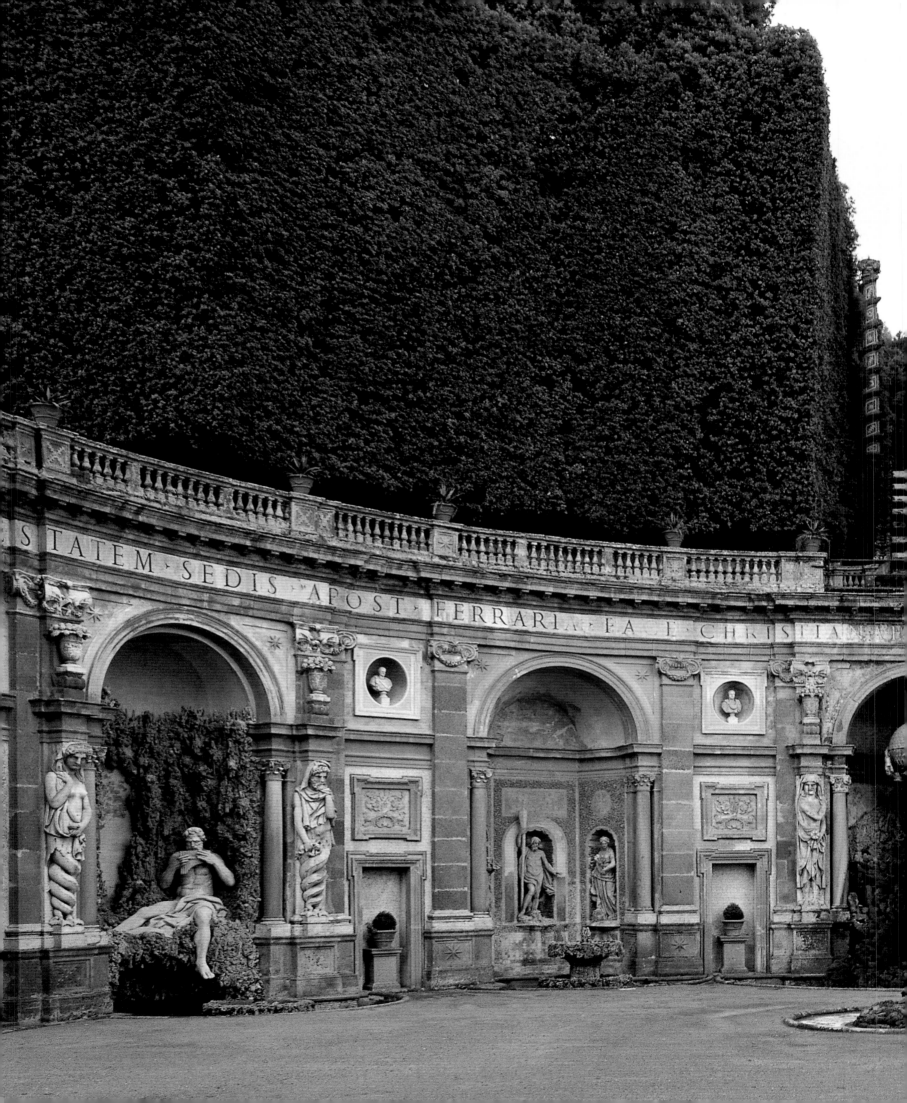

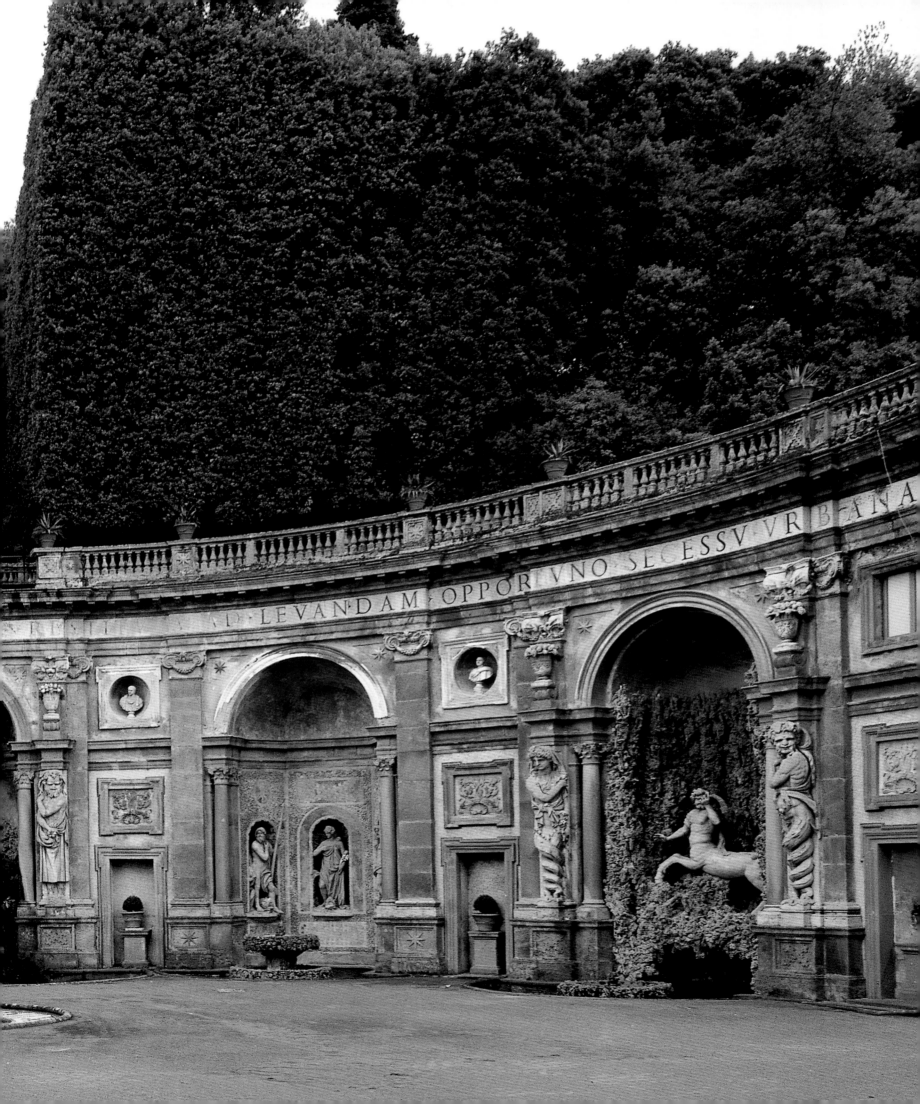

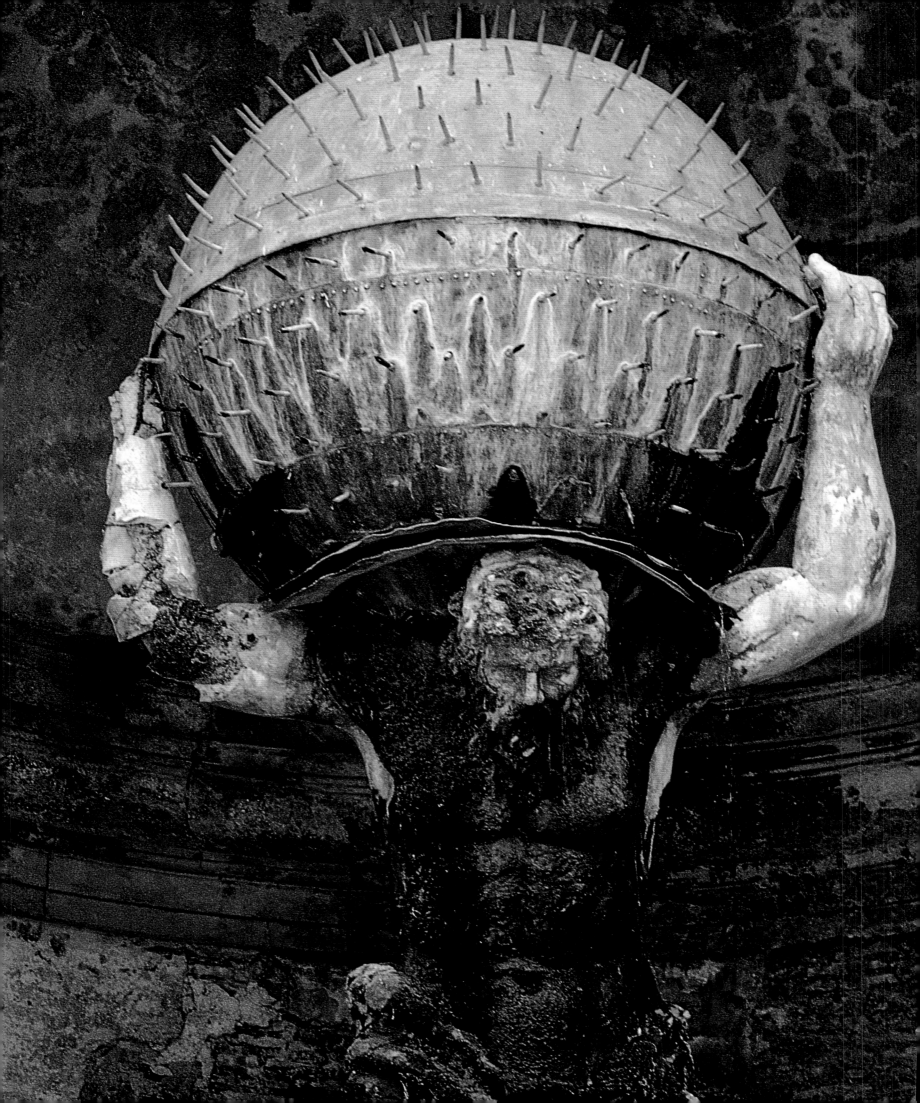

ABOVE: CARYATIDS AND POLYPHEMUS IN THE WATER THEATER.

LEFT: ATLAS SUPPORTING THE CELESTIAL GLOBE (BY JACQUES SARRAZIN)
IN THE WATER THEATER; THE STATUE HAS BEEN RESTORED.

ABOVE AND LEFT: FRESCOED VAULT IN THE ROOM OF PARNASSUS
WITH ILLUSIONISTIC BOWER.

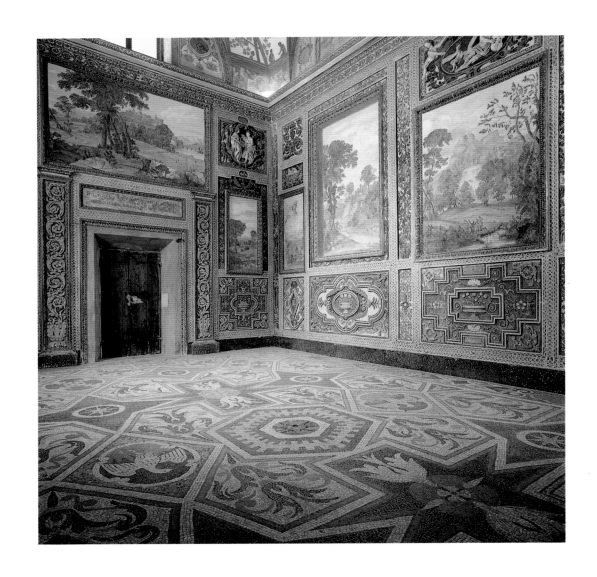

ABOVE AND RIGHT: ROOM OF PARNASSUS WITH HYDRAULIC ORGAN.

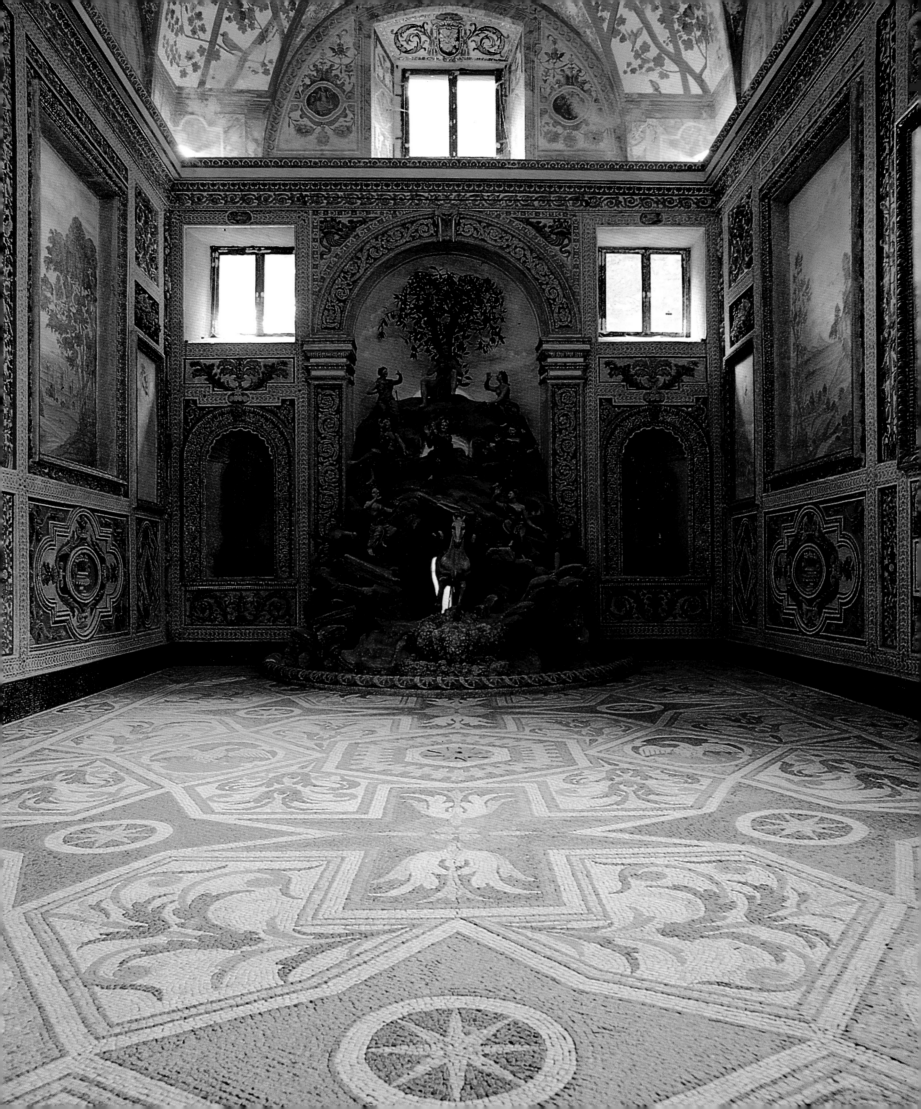

ABOVE AND LEFT: PAINTED WOOD SCULPTURES (BY ANGUILA AND SARRAZIN)
OF PARNASSUS WITH PEGASUS AND THE MUSES IN THE ROOM OF PARNASSUS

At the extreme edge of the system of *villae tuscolanae*, in the direction of Grottaferrata, this villa was built by Cardinal Antonio Carafa before 1580, "having in mind not so much to abandon himself to leisure, but to achieve, in peace, celestial nourishment" (as Pope Gregory XIII asserted when he consecrated the small chapel dedicated to Battista); it later passed into the possession of the Acquaviva and the Peretti-Montalto families. At the beginning of the seventeenth century, the villa—which is depicted in a fresco of the Antonio Carracci school in the Room of Elysium—appears as a U-shaped casino, modeled after the Villa Chigi-Farnesina and the early villa of the Quirinale in Rome; it stands at the center of a cross-shaped knoll-belvedere made up of a large piazza with a fountain and three small "secret" gardens.

Among the *villae tuscolanae*, Villa Grazioli, along with Villa Falconieri, is the richest in fresco decoration. In 1776, the Marquis de Sade wrote: "This villa (named Belrespiro because of the pleasant air that is enjoyed here) appeared to me the most elegant of all those in Frascati, and one can in truth say that the taste and propriety that rule here make it one of the prettiest countrysides one could ever see and truly in the taste of our villas outside of Paris."

VILLA GRAZIOLI

•

Frascati

The early-seventeenth-century fresco cycle appears to be in harmony with classical and moral customs of the time. On the vaults of the main rooms were painted "works inspired by the passing of time (associated with themes deduced from pastoral poetry), the four elements and seasons, the celebration of the garden as Eden, along with the exaltation of poetry, fame, and virtue. Classical themes such as the representation of 'Day' or 'Repose' acquire an atmosphere that evokes the ancient poetry of nature, thus elevating the relationship between the villa and the surrounding landscape" (A. Tantillo Mignosi, 1993).

The villa was purchased by the Odescalchi family in 1683. About 1735, it was enlarged with the addition of the gallery, built above the entrance portico, and a new apartment above the gallery incorporating the sixteenth-century belvedere-tower. The gallery was frescoed in 1736–37 by Giovan Paolo Pannini "who summed up the previous decorative themes: the vaults that simulated the open sky, the illusionistic statues and reliefs inserted within the architecture of the rooms, the representation of the passage of the seasons, the elements, and the continents. The decorative divisions bring to the interior the colors and atmosphere of the surrounding landscape, acting as an intermediary between real and imaginary space" (Tantillo Mignosi).

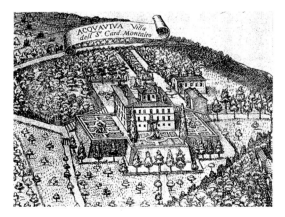

Left: Early-seventeenth-century view of the villa (etching by M. Greuter, 1620).

Right: Fresco in the gallery (by G. P. Pannini) showing Neptune.

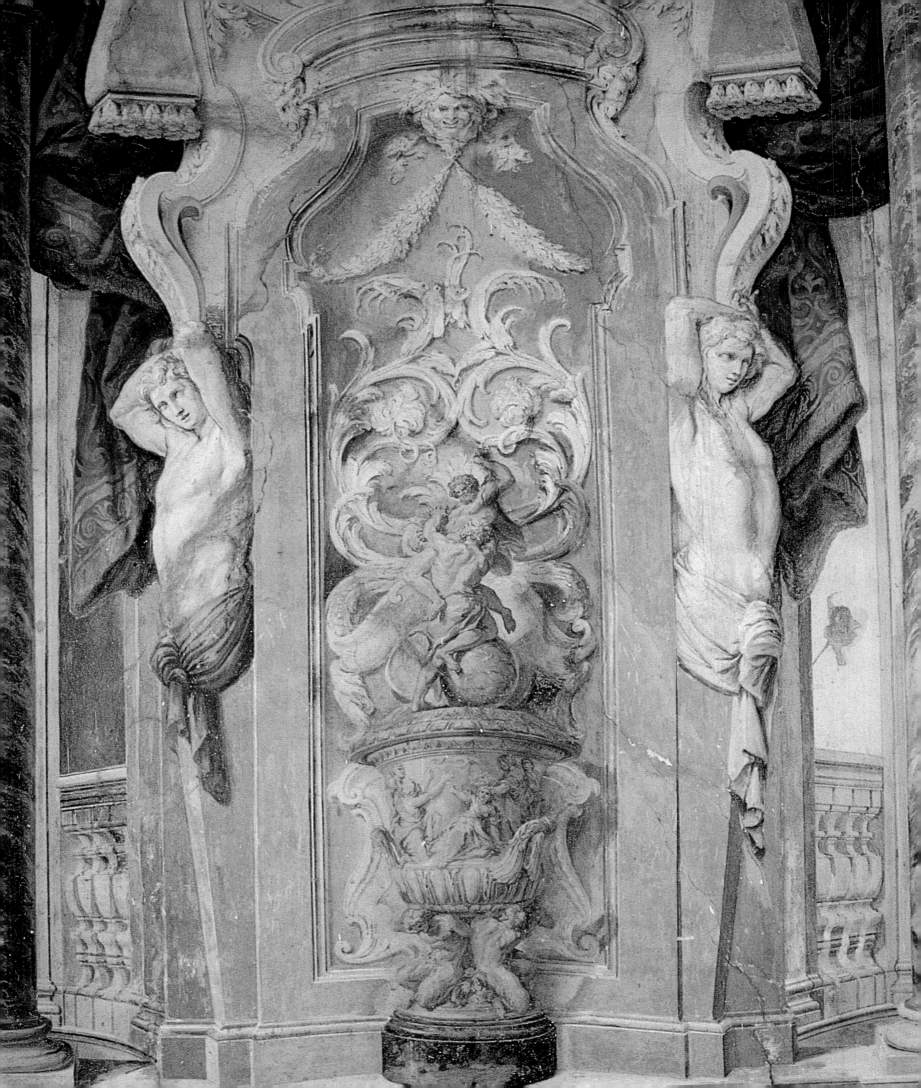

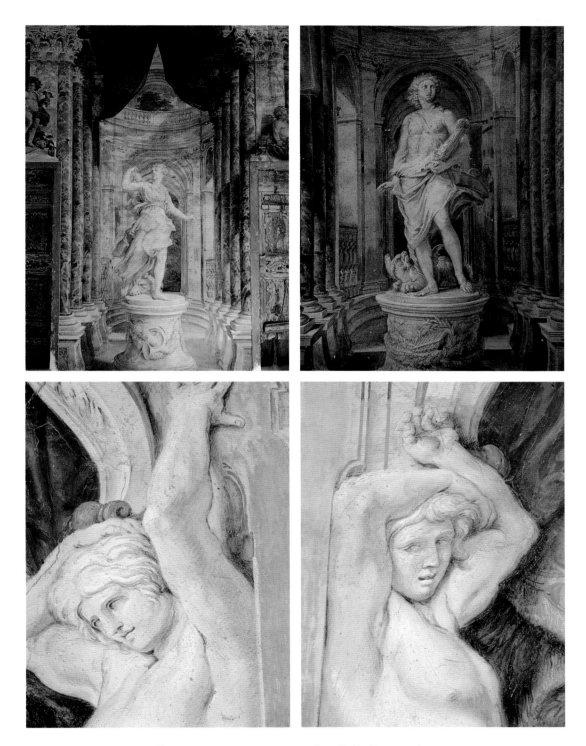

ABOVE: FRESCOES IN THE GALLERY (BY G. P. PANNINI) SHOWING
DIANA, APOLLO, AND TWO TELAMONS.

LEFT: FRESCO IN THE GALLERY (BY G. P. PANNINI) WITH AN
ILLUSIONISTIC-SCENOGRAPHIC VIEW OF ANGELS.

ABOVE AND LEFT: FRESCOED VAULT IN THE ROOM OF PEGASUS OR OF VIRTUE
(BY A. CIAMPELLI, EARLY SEVENTEENTH CENTURY) WITH GROTESQUES.

Above and right: Frescoes in the apartment addition (by G. Aldobrandini, about 1737) showing Apollo and Mars and an ideal landscape.

Overleaf: Fresco in the Room of Elysium (from the Carracci school, early seventeenth century) showing a late-sixteenth-century view of the villa.

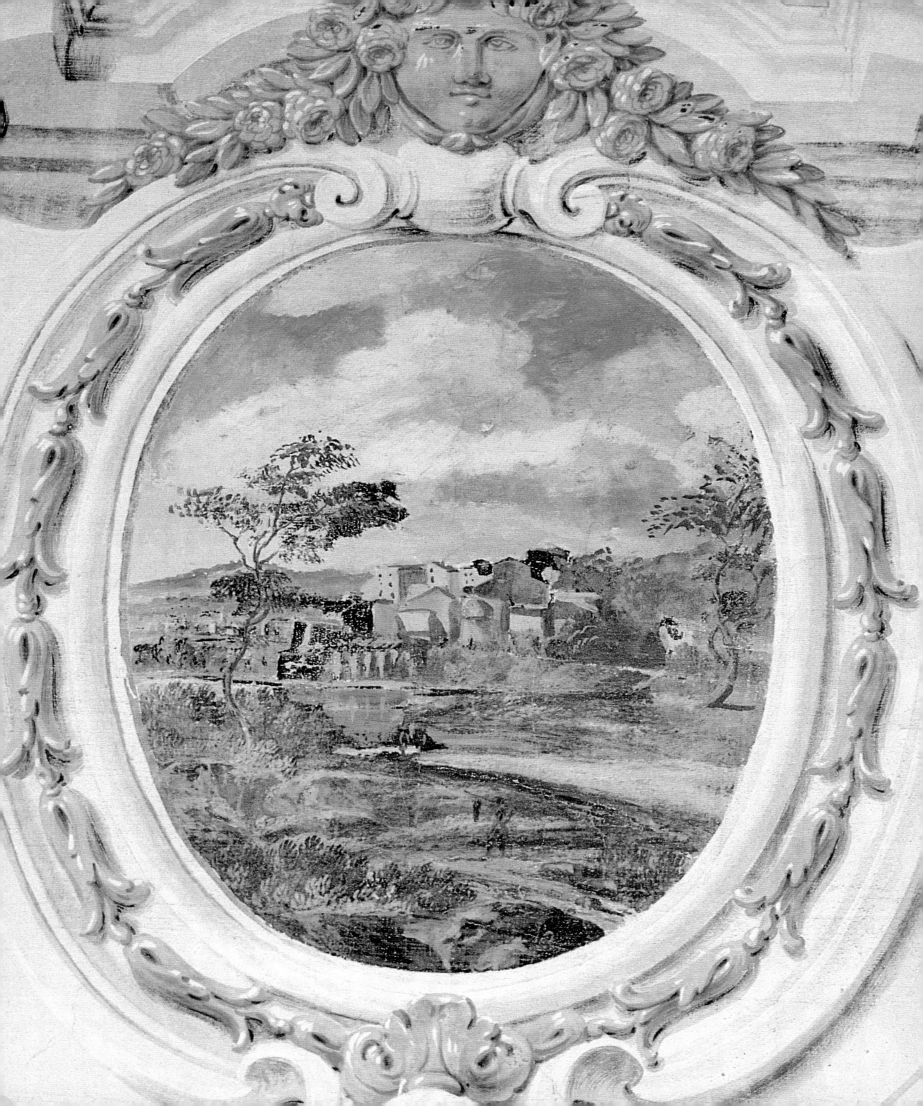

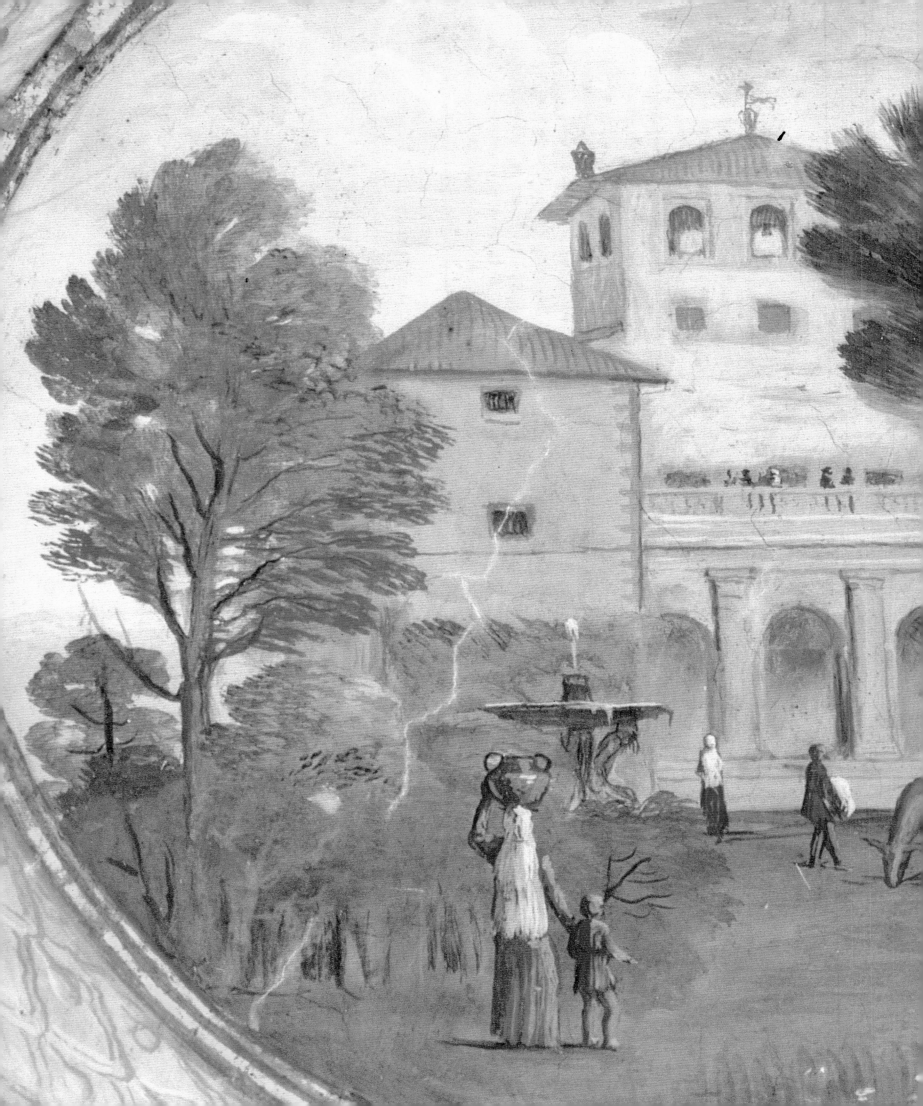

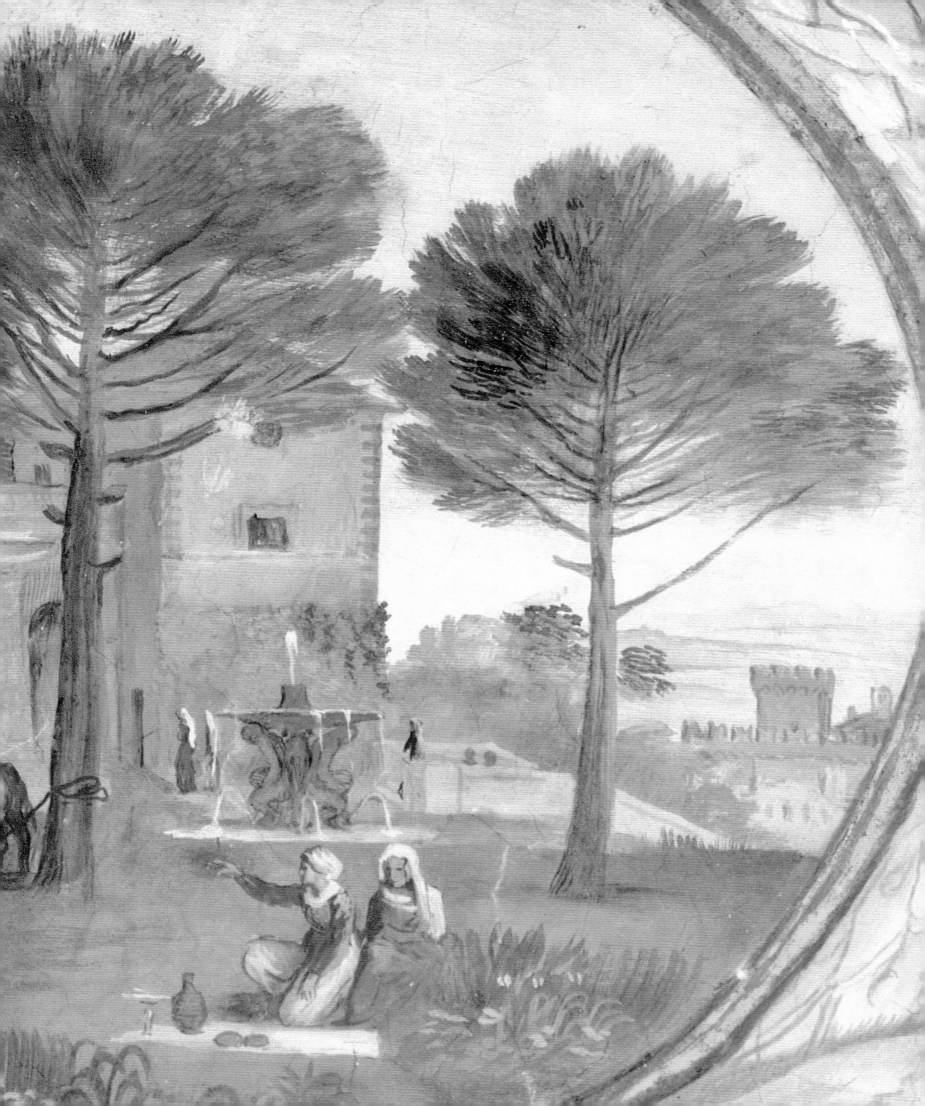

Defined by Gregorovius as the medieval Pompeii, the town of Ninfa was founded in the Middle Ages next to the spring of the limpid Ninfa River. Here, in 1159, Alexander VII was crowned Pope; beginning in the fourteenth century, the Caetani family took possession of this territory and dammed the river to create the artificial lake. Plundered and destroyed many times, the town gradually fell into decay in the late Middle Ages, and was completely abandoned in the seventeenth century due to an outbreak of malaria. In the late sixteenth century, next to the Castello Caetani, were built the Horti Nympharum, gardens with geometric flowerbeds and fountains.

The gardens at Ninfa today were created due to the initiative of the proprietors, all intellectuals or artists, who had a passion for gardening and were grounded in a culture that was partly Italian and partly English. Gelasio Caetani, scholar and engineer, restored the ruins at Ninfa between 1910 and 1922. He planted cypresses, cedar trees, holm oaks, and great poplars, and planned a series of small waterfalls in order to render the course of the river more picturesque. In 1950 his brother Roffredo definitively channeled the waters, while in the 1930s, his American wife, Marguerite Chapin, planted the roses, fruit trees, and along the river, willow trees. But the garden of

GIARDINO CAETANI

•

Ninfa

flowers and rocks as it stands today owes its form above all to the initiative, between 1950 and 1977, of the painter and gardener Lelia Caetani, who married English intellectual Hubert Howard. He administered the Ninfa estate, took over the works begun by his wife, and served as president of the Fondazione Roffredo Caetani from 1977 until his death in 1987.

Considered by many the most romantic garden of Europe, Ninfa reflects the style of Lelia Caetani. "She loved finishing touches, details, as we can see west of the ruinous walls where she organized a fantastic rock garden. She had a passion for ancient roses: the Banksia rose in particular, as well as clematis, both compatible with the proper conservation of the ruins. . . . The creators of this garden were acquainted with the principles of the English garden, the romantic pairing of the ivy and the ruins, and the pleasant organization of the waters, and thus they often adopted formal solutions that can be considered ingenuous. This connotation of ingenuity, which could also be considered naive, is one aspect of Ninfa's fascination, rendering this place a unity in the world.

The final effect is magical, like something beyond space and time. The cabin, the small bridge, the two lakes next to the entrance, the waterfalls, the watercourses emphasize this fairy-tale appearance" (L. Soprani, 1990).

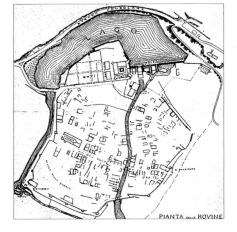

Left: Plan of the ruins with the Castello Caetani and gardens.

Right and following pages: The gardens of Ninfa with ruins of houses and churches, including Santa Maria Maggiore (first overleaf), San Biagio (third overleaf), and the park dominated by the tower of Castello Caetani (fifth overleaf).

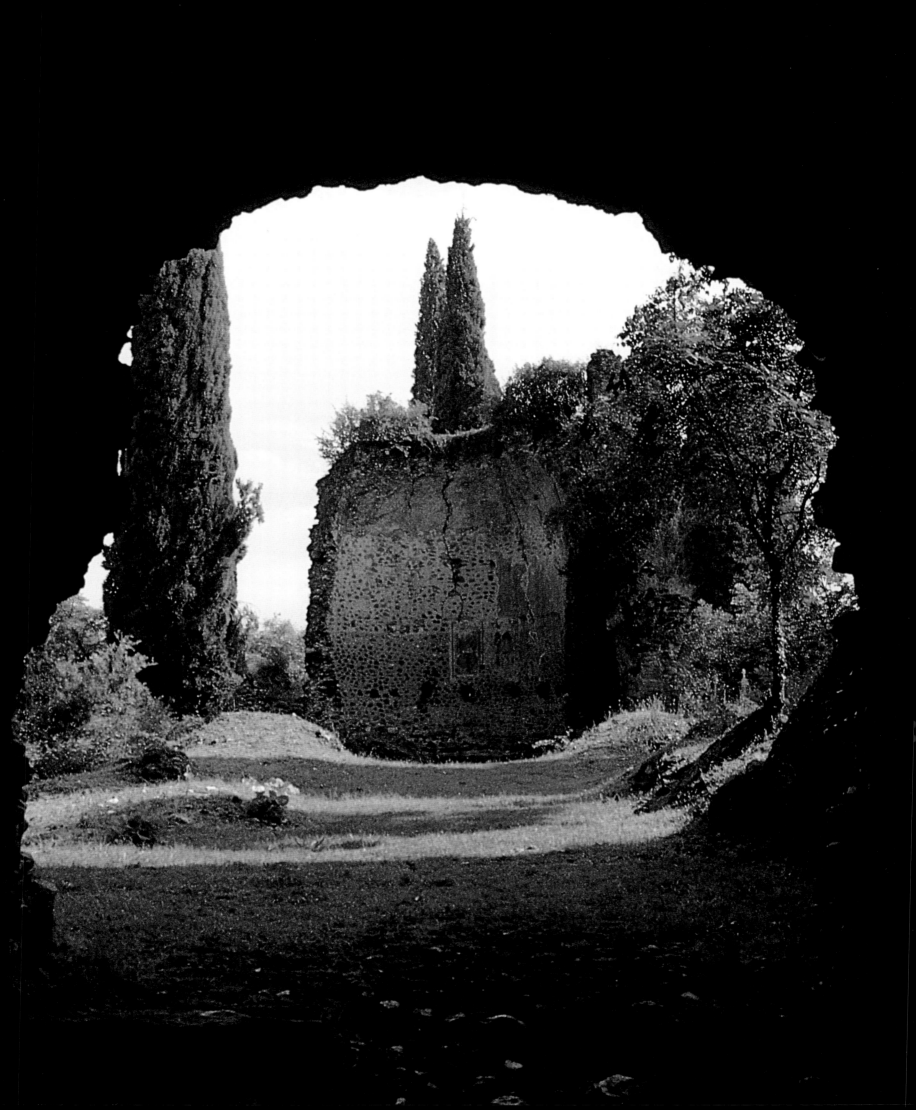

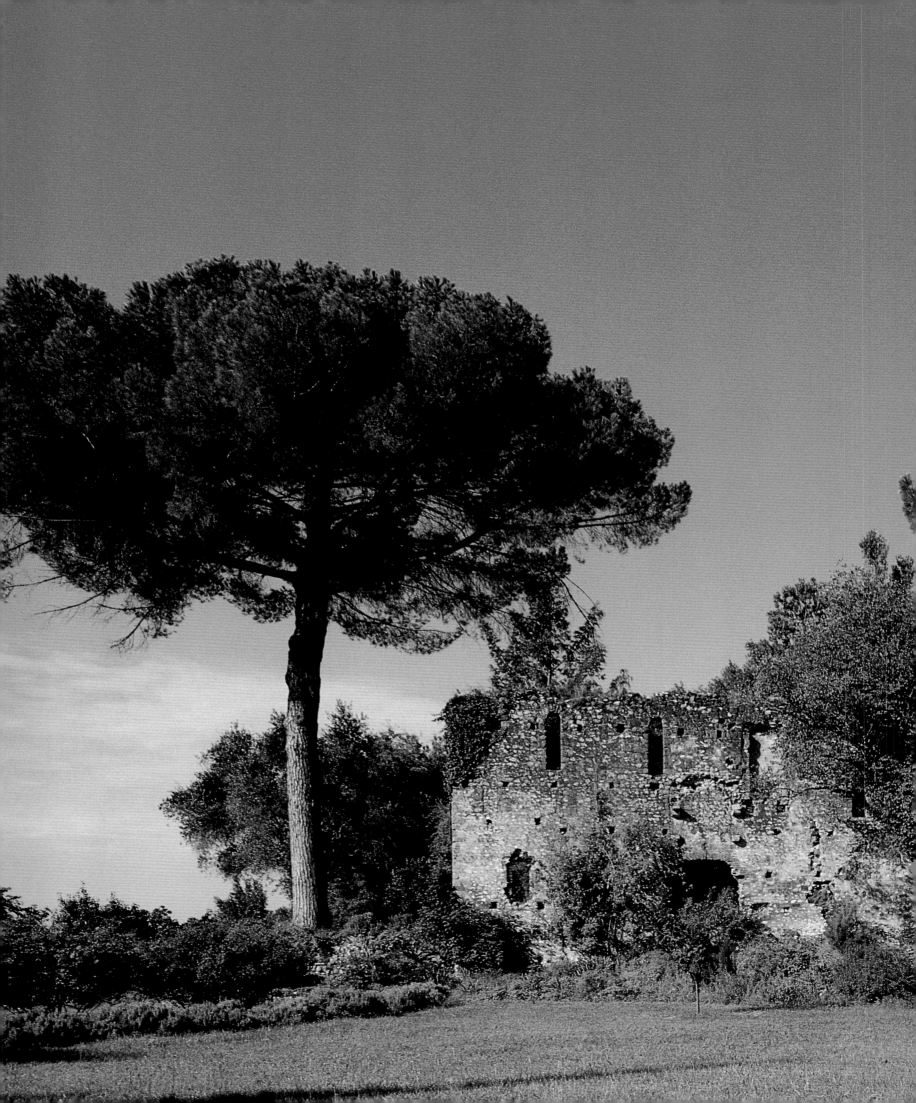

Paolo Portoghesi has provided the following description of his garden: This garden—a product of its environment and history—is laid out in respect to its visual perspectives and visual foci. There are internal visual foci as well as external ones, like the four cardinal points, which orient the Tempietto and the Vasca. Together these foci are seven, like the seven "moles" of the Sacro Bosco at Bomarzo, a great source of inspiration of this garden, as were Hadrian's Villa and Villa Lante at Bagnaia.

The first visual focus is the decastyle circular Tempietto, which I planned with the one designed by Eupalino in mind, which was inspired by the proportions of a Corinthian girl (the same one, perhaps, on whose tomb Callimachus had gathered acanthus leaves growing around a basket). I chose the Doric order, since I like the contrast between the grace of the fluting and the crude rising from the ground of the inflated shaft, the profile of the echinus being the most beautiful line ever to have been derived from natural forms. The Tempietto, made of cedar wood, is surrounded by a ring of water (both a *eurypus* and an *ouroboros*). The second focus is the paradisiacal crossroads of the four rivers of Eden: these spring out of circular fountains that glitter due to a pretty mosaic—a gift from the Maghreb artisans who worked on the Roman mosque—underneath the swirling current. The third is the Vasca (basin), which resembles a pond filled with blue-green algae because of its green Issoire marble. Above it, controlled by an electronic device, a number of water jets cross each other, almost suggesting a transparent vault with crystal ribs, reminiscent of the Generalife Garden at Granada.

GIARDINO PORTOGHESI

•

Calcata

The fourth visual focus is an homage to duality: a pair of facades, similar to human faces, with blue eyes and sealed lips; doors that cannot be opened but that bear the image of two trees—the Tree of Life and the Tree of Knowledge. Between the two facades is a stone table with benches and thrones sculpted in *peperino* stone. A similar table was erected by Cardinal Gambara at Bagnaia, with a stream of water flowing through it, inspired by a description in Pliny of a table in his Tuscan villa.

The fifth focus is the olive tree, called "Odysseus" because of its long voyage from the Sabina territory, where it was planted in the ancient properties of the Farfa Abbey more than five centuries ago. Its roots and branches now regenerated, the olive tree maintains a dialogue with an oak tree that has leaned toward it, since even before the tree was transplanted, almost like a waiting Penelope. Situated so that it dominates the plane of the Tempietto and the underlying Italian garden, the olive tree unites and, at the same time, distinguishes these two areas.

The Italian garden, the sixth focus, projects toward the landscape in a "Tuscan" manner and is dedicated to the unity of the mineral and vegetable worlds. The geometric structure is that of an ear of corn or of a fishbone, and the fountain that demarcates its beginning is the image of a tulip and at the same time a proliferation of crystals, a stellar nexus connecting earth and the heavens, water and air. (A recent study has indicated that the creation of life is manifested in the formation of a crystal.) The seventh and final visual focus is a small theater of greenery, enclosed within a semicircular laurel hedge: here, one day, a tufa stone obelisk will be erected and around it will be musicians playing the double flute.

Left: Study for the twin portals (P. Portoghesi).

Right: "Odysseus," the olive tree.

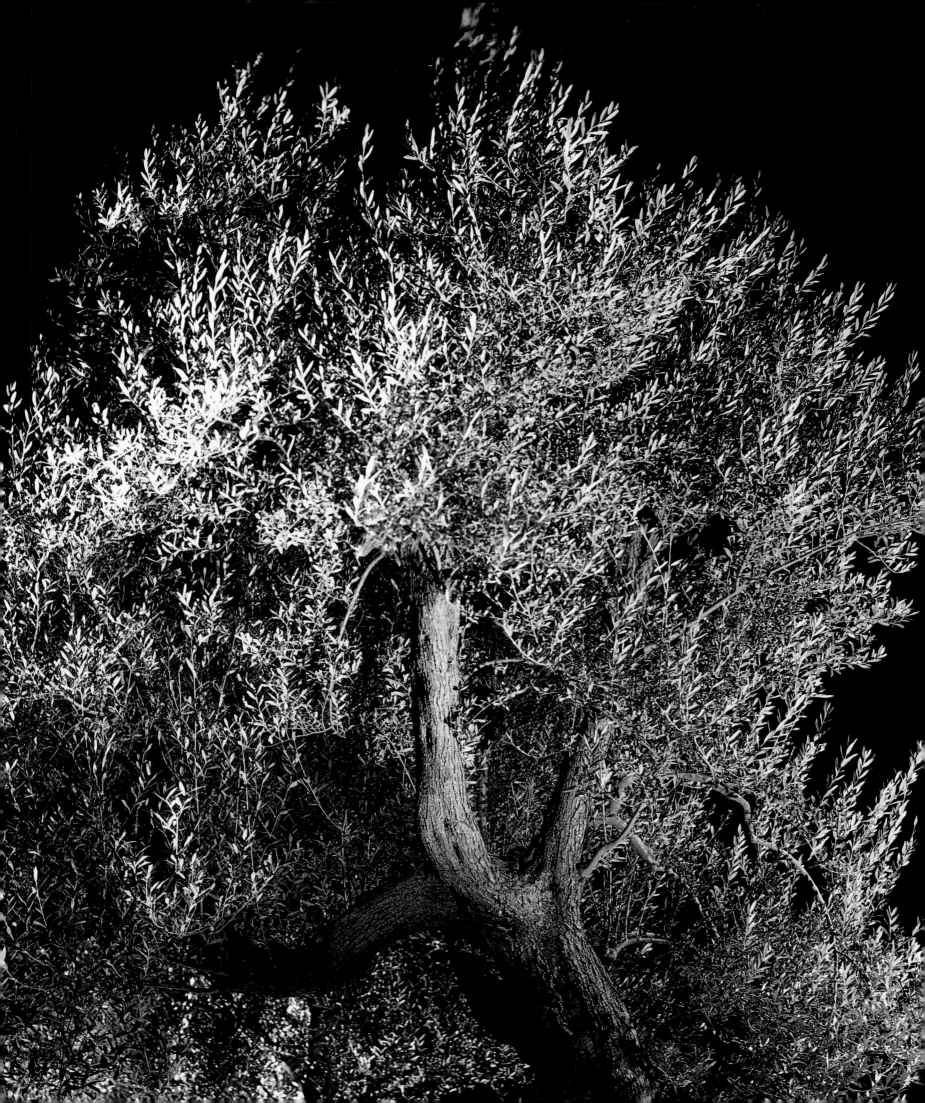

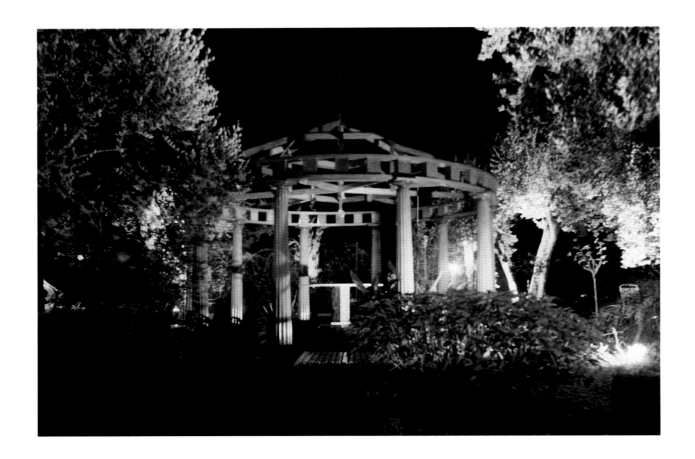

THE TEMPIETTO.

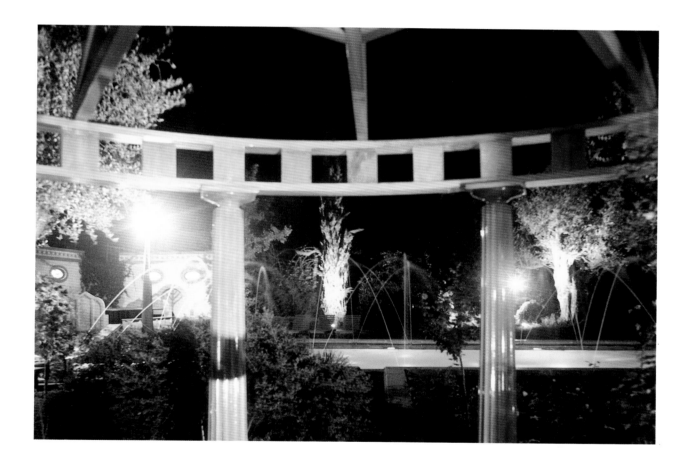

THE INTERIOR OF THE TEMPIETTO LOOKING TOWARD THE TWIN FACADES.

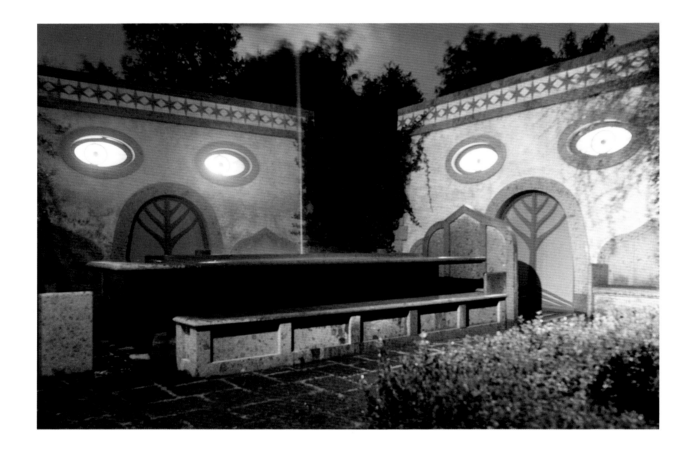

The twin anthropomorphic facades and the stone table.

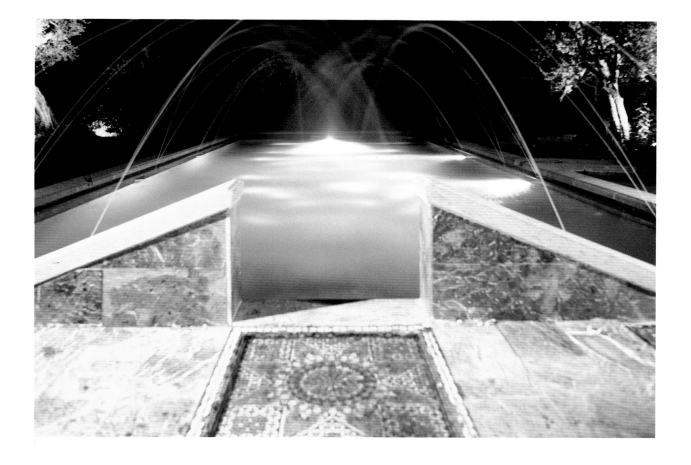

THE VASCA WITH MOSAICS AND WATER GAMES.

Overleaf: The Italian garden with the crystallized tulip fountain; in the background is the theater of greenery.

Second overleaf: Detail of anthropomorphic facade.